SKATE LIKE A GIRL

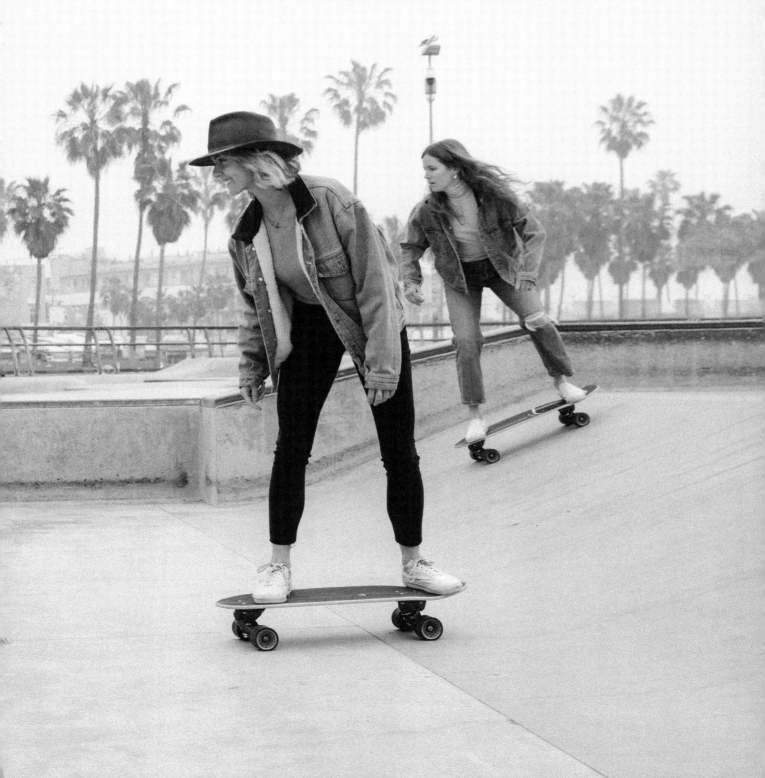

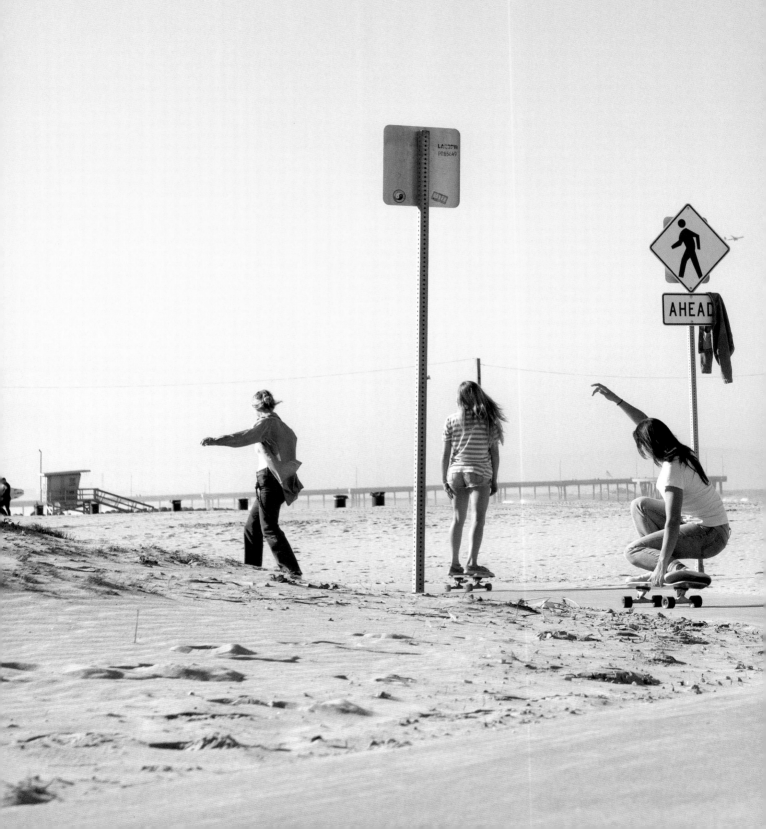

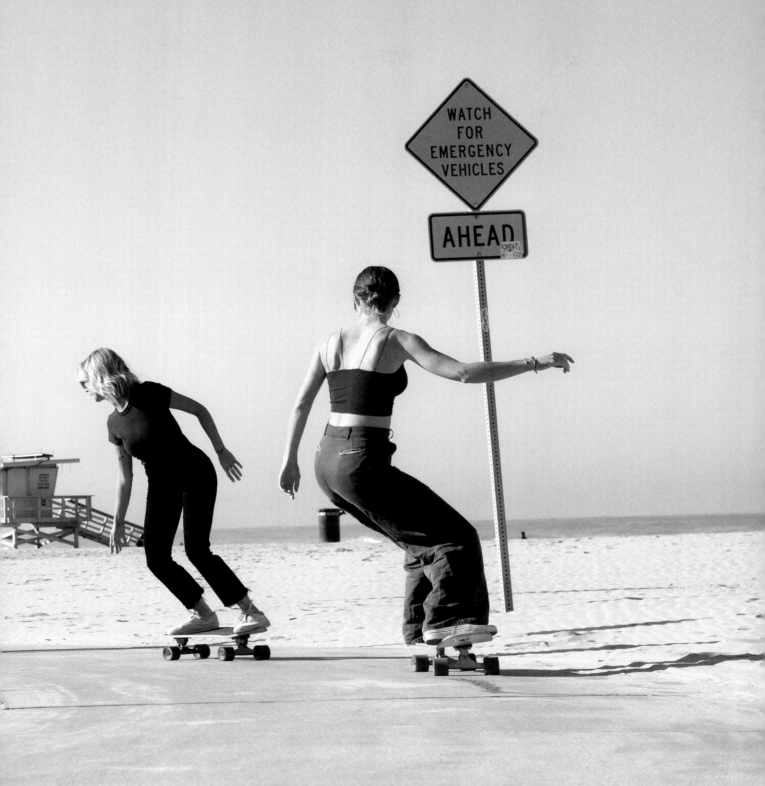

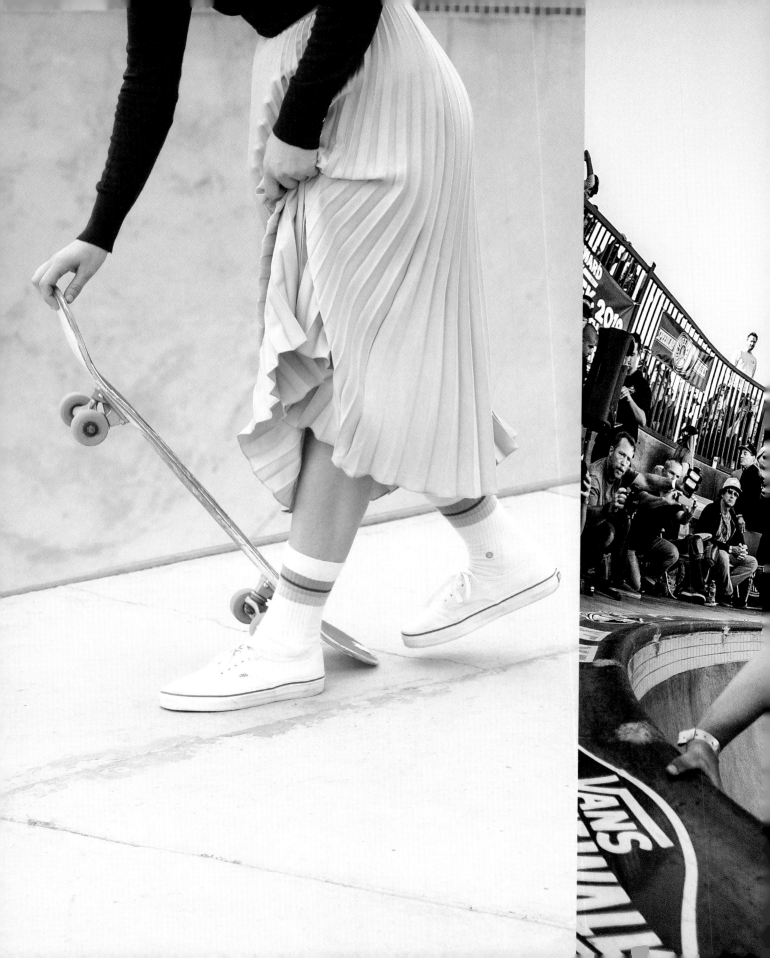

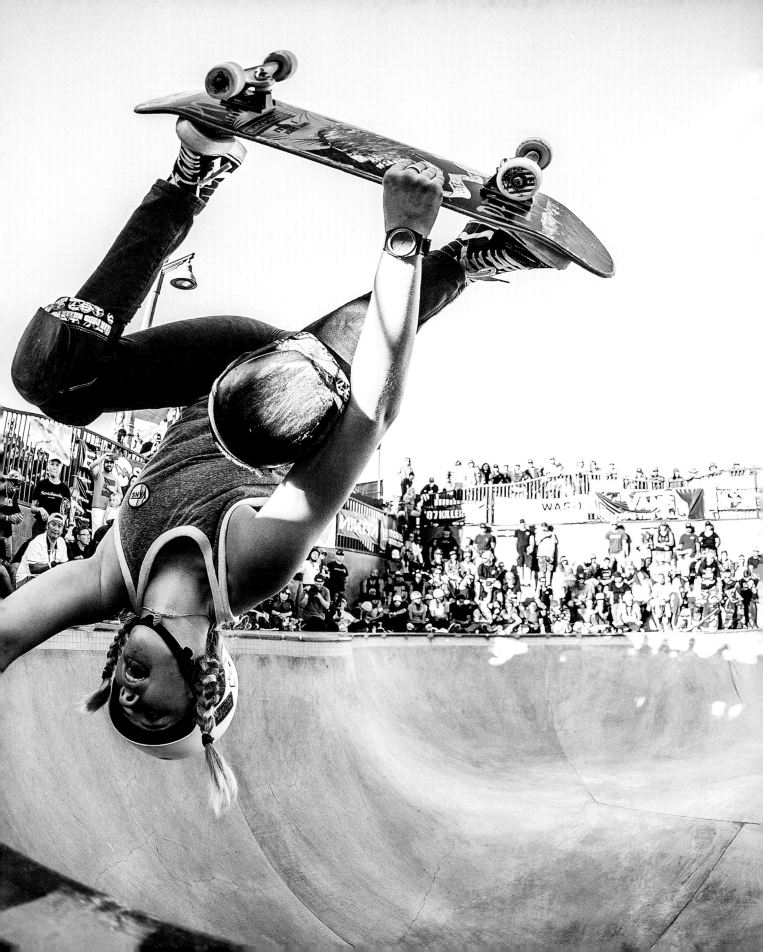

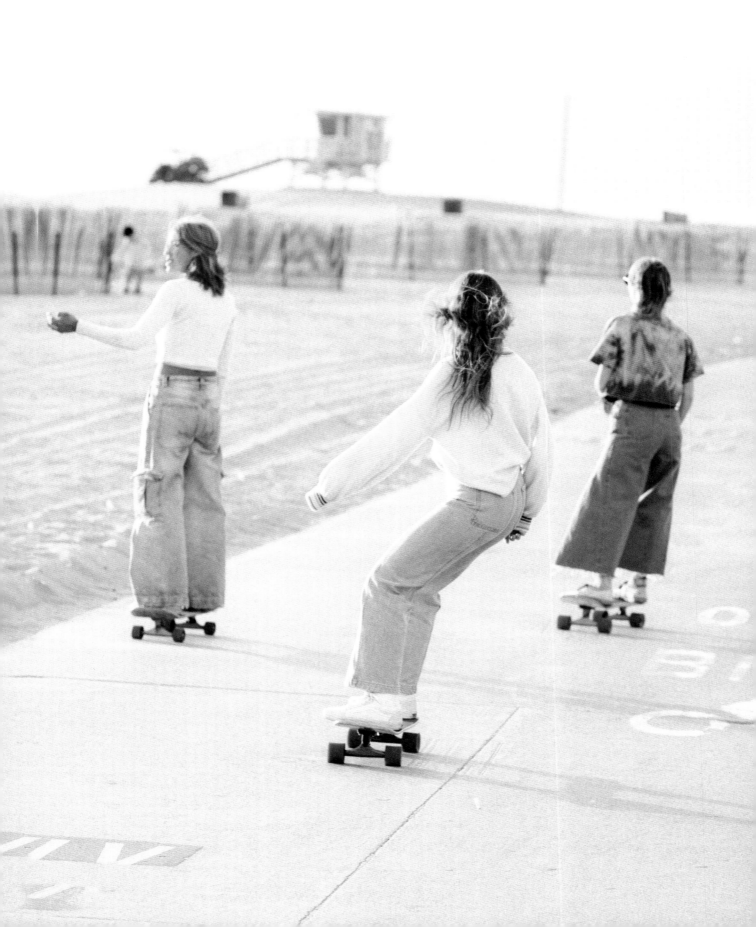

SKATE LIKE A GIRL

CAROLINA AMELL

PRESTEL

Munich · London · New York

Valeriya Gogunskaya
Longboarding days and nights

@valeriya_gogunskaya

I'm originally from Russia and have been living abroad since 2010. In 2014, while studying in Finland, I stepped on a longboard for the first time. I had no idea that it would change my life in every aspect. Longboarding helped me to battle a severe eating disorder, build confidence, and find my own voice. Back then I'd always skate alone, as there was no one practicing longboard dancing or freestyle where I lived. Then I moved to Portugal—for love, but also with the hope of finding a community. I was thinking: There are three hundred sunny days a year there—there must be a long-board community.

To my surprise, there wasn't. I kept venting to my boyfriend about it, and he finally said, "Why don't you start one?" The idea sounded surreal and frightening, yet it made sense. That question sowed a seed, and we partnered up with a local association called Sealand and hosted our first long-board meetup at Praia de Santa Cruz, where we're based. I honestly thought it would be just me, my boyfriend, and Joana, the Sealand representative, but we ended up with a happy crew of over thirty people, from toddlers to grown-ups, and spent a wonderful afternoon skating together.

This was in May 2017, and since then, Longboard Dancing Sunsets in Santa Cruz has become a beloved tradition of our coastal town, with longboarders from all over Portugal taking part and some of the world's top riders coming to throw a show and share their passion. My boyfriend and I also started the first longboard dancing and freestyle com-munity in Portugal, Longboarding Days & Nights, and we've organized meetups in other places, too: Lisbon, Porto, Praia de Areia Branca, Torres Vedras, Ericeira, and Aveiro. Then

came longboarding lessons, and then—more as a joke—we thought, How about organizing a longboard camp? We wanted to create a fun and safe environment where anyone, regardless of experience or age, could learn to longboard from some of the most skillful riders around. Many people struggle to get started on their own, or to progress by just watching videos online, so the concept received very warm feedback. We recently hosted our eleventh camp, with women and men ranging from their twenties to their sixties joining us from more than twenty-five countries, includ-ing such remote corners of the world as Japan, Malaysia, Australia, and the US.

I take pride in and love our longboard project: it has already brought smiles to so many people. But what really makes my heart sing is the diversity of people who come to skate with us, which is something that's harder to encounter in skateboarding, for example, which is still a more closed, male-dominated subculture. Last but not least, through our Pushing Forward initiative, we donate part of our profits to social causes and individuals in need, which allows us to give back to communities near and far.

I recognize that it's a privilege to live off what you love, to have opportunities and a choice. It's important to keep in mind that what we possess isn't just a result of our work but to a large extent a matter of chance, and it's our responsi-bility to use our privileges to transform this world so that more people can access those opportunities and have a choice. And I believe that it's our passions that are the most powerful tool for doing this, and our streets are the best place to start.

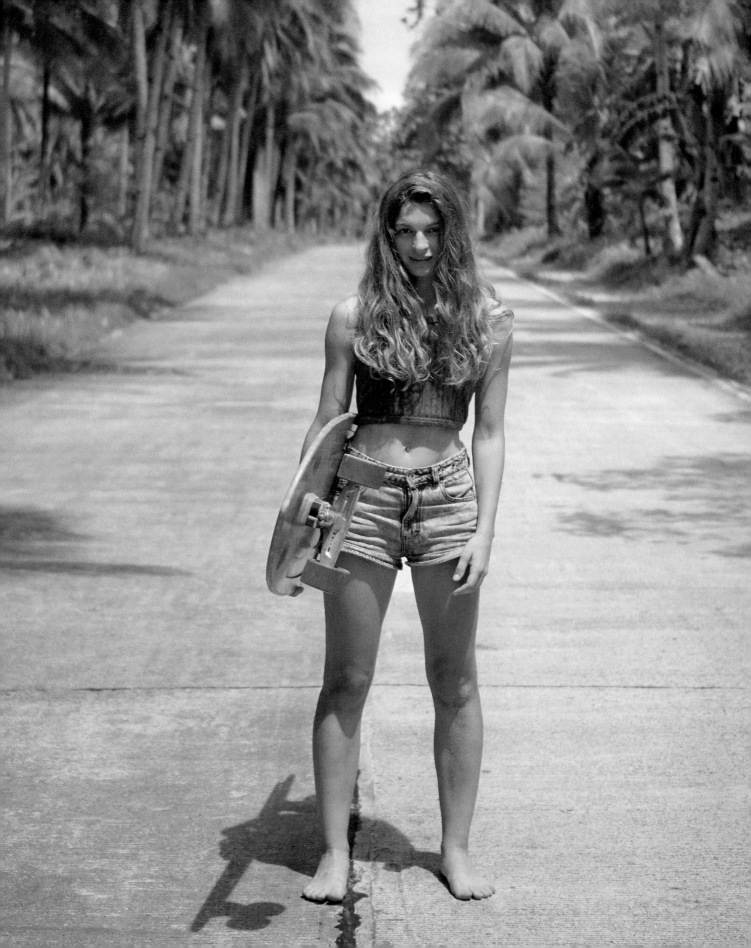

Born to ride.

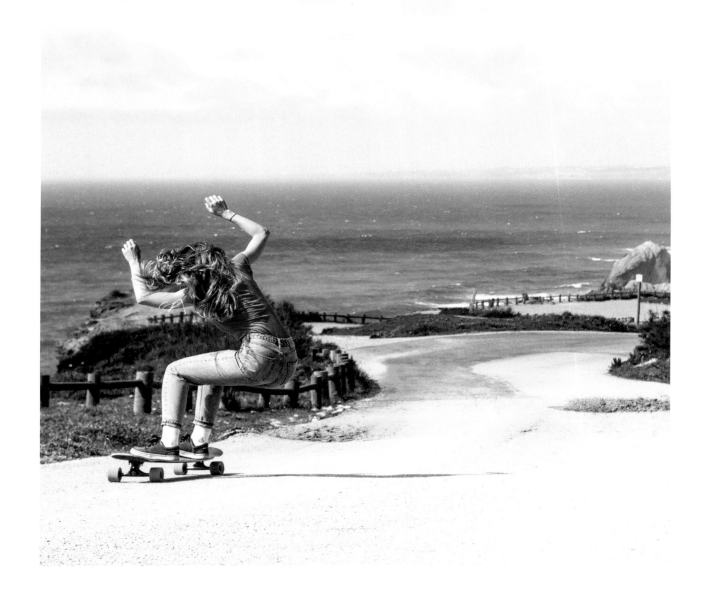

Praia de Santa Cruz, Portugal

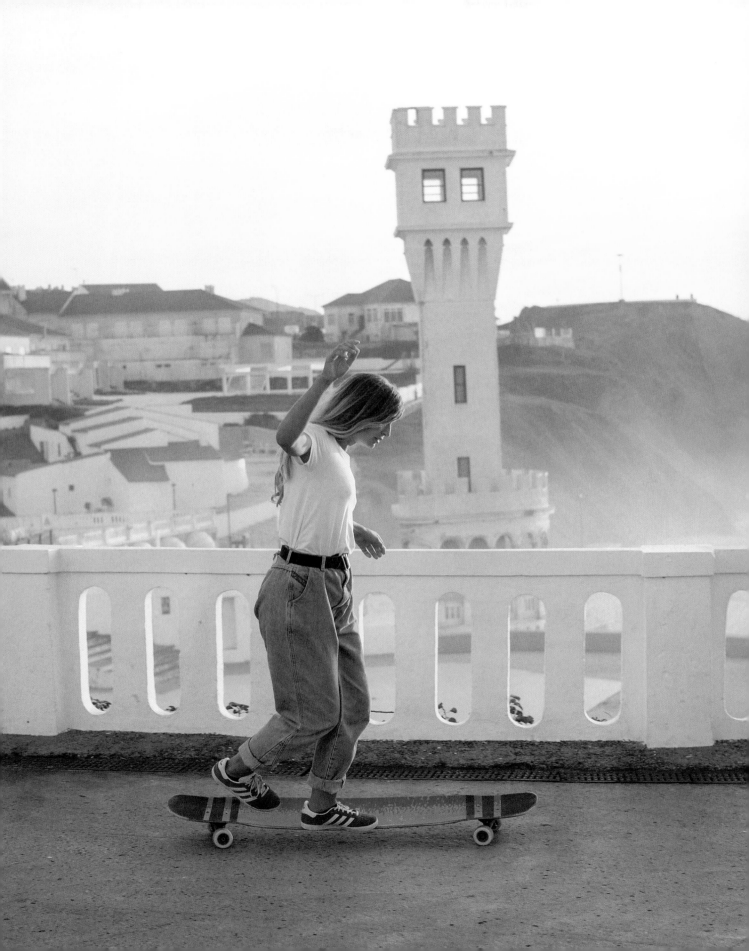

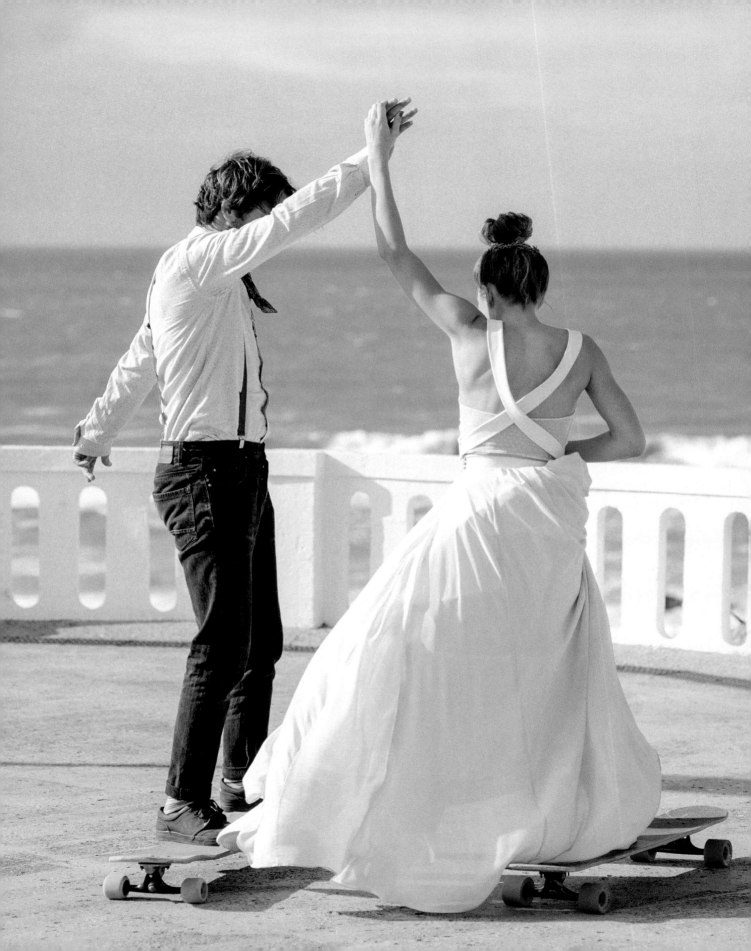

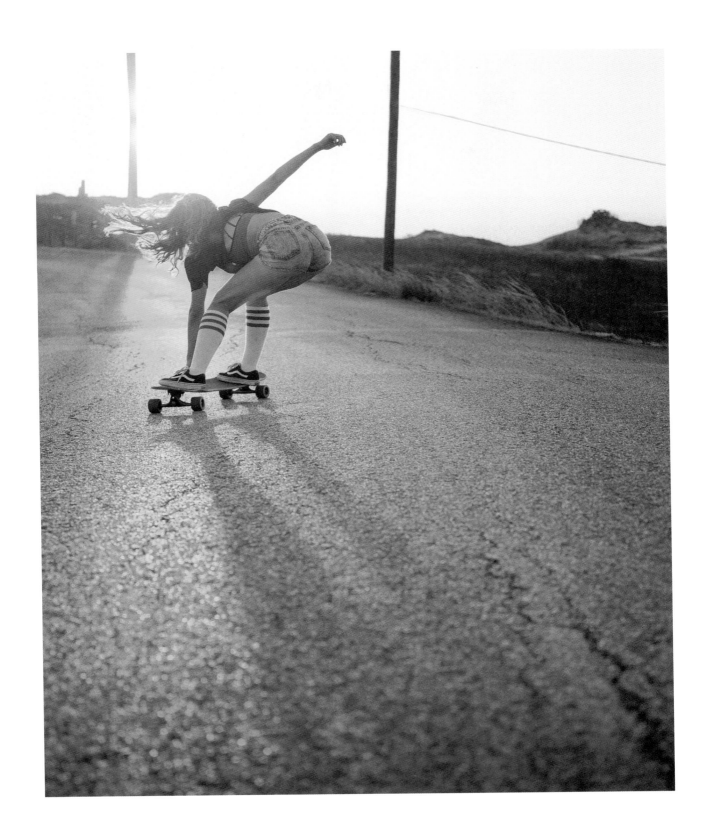

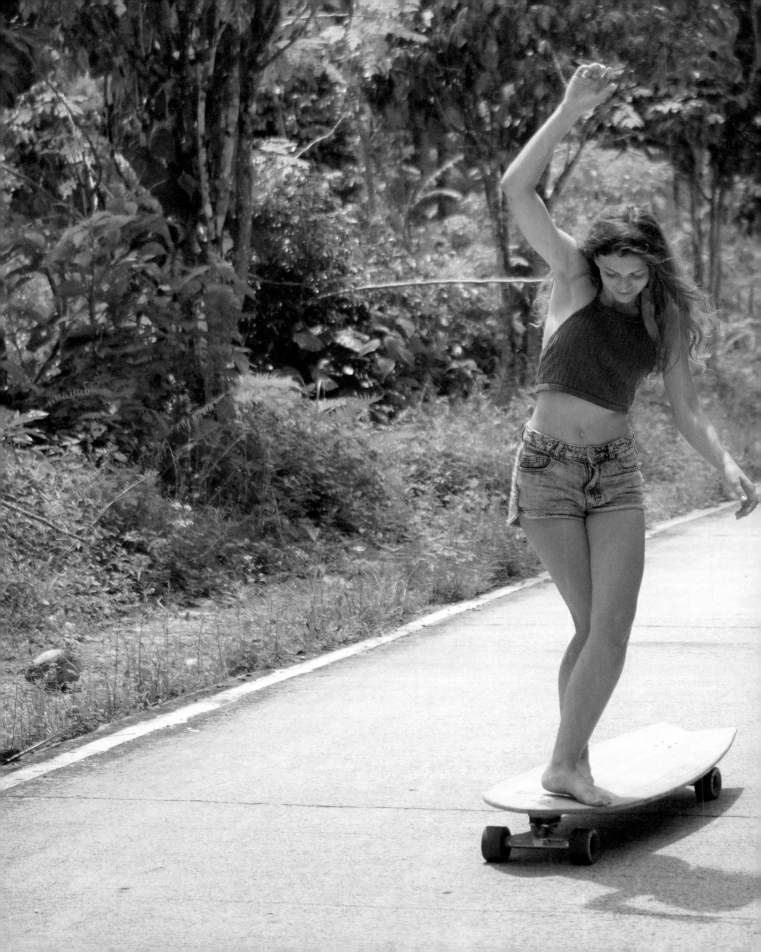

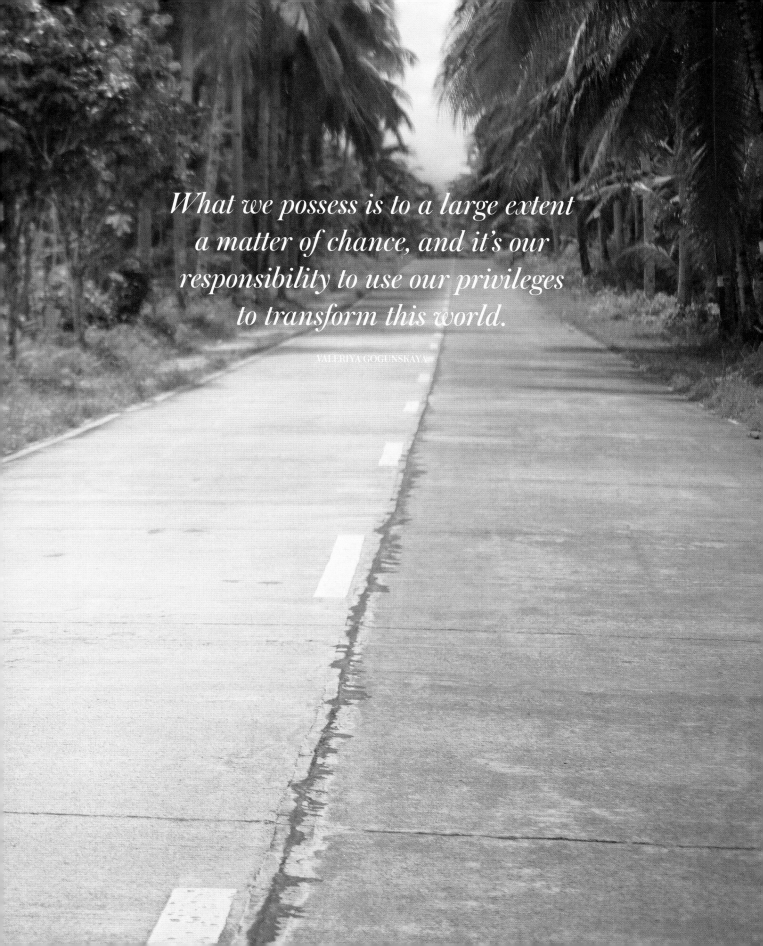

*What we possess is to a large extent
a matter of chance, and it's our
responsibility to use our privileges
to transform this world.*

VALERIYA GOGUNSKAYA

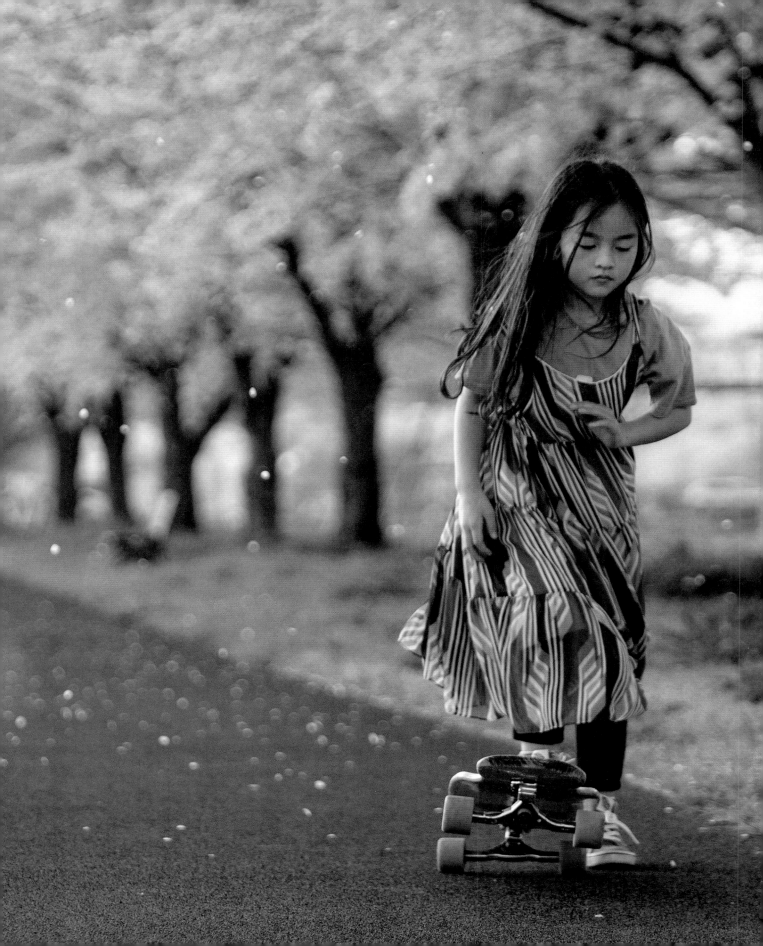

Yuni Kim

Young passion

@longboard_yuni

My Korean name is Kim Si Yun and my English name is Yuni. I'm nine years old and I live in Changwon, South Korea. I'm in elementary school and started longboarding in 2017—I've been riding with the longboard crew Longlight for two years.

I'm now also an international rider with a longboard company in Hong Kong called Travelol, and I'm part of the junior team at AKA Board Shop here in Korea. I won first place in the junior division at the 2019 Longboard Festival in Korea, and third place in the women's freestyle category.

My father says that when I was younger I lacked confidence and that I was terribly afraid to stand in front of people. However, by riding my longboard I've been able to meet other people and have fun with them. As I entered competitions and won prizes I started to receive support from so many people, and that's made me so happy and has really built my confidence.

I ride for more than two hours every day and enjoy practicing new skills. That's when I'm happiest. I want to spread the message that, even if you lack confidence, you can achieve what you want if you work hard. People will support you and give you positive energy.

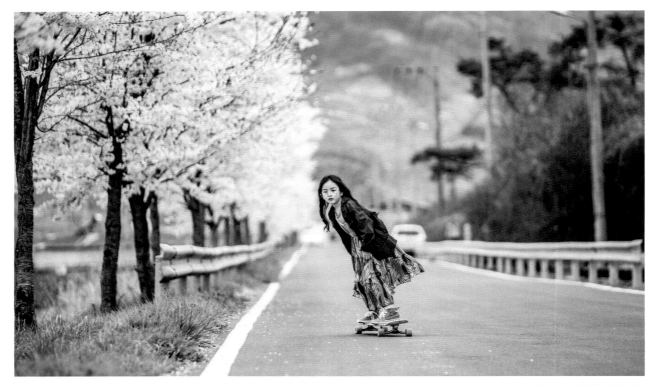

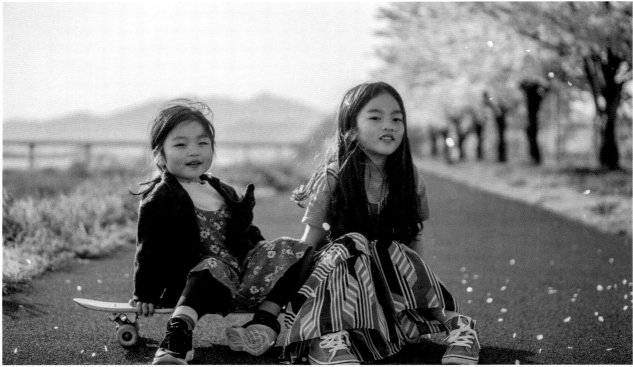

Miryang, South Korea

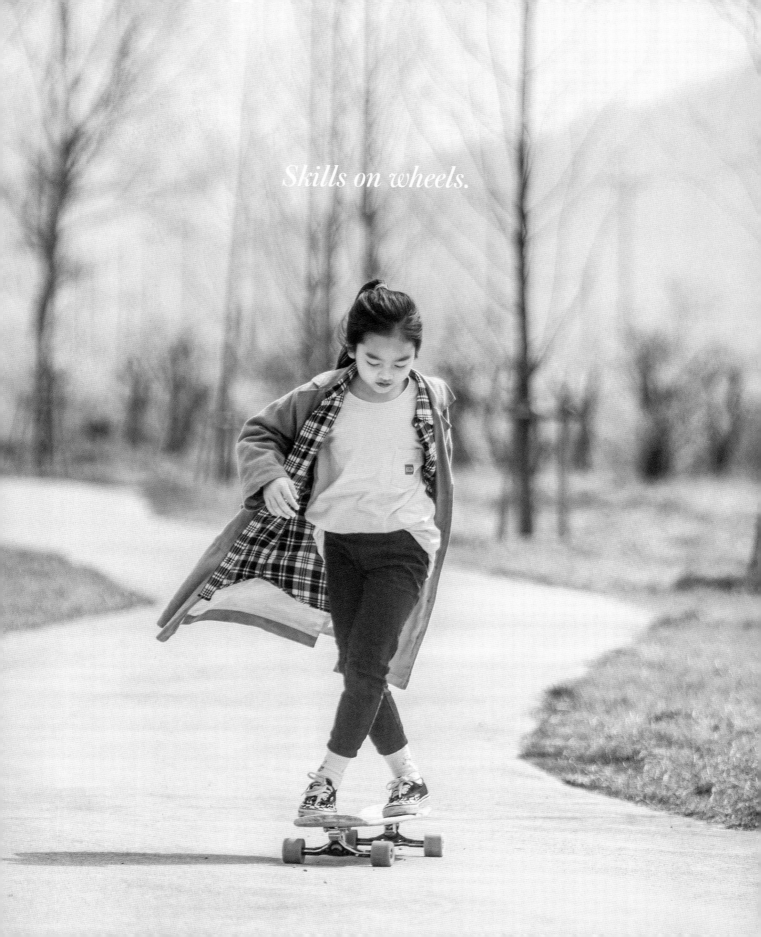

Skills on wheels.

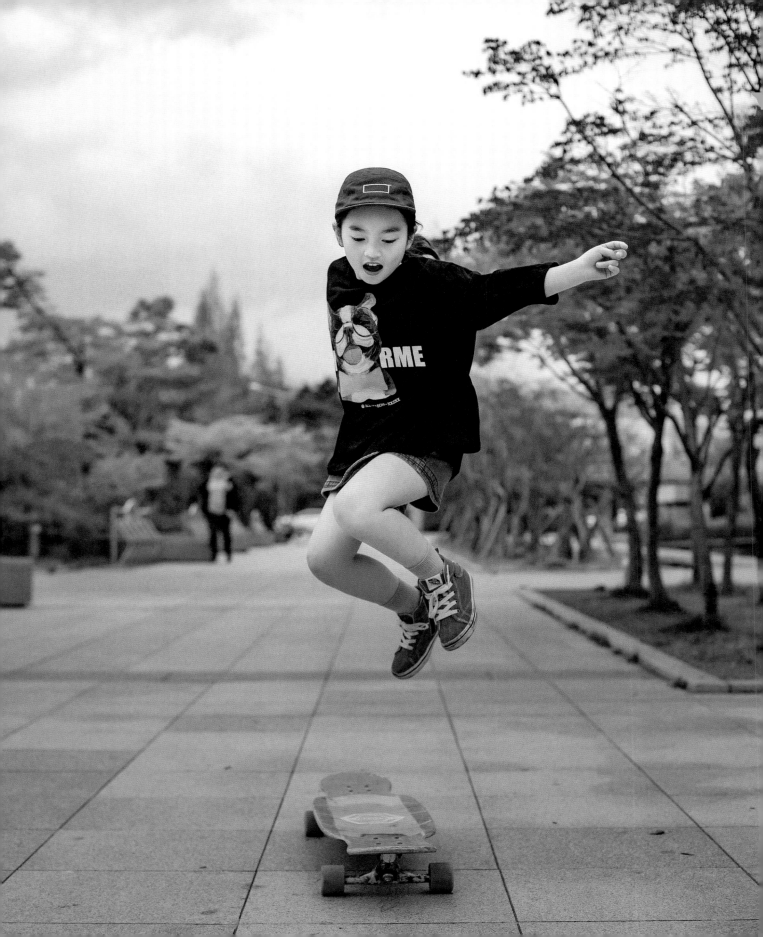

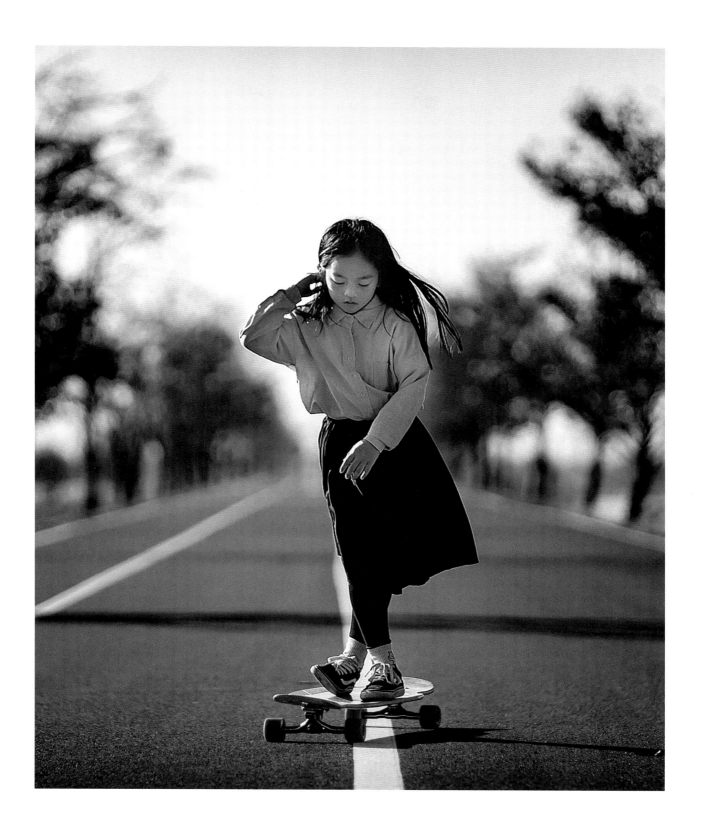

Gyeongsangnam-do, South Korea

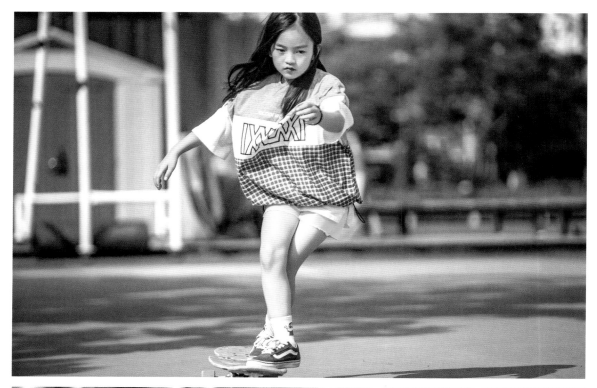

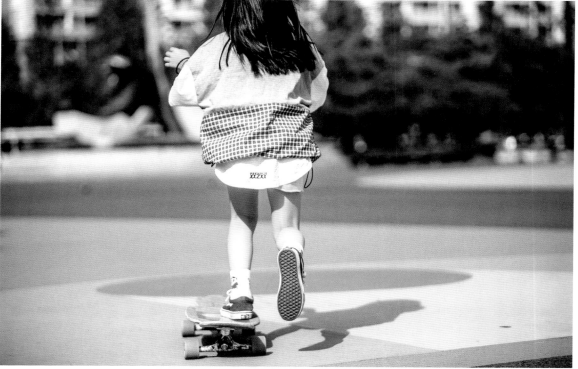

　Changwon Sports Park, Gyeongsangnam-do, South Korea

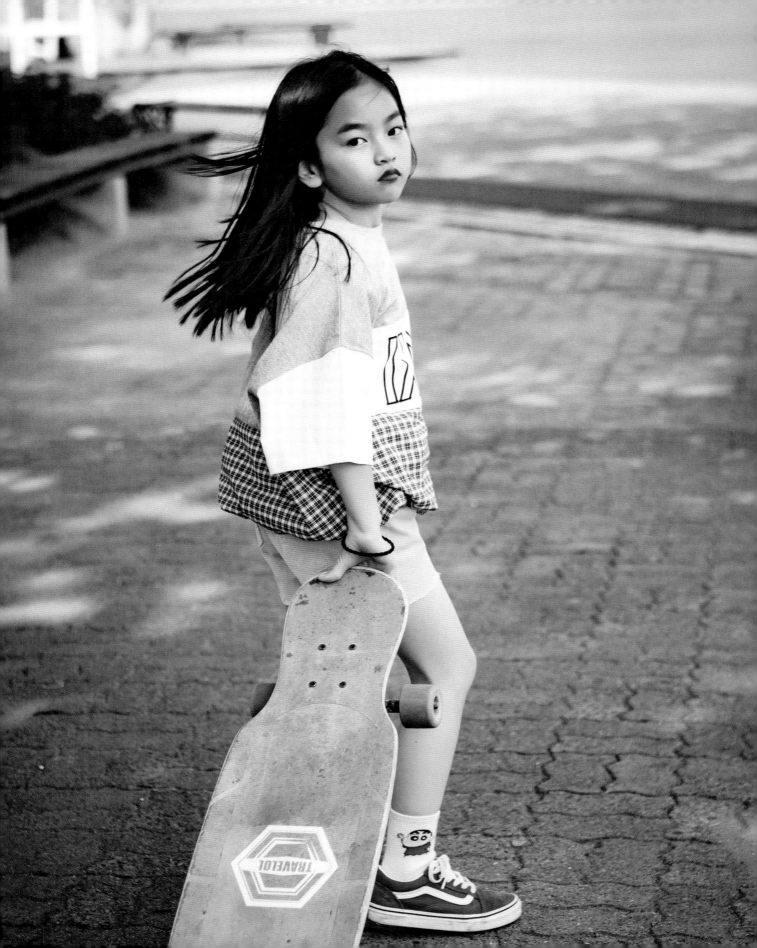

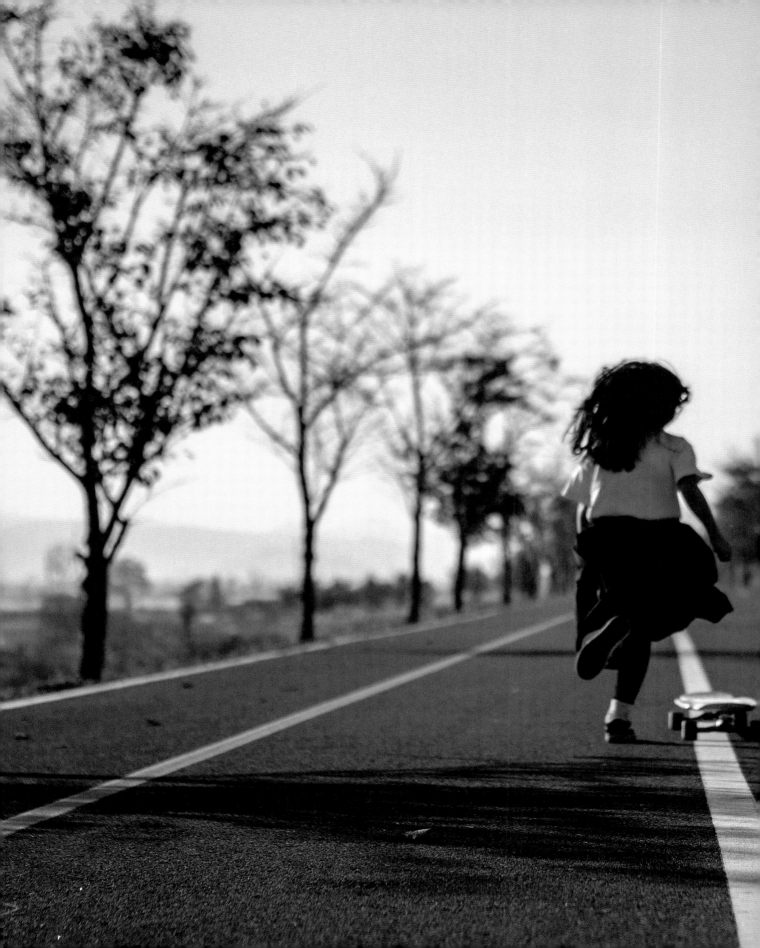

I ride for more than two hours every day.
That's when I'm happiest.

YUNI KIM

Maria "Masha" Zakirova

Downhill skateboarder from Russia

@koteeeeo

I'm Masha and I'm a downhill skateboarder from frosty, snowy Siberia, one of the northern regions of Russia, where winters last about six months. For the first eighteen years of my life I grew up just like most other Russian children, but when longboarding suddenly burst into my life five years ago, things completely changed. Stepping onto my new longboard for the first time was so exciting and made me want to skate more and more, even faster, even further. I became obsessed, skating from early morning until late in the evening. My board and I were inseparable. After riding, I'd sit down to watch hundreds of tutorials on YouTube.

Racing downhill along an open highway, developing speeds of up to 90 kilometers an hour: this is what gives me energy, makes me happy, and allows me to leave my comfort zone, conquering new frontiers. At the beginning of this journey I had no idea what a huge impact longboarding would have on me and my life. It has allowed me to achieve everything I'd ever dreamed of: to make new friends from around the globe, travel, and take part in interesting projects and amazing adventures.

Love what you do and be proud of your success. Remember, the first rule of a proud club is to never compare your progress with the progress of others. The second rule is: *never* compare your progress with the progress of others.

And the most important thing: always wear a helmet when you're skating down, girls!

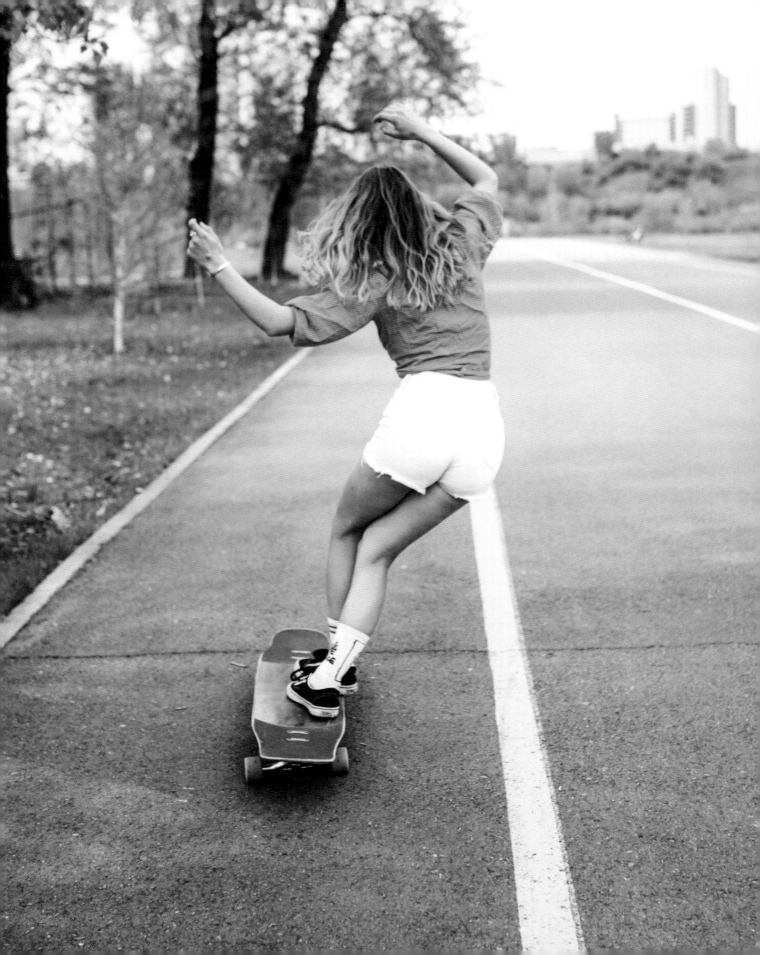

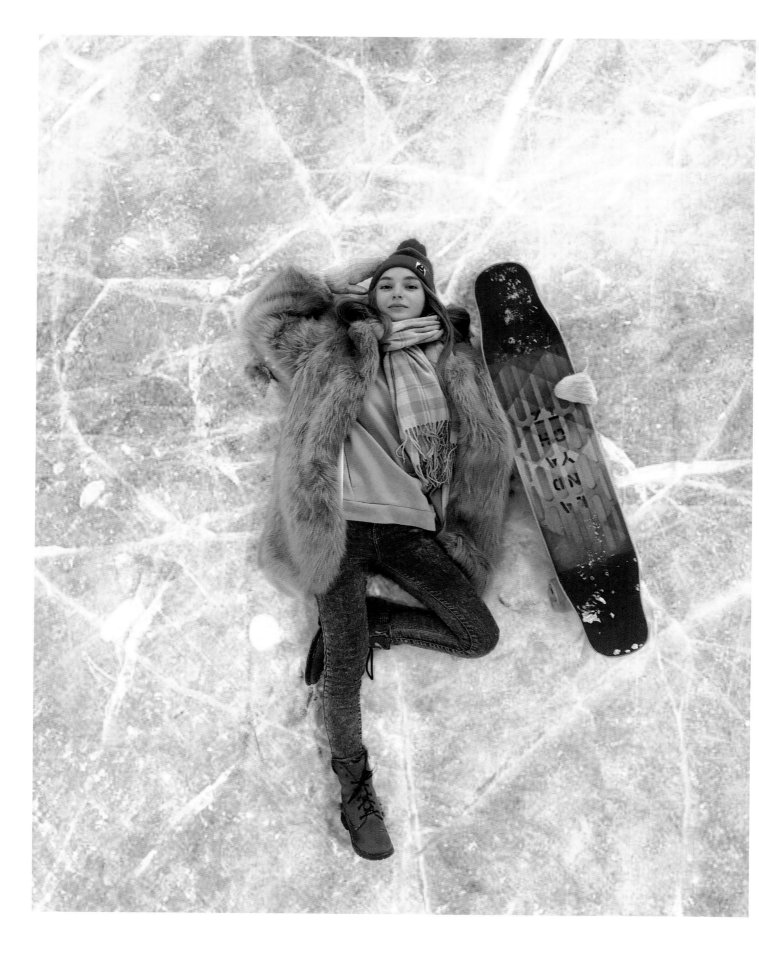

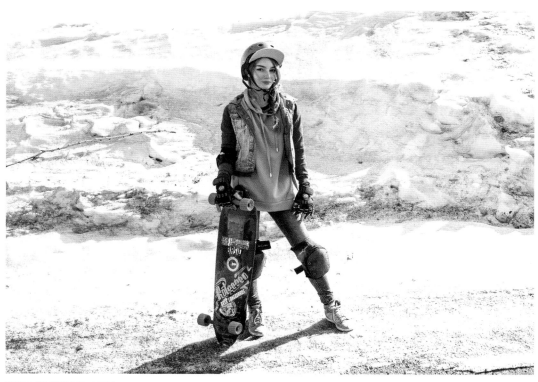

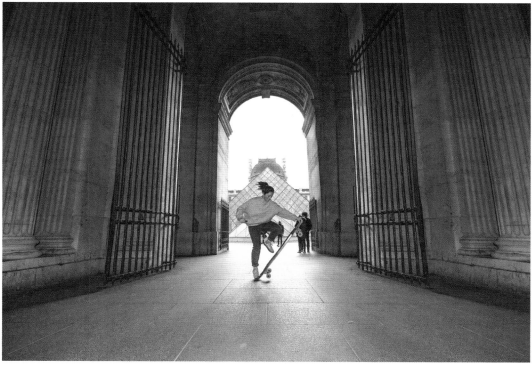

*Worry less,
skate more.*

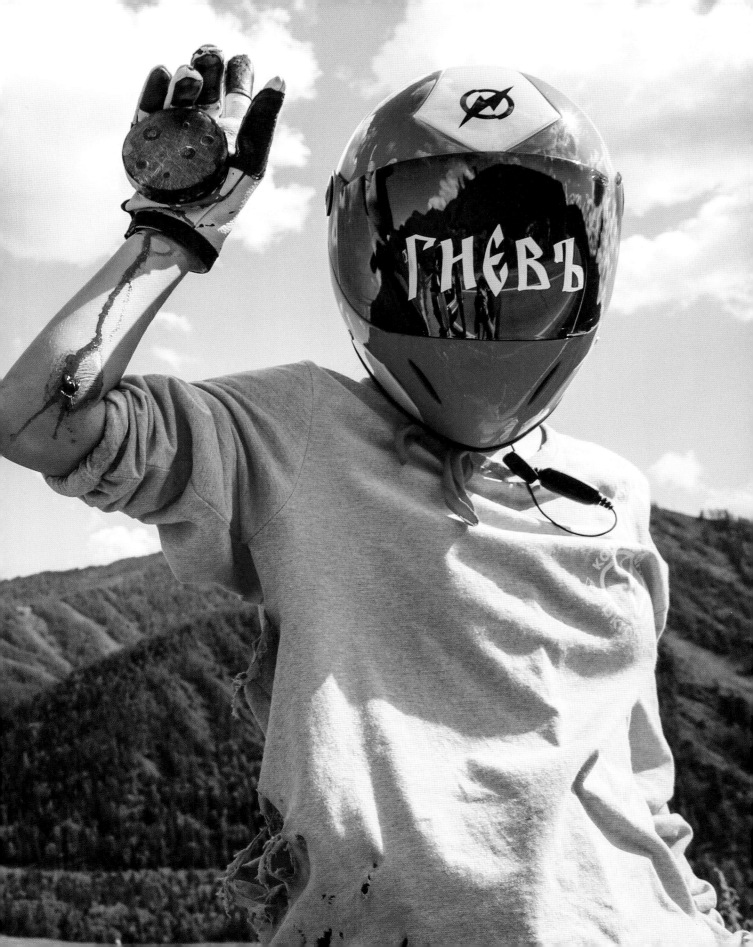

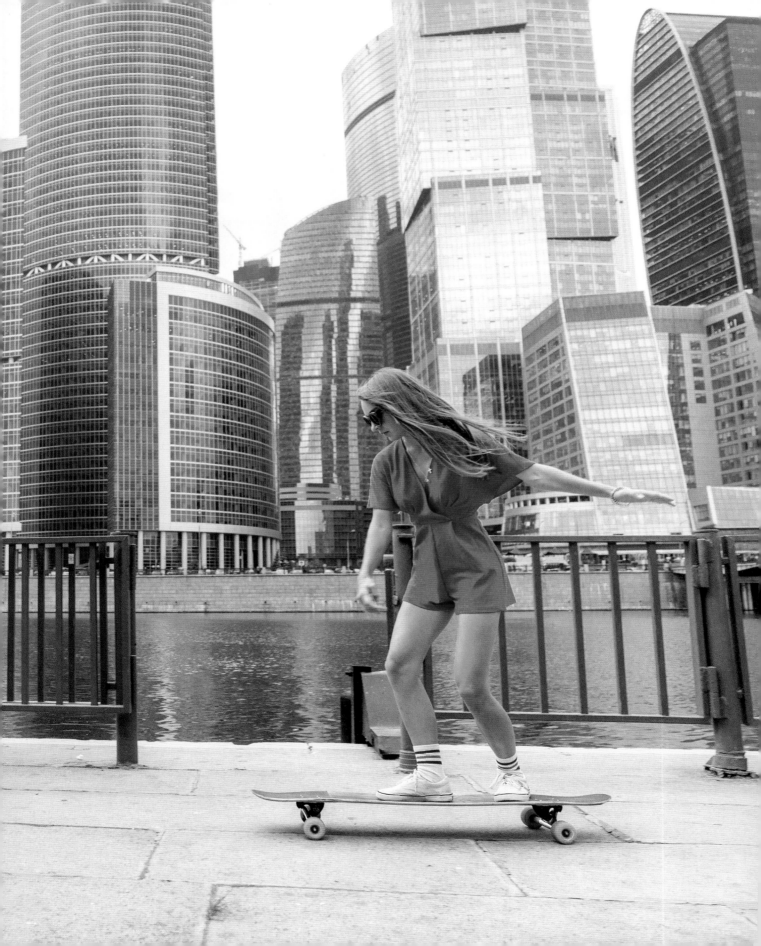

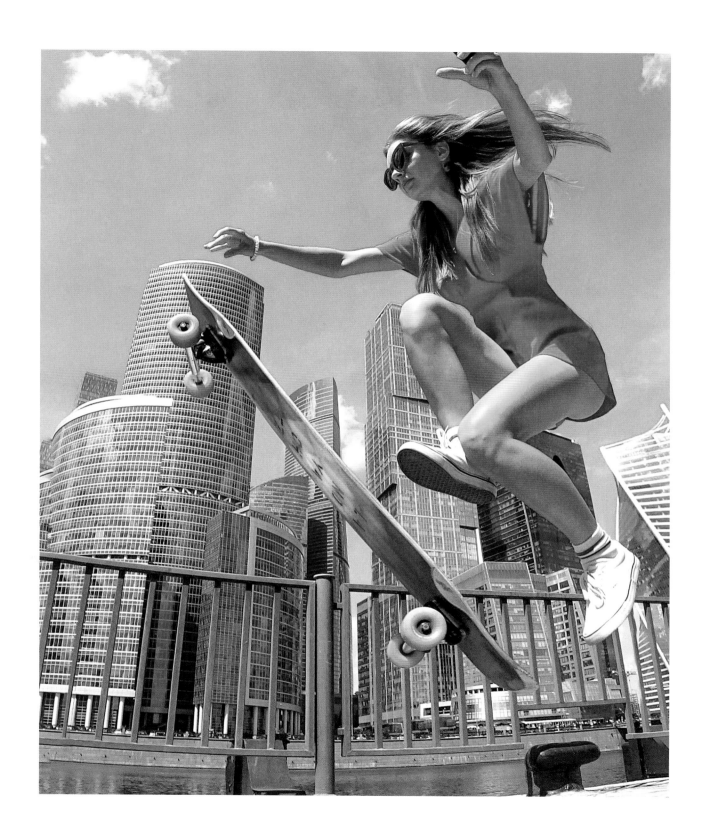

Moscow, Russia

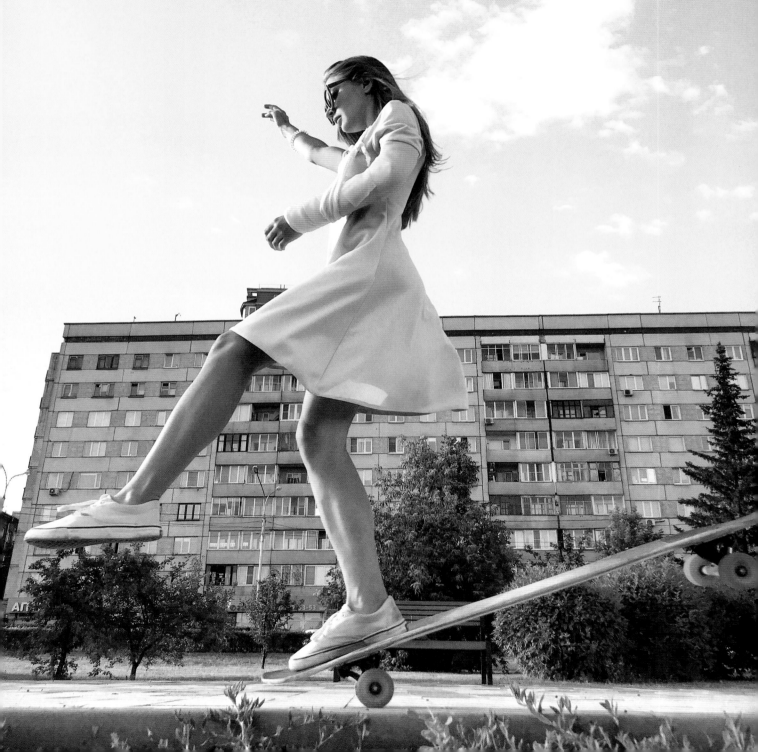

Never compare your progress with the progress of others.

MASHA ZAKIROVA

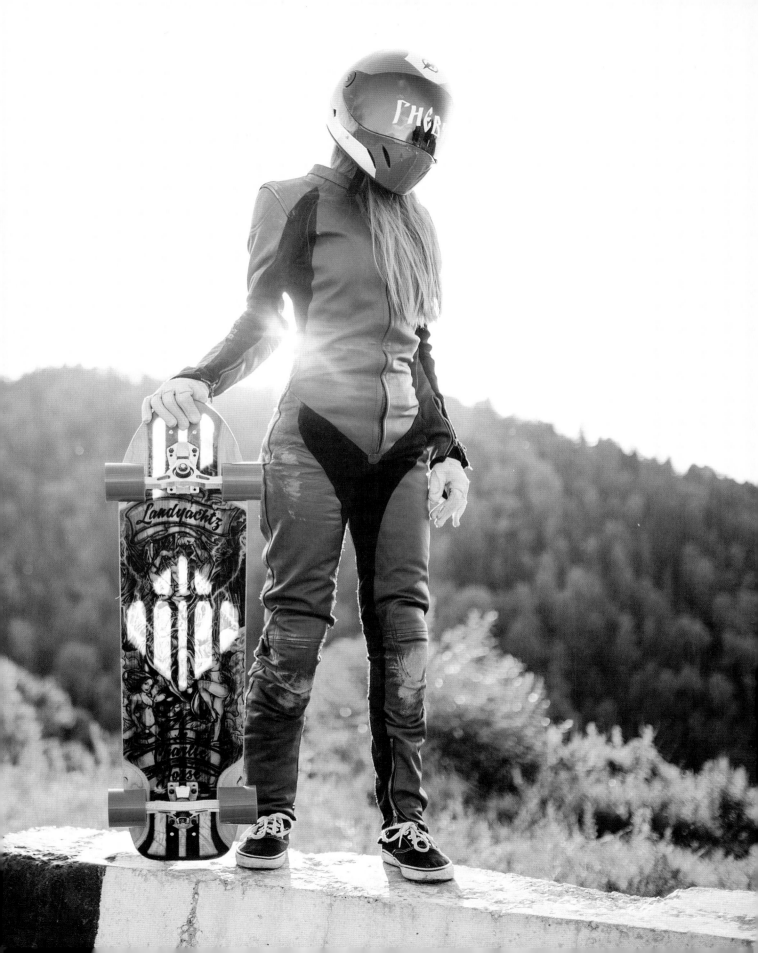

Yasmeen "Yaz" Wilkerson

Skate to impact lives

@yaz.so.mean

My name is Yasmeen Wilkerson; Yaz for short. The driving force in my life has been my desire to uplift others as well as myself. I've fallen in love with skateboarding as a lifestyle: it's not only a physical activity through which to test my body, strength, and endurance but a way of engaging mentally that teaches me about determination, resilience, and the strength of the mind.

The first evidence of this driving force can be traced back to when I decided to take up longboarding for the first time. I was introduced to my first longboard by an ex-boyfriend, who would let me experiment with what was for me, at the time, a wooden death trap! But I'd watch him turn it into an extension of himself: right before my eyes, he would dance with his board, expelling tricks, slides, and footwork I'd never seen before. I wished I could do the same, not only performing tricks but taking falls as well—the art of persistence was something that intrigued me. Little did I know my persistence would be tested in the days to come.

Fast-forward to 2015, and I'm being reintroduced to skateboarding after two life-threatening longboard-related accidents. They left me traumatized, and for a couple of years before my comeback I had stopped skating. My parents had reacted (with good reason) to my hospitalization by demanding I throw all my gear, decks, and boards away.

After a couple of years, I was introduced to a new type of skateboarding lifestyle at a backyard mini-ramp session in Brooklyn. Mini-ramp sessions that were inclusive towards women were being hosted every weekend, and I couldn't get enough of how empowered it made me feel. We didn't know it at the time, but we were building a community, and before I knew it I was progressing faster, with the support and love of my new extended family.

Making this transition back into skateboarding, and being supported by other women rather than skating with guys, was something I wasn't used to. Not only did I feel like I truly belonged, but I was claiming spaces and skating better than ever. My persistence paid off, and soon a *New York Times* article came out that exposed me to a life in front of the camera. As well as that, I was now shifting my focus to teaching my passion to young people. My life was changing—I was learning about the commercial world and modeling as well as using skateboarding as a tool for community activism and change. I found a new purpose in life: to use skateboarding as a medium not only of expression but of activism as well. I love what I do, and presently I'm looking forward to helping to host more meetups with my good friend Briana King, to promote inclusivity for women, queer and nonbinary people, and people of color alike. It's what I'm using to impact lives and leave my mark in the world.

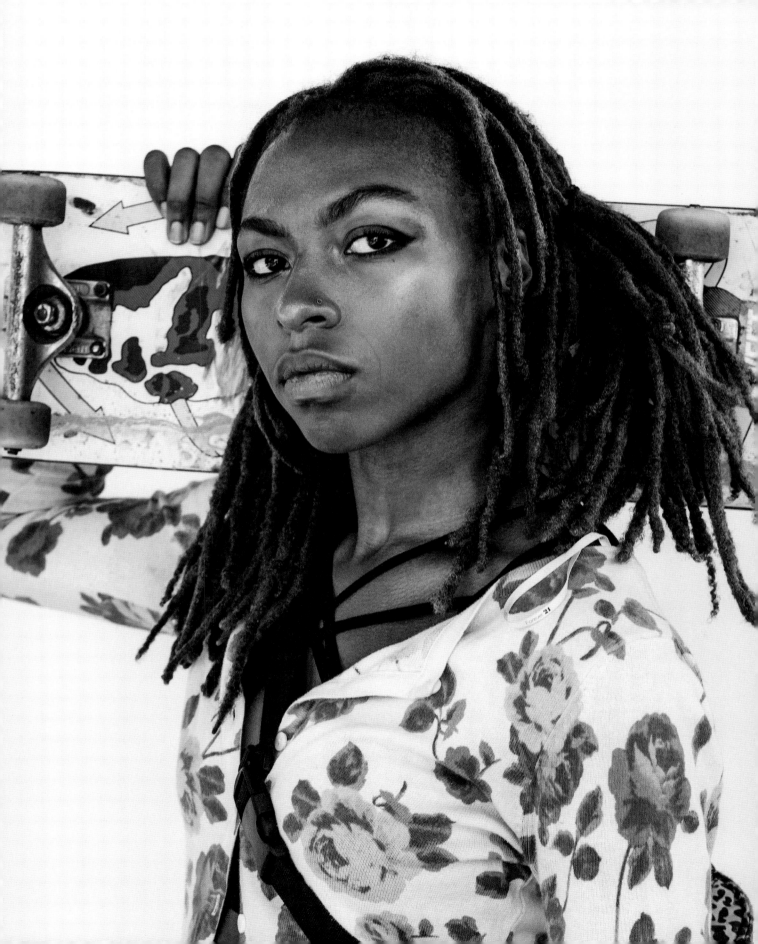

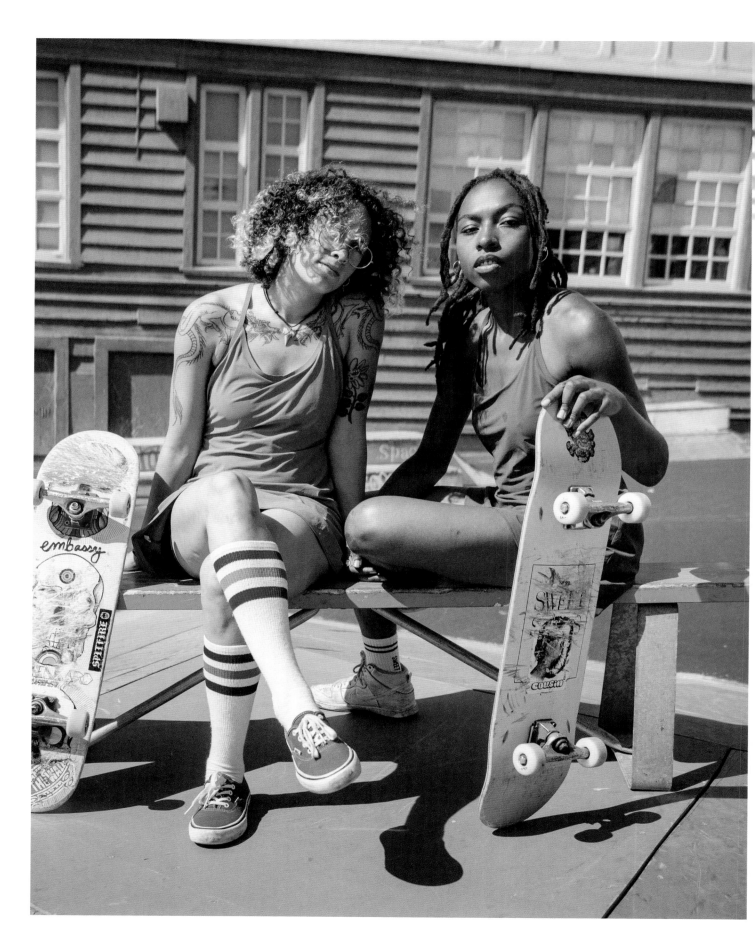

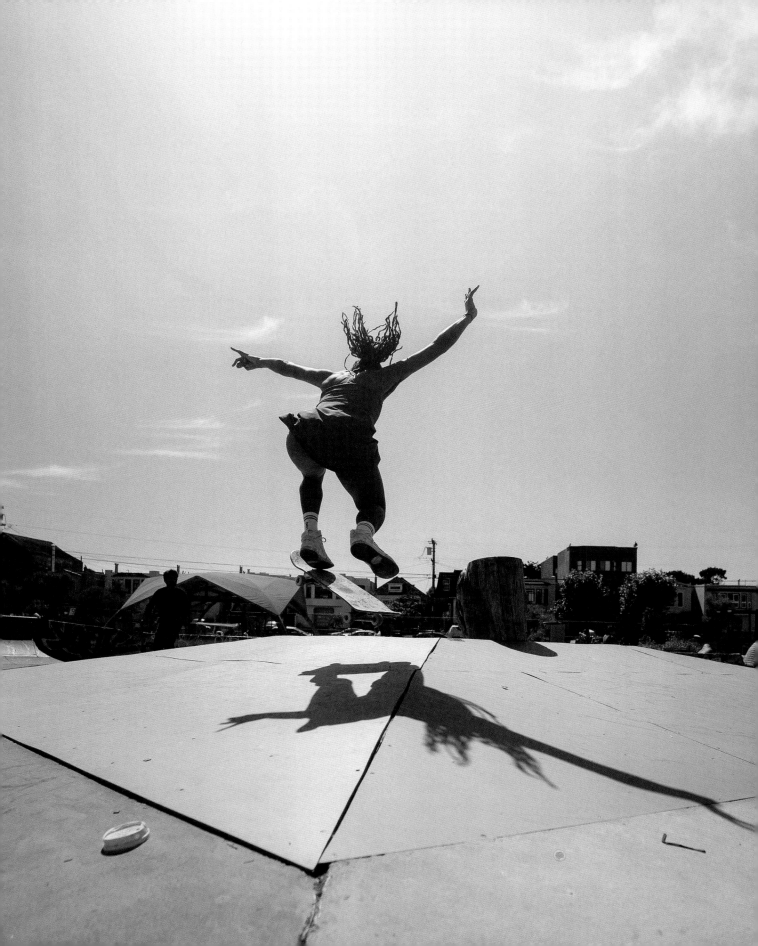

Skateboarding teaches me about determination, resilience, and the strength of the mind.

YASMEEN WILKERSON

▷ LES Skatepark, Manhattan ▷▷ Williamsburg Bridge, Brooklyn | New York City, USA

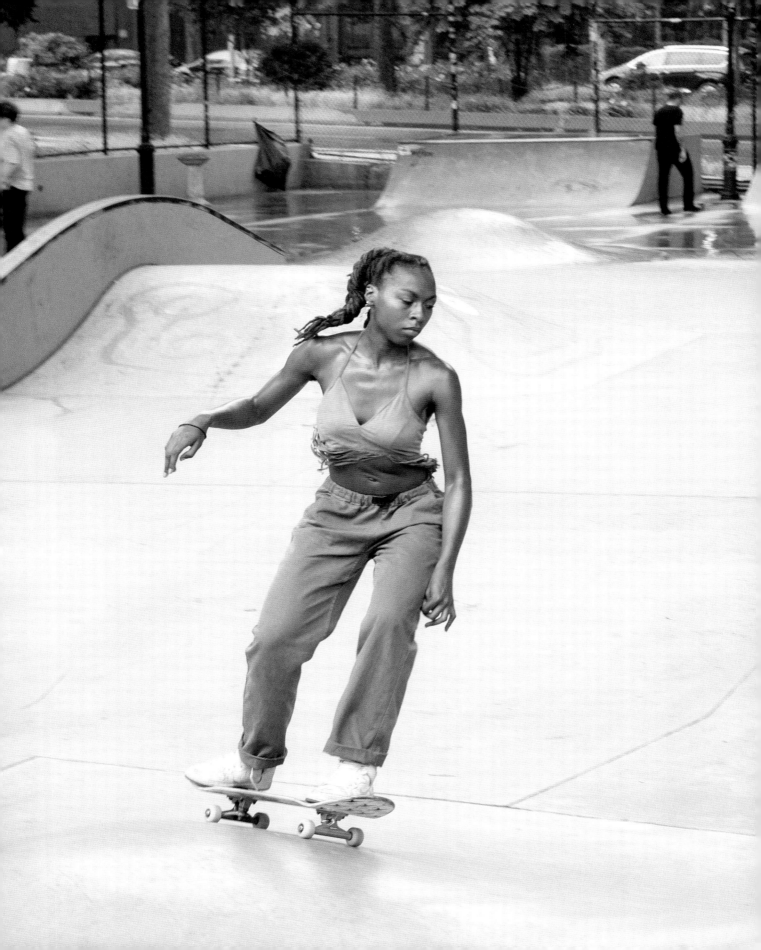

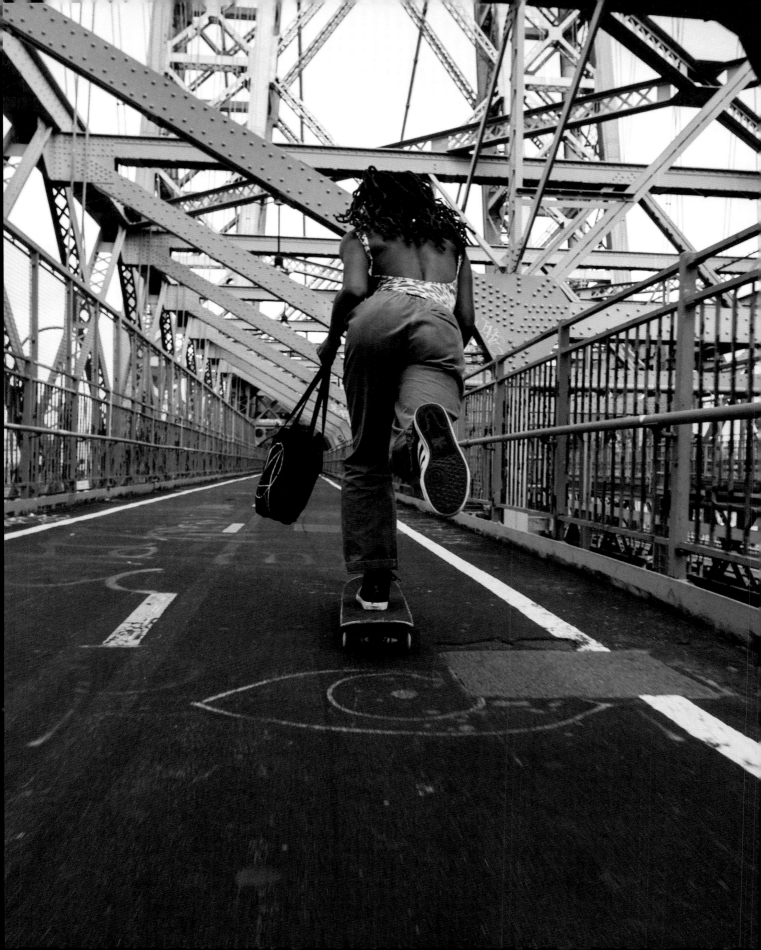

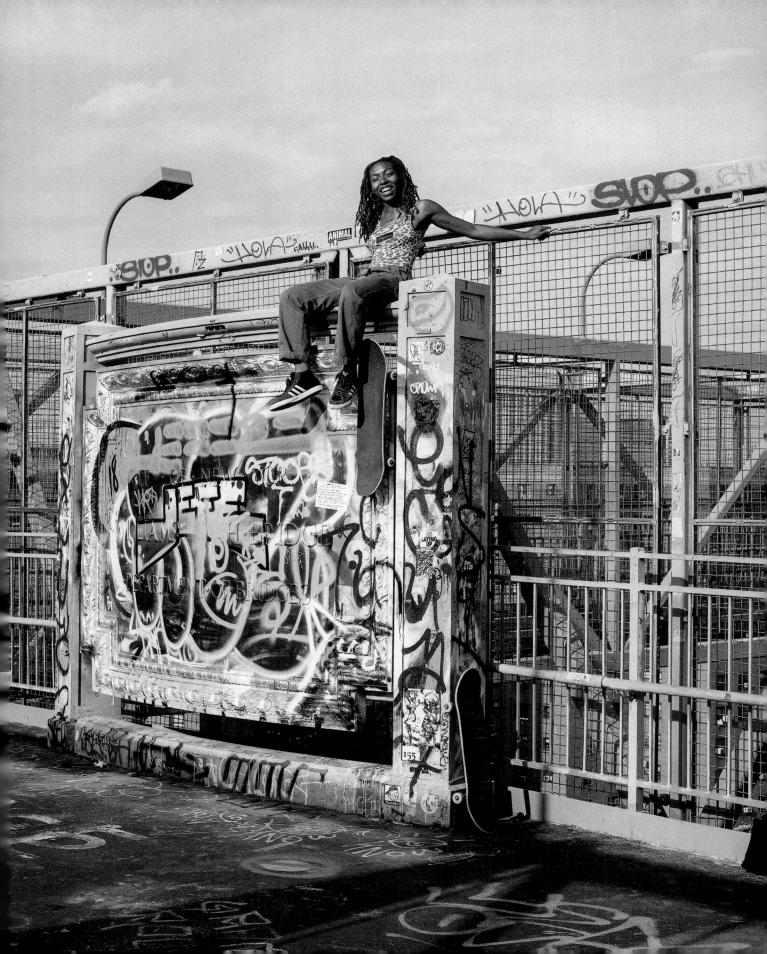

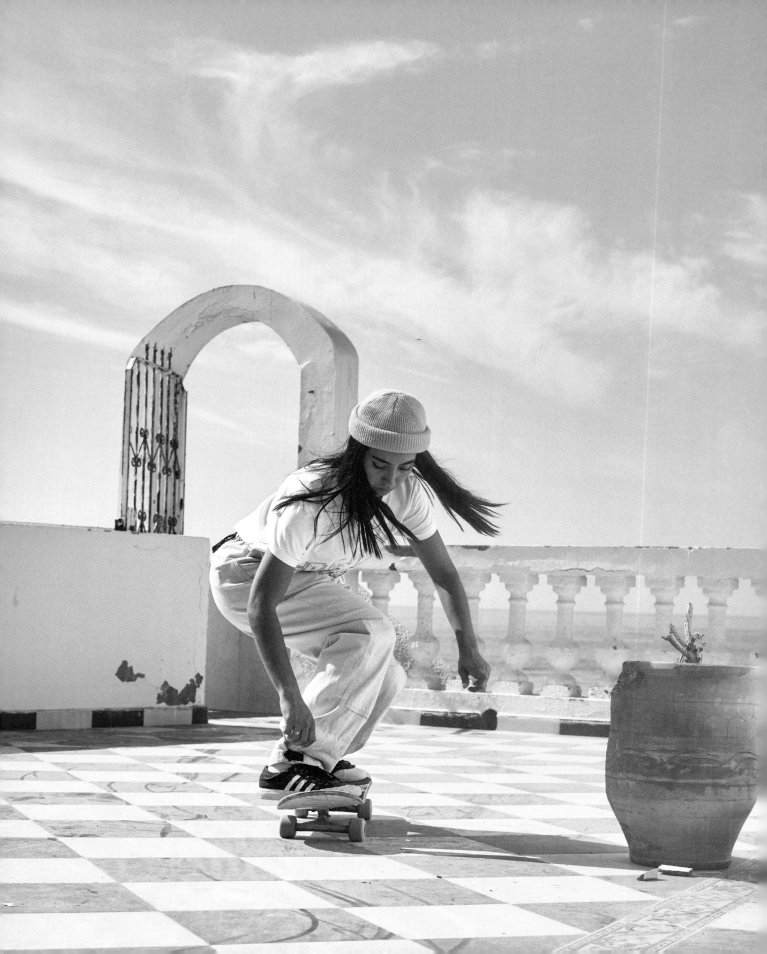

Wafa Heboul
Skateboarding in Morocco

@wafaheboul

My name is Wafa Heboul and I grew up Agadir, Morocco. I started skateboarding when I was in high school, as a confused teenager seeking a distraction from what life was throwing at me. I was looking for something to vibe with; I wanted to put all that energy I had into something. I tried a few different hobbies here and there, but they weren't my thing. I didn't like basketball, I quickly got bored of soccer, I even tried crafts—don't get me wrong, these are all cool, but I've never been someone who does something because everyone else is doing it.

Then I started skating with my best friend using a skateboard we'd bought super cheap from a kid in our neighborhood. Skateboarding made our friendship stronger, and I still skate with her ten years later. It also introduced me to so many awesome people who I can now call friends; it kept me out of trouble (kind of); and definitely shaped me into the person I am today.

Everyone asks me what it's like to be a girl skater in Morocco, and to be honest I never know how to answer. It's the only thing I know, and I don't have anything to compare it to. There was definitely some nonsense here and there from people (mainly men), but I don't blame them—it was something they weren't used to seeing. With time I became immune to the comments, the opinions I heard in the street; and occasionally I'd skate past a woman and she'd smile at me like she approved, and that made a difference. Skateboarding did build my character. It taught me how to be brave and that I do have a voice, and it taught me that if I can choose to skate in a place where people think skating is a "boy thing," I can also choose a lot of other things too, in spite of what society thinks.

And it taught me that if I fall, I fall; people might stare or even laugh, but what matters is that I'll stand up and try again until I land my trick. That's similar to a lot of things in life.

My goal is to protect and build our skateboard community, and to do this I'm creating a skateboard brand, one that describes us and that speaks on our behalf and that can be a platform for all artists—not just skaters but designers, artists, photographers and more. The company is called Zoutland, which is my nickname for Taghazout, the town where I live. I want to build a brand where skaters can express themselves through their designs, spreading awareness and messages using the same tool that they use to perform their art.

Deep down I'd always wished that I could establish my life around skateboarding; I'd dreamed about competing or getting sponsored, but it seemed like such a long shot, and there have been times when I've skated less because of things like school or work. But I never stopped doing it—I skate for the love of it, and I guess it paid off, because it shaped my life into what it is today. But at the same time I can't help but think about those ideas I had when I was younger, and what I might have achieved, because everything is possible, and why not wish for the stars? We should work hard for the things we want and believe in ourselves. So what I'd like to tell those girls who tell me they want to skate too is: If you want to do something and you feel good doing it, don't think twice. Believe in yourself and everything else will follow. Skateboarding has always been here for me, providing me with opportunities, and in so many ways I think skateboarding is telling me: I love you back, I believe in you.

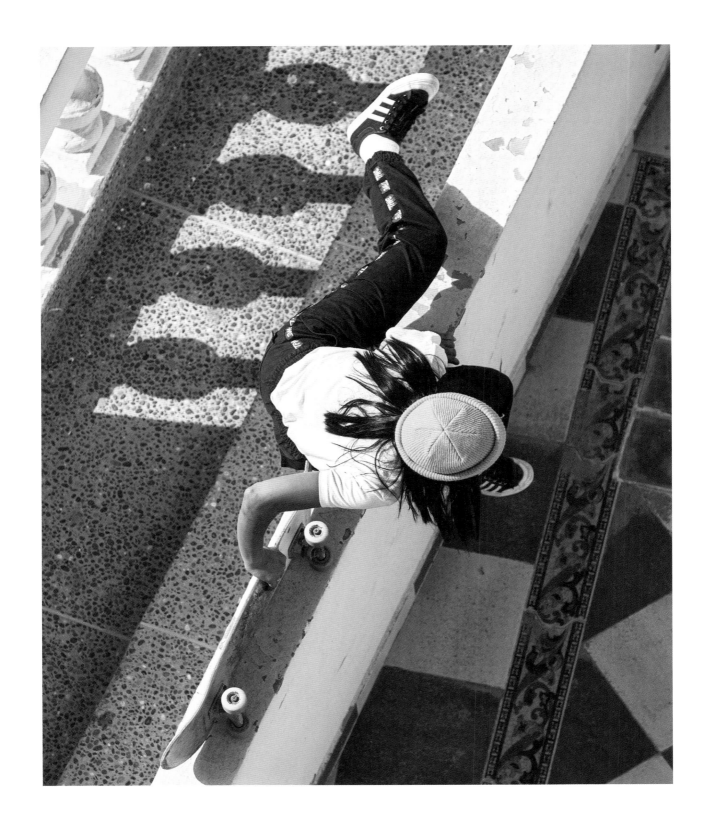

Tagazout, Morocco

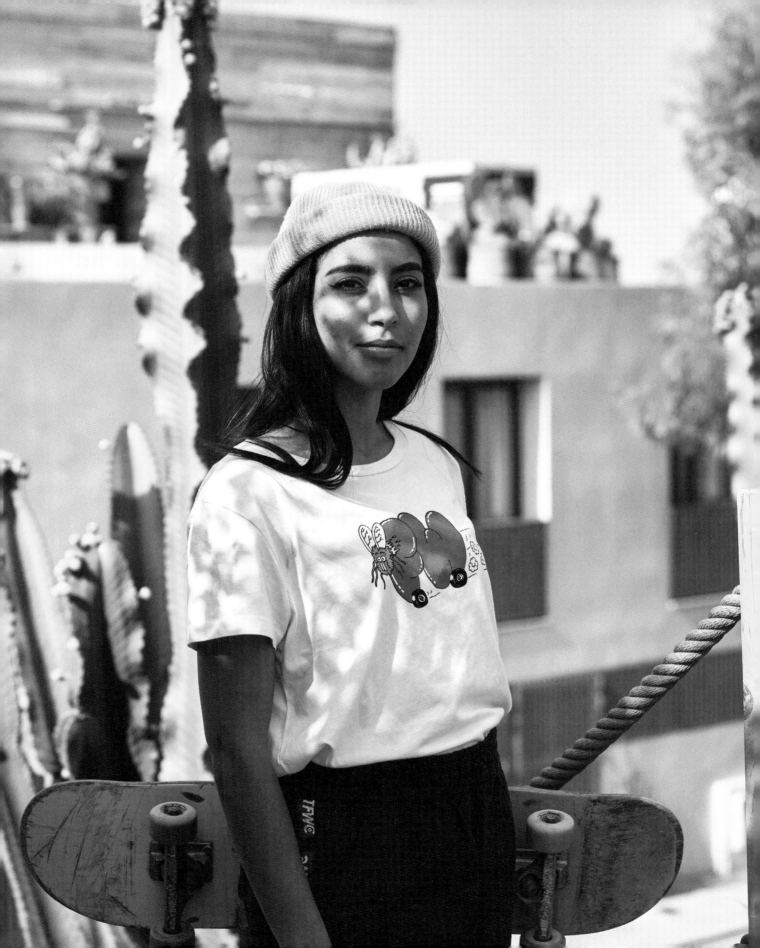

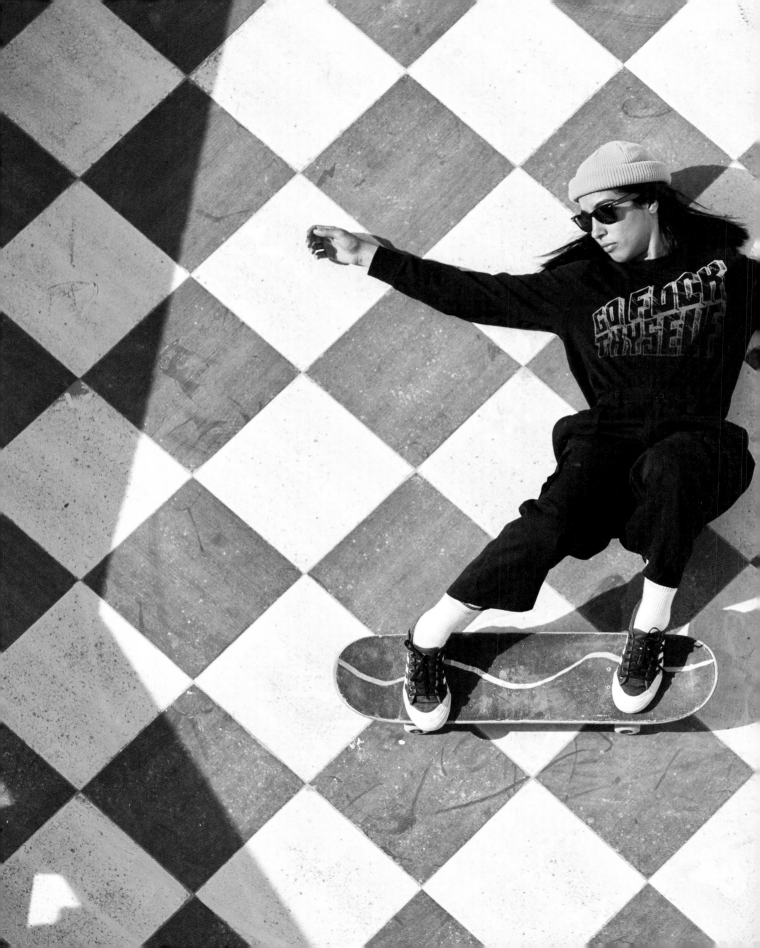

*Believe in yourself and
everything else will follow.*

WAFA HEBOUL

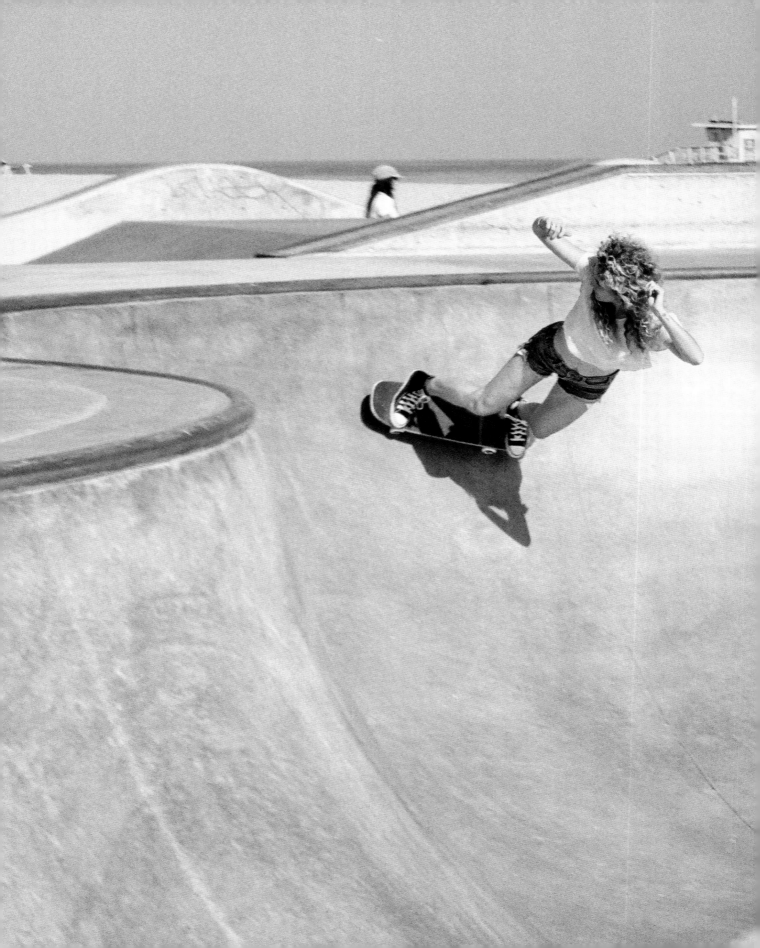

When in doubt, skate it out.

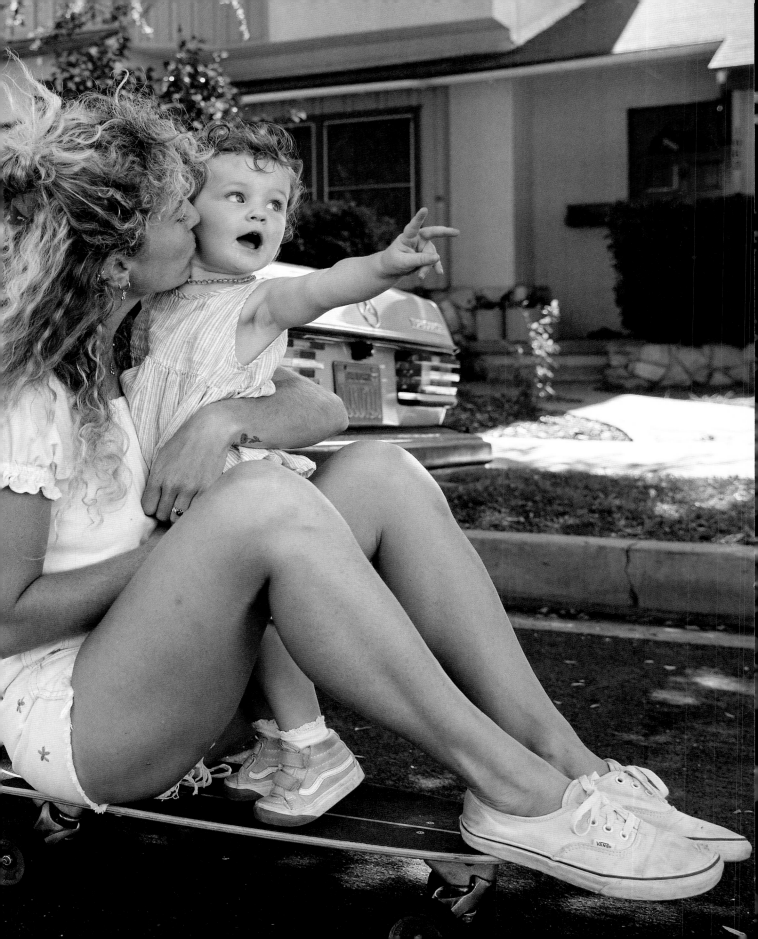

Danielle Francine

Mom, skater, entrepreneur

@theladydandelion
@shopladydandelion

I was born and raised in LA and am a California girl through and through. The beach has always been one of my deepest sources of inspiration and is the place I feel most at peace. I had expressed myself through fashion from a very young age, so I moved to New York City to attend Parsons and got swept away by all the city had to offer. I stayed in New York through my twenties but, like clockwork, when I turned thirty, California called me home.

I settled back in Venice Beach and began working for an Australian fashion brand. I started surfing again and soon took up skateboarding for the first time—until then, I'd always thought of skating as "the thing my boyfriends did," but had never tried myself. Even though I was thirty years old before I ever got on a board, I was instantly hooked on the sense of freedom and exhilaration it gave me. Most people assume that starting to skate later in life is impossible, but I'm here to tell you that it's not. Within a year, I was carving down the streets of Venice every day and skating bowls at the skate park.

Two years later, on a weekend trip to Portland, I met my fiancé and we fell in love pretty much overnight. Within three months I was pregnant! Becoming a mother was a huge turning point in my life. It lit a new sense of conviction inside me, which led to me starting my own brand, Lady Dandelion. I went all in, and within a year it had evolved into a clothing and lifestyle brand—"for all the girls who like to get dirty but clean up real nice." It's inspired by skate and surf culture, California girls, and iconic feminine tomboys throughout history. It gives me a chance to infuse all my favorite things into something wearable for others.

In 2019, I opened my first brick-and-mortar store in Santa Monica. It was a lifelong dream come true. Alongside selling my ethically made designs, I love to host events and skate meetups and collaborate with amazing artists at our headquarters. I strive to inspire girls and women to be fierce in their femininity. Much of the brand imagery is of me and my friends skating in our Lady Dandelion dresses and cartwheel shorts. I'd always said that when I had my own brand, I wouldn't hire models to pose in my clothes—I wanted to feature real people doing authentic things, and I've kept my word on that. My daughter, Lulu, is joining in on the fun as well now that she is almost three. She loves wearing her matching baby designs while she pushes around on her little scooter! Going out with her and watching her learn is so much fun.

No matter what age you are or what you do for work, or whether you have children, I encourage you to give skating a try. Skate culture can be intimidating, but that doesn't mean it's not open to everyone. I love putting my personal girly spin on it and challenging beliefs about what a skater looks like. I love wearing a dress while I skate and feeling the wind blow my skirt as I fly by in the park. My favorite sneakers are pink, and I usually have some freshly picked flowers in my hair and behind my ears. People always seem surprised by this, and I love that! I hope it gives other girls permission to be themselves as well. My advice to anyone who is thinking about trying skateboarding but who might be scared or intimidated is to go for it. Take it slowly—it's amazing how much is possible when you take baby steps consistently over time. I've created an introduction to skateboarding video on my Instagram that takes you through all the steps of learning how to kick-push and get your stance right. Once you have that down, you're on your way, and anything is possible.

I could never have imagined all the unexpected gifts skateboarding would bring into my life, and I'm so grateful for it. I hope everyone reading this feels inspired to embark on their own journey with this magical sport.

◁◁ Venice Skatepark ◁ Danielle and Lulu, Venice Beach | California, USA

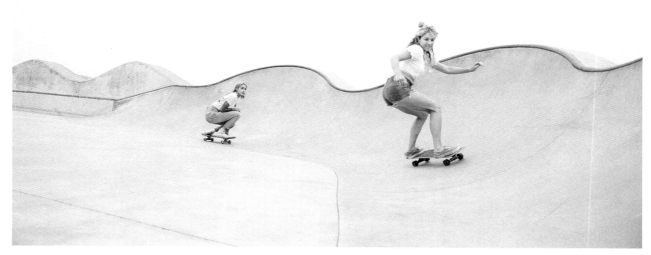

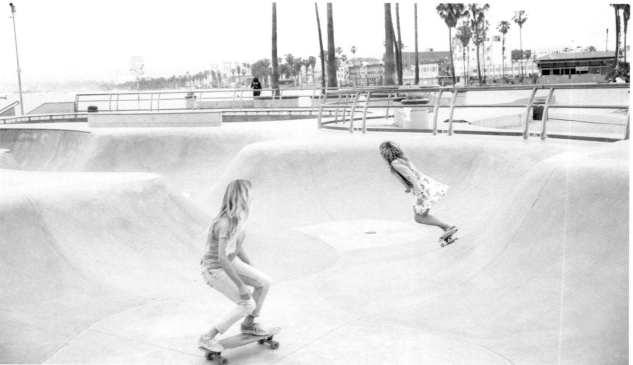

Venice Skatepark, California, USA

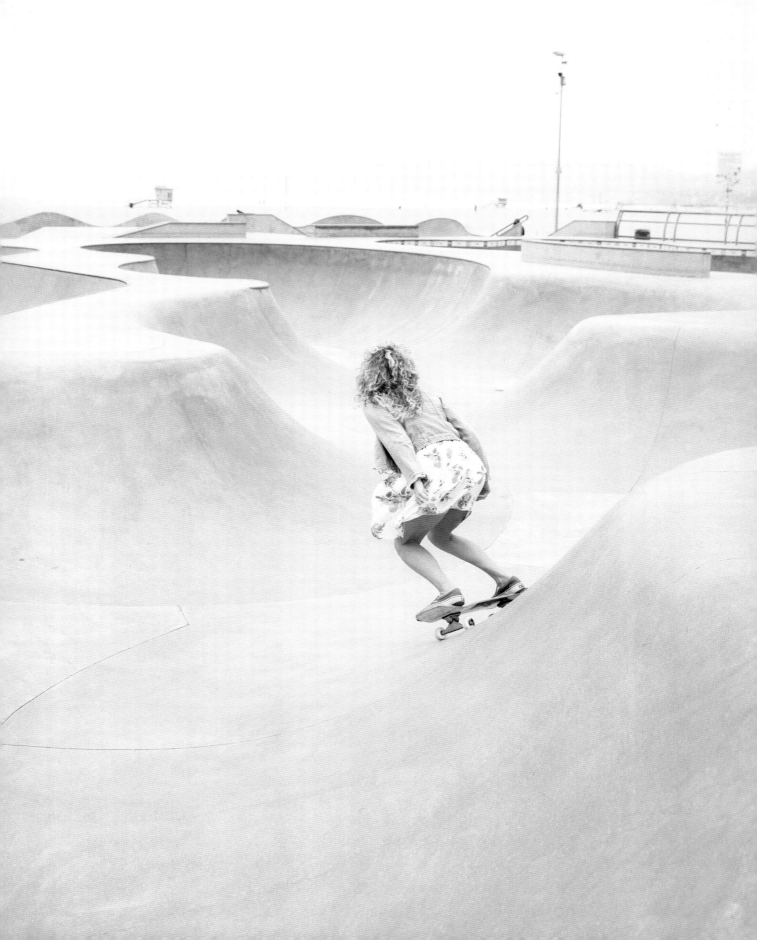

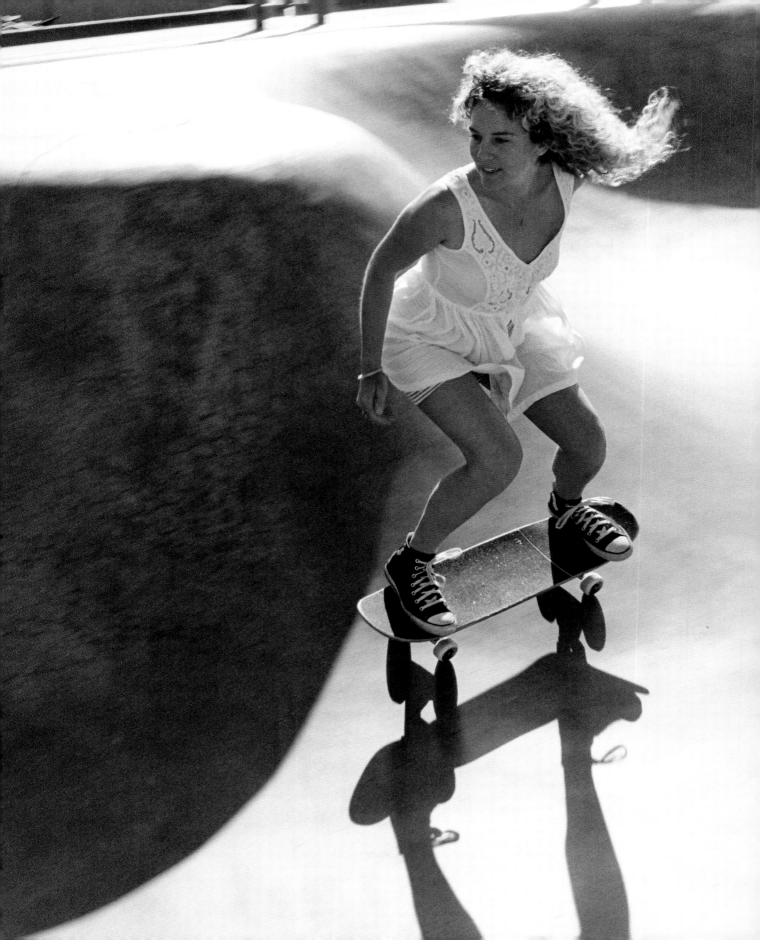

Venice Beach, California, USA

*I strive to inspire girls and women
to be fierce in their femininity.*

DANIELLE FRANCINE

Venice Beach, California, USA

Maria Arndt

Graphic designer

@spin_skate
@mari_aprilfool

I'm Maria Arndt, a graphic designer and hobby photographer from Bielefeld, Germany. When I started skateboarding in my early twenties I struggled with my confidence and kind of quit, even though I'd been dreaming about doing it for a decade. When I came into contact with longboarding at the age of twenty-seven, I still lacked confidence, but it was different because I had more insight. I realized that I'd been lacking role models: I hadn't seen female skaters in the situations I'd encountered or the photos I'd seen.

When I met female skaters—longboarders—for the first time, I was totally blown away; like, really stoked. I wanted them to be seen as skaters, and for others to see them as well. When I looked at them, and then at myself and my camera, it was easy to connect the dots: if I didn't do it, maybe no one would. That's why I founded my photography project, Girls in Longboarding, in 2014. It made quite a splash, which I hadn't

expected at all—I did it for the skaters I was photographing, and also for myself, because it made me happy to see them and to be able to capture their essence as skaters.

When the end of my graphic design degree came nearer, one thing led to another again: I combined my passion for longboarding and specialization in supporting women within the longboard community with graphic design, and *S*pin* was born: a longboarding magazine emphasizing women riders. I did that full time for almost a year, until my savings were used up and I got a job offer. I've been doing my best to keep it running ever since.

At events, or when people send me messages, I'm reminded over and over again how important it is to provide true role models, help people overcome their insecurities, welcome people to our loving community, and stay true to the things you love.

Katarzyna Hajdan in Piłsudski Square, Warsaw, Poland

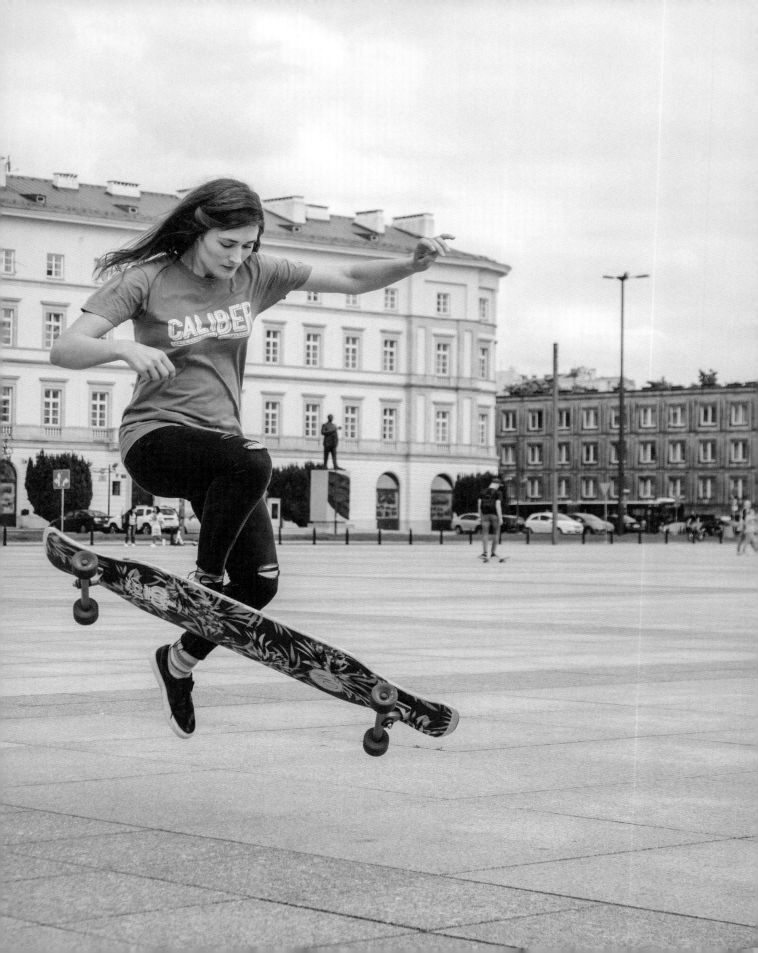

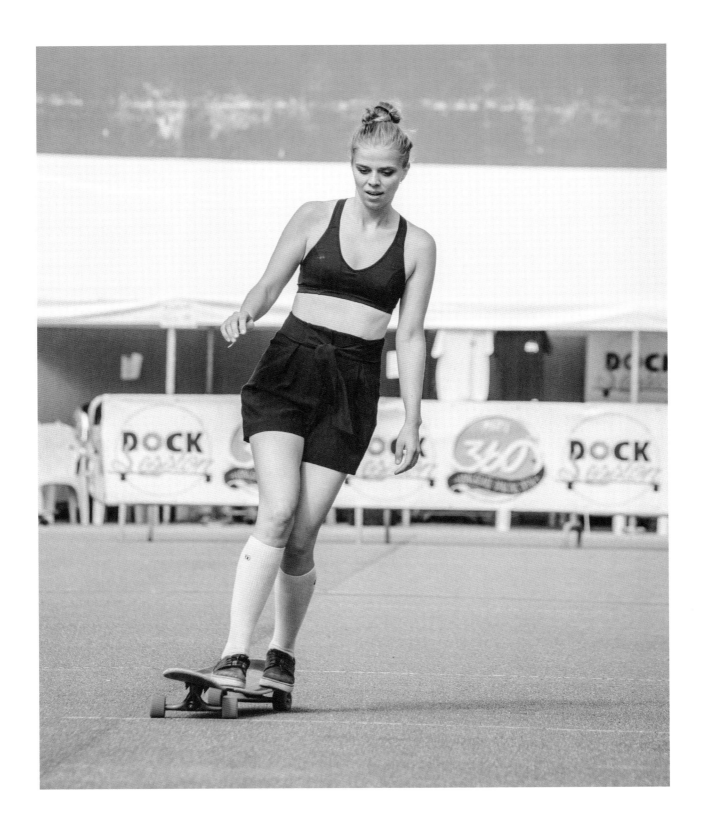

◁ Katarzyna Hajdan in Piłsudski Square, Warsaw, Poland △ Karolina Ogiołda at the 360º Longboard Dancing Open, Paris, France

I'm reminded over and over again how important it is to provide true role models.

MARIA ARNDT

Ophelie Lahouille in Place de la Republique, Paris, France

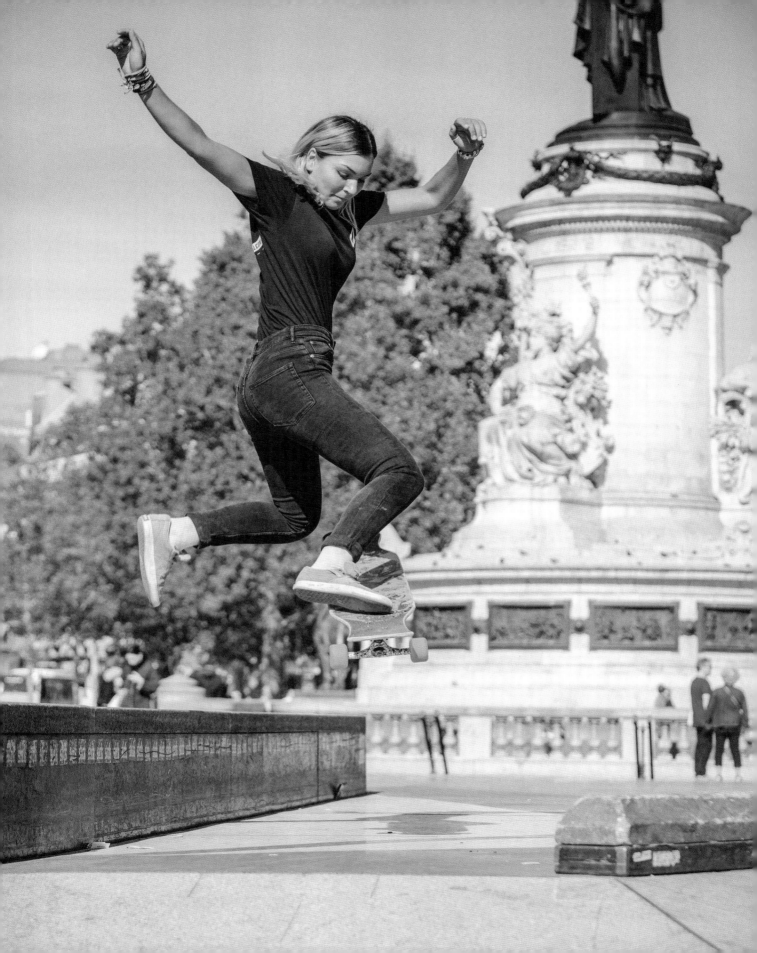

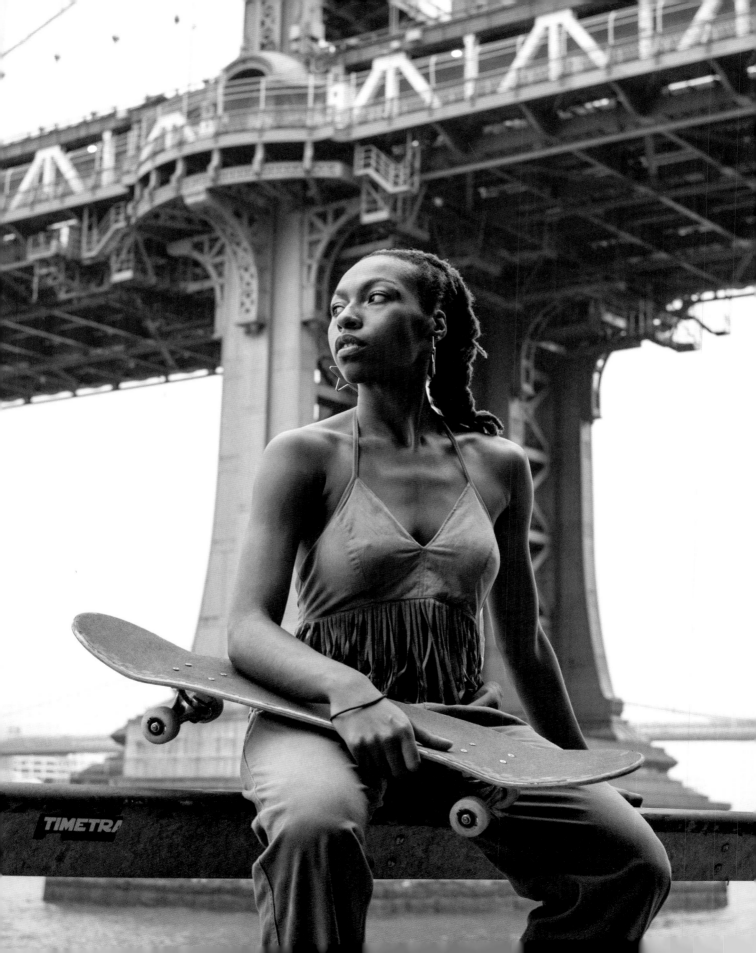

Lanna Apisukh

Photographer and former athlete

@apisukh

As a former Division I athlete, I've always been interested in female athleticism and the powerful psychological effects that sports can have on individuals. Growing up, I spent a large part of my life training and competing internationally as an elite gymnast. Although I experienced a great amount of burnout at times, I also gained confidence and a sense of accomplishment from performing well and learning new skills.

Once I retired from gymnastics, I was immediately drawn to skateboarding as a fun and creative outlet that continued to challenge me both physically and mentally, without the stress of competition. Through skateboarding I made lifelong friends, connected to a community, and developed

more creativity in my life. Making images of other skateboarders has simply been my way of honoring a sport that has given me so much.

While it's exciting to capture the big tricks and landings with my camera, I've always been more interested in the culture and exploring the emotional psyche of skaters by making deep human connections with them through photographic portraits. More recently, my work has been focused around the inspiring women and gender nonconforming skateboarders in New York City who are determined to grow the space into one that's more inclusive and supportive of all ages, abilities, and genders.

Yasmeen Wilkerson at Manhattan Bridge (Lower East Side), New York City, USA

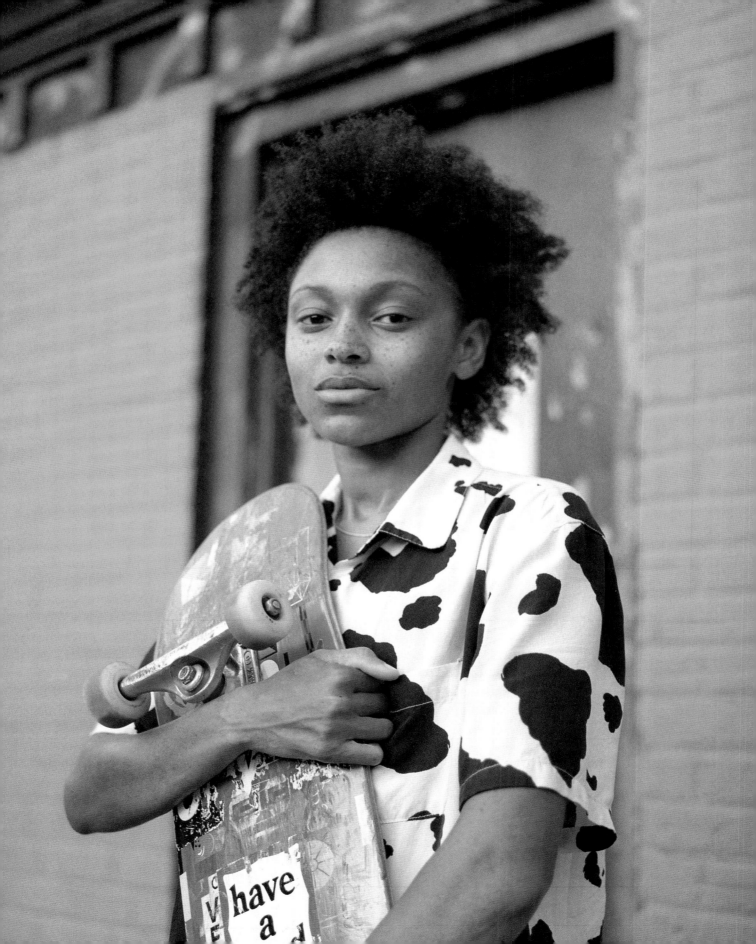

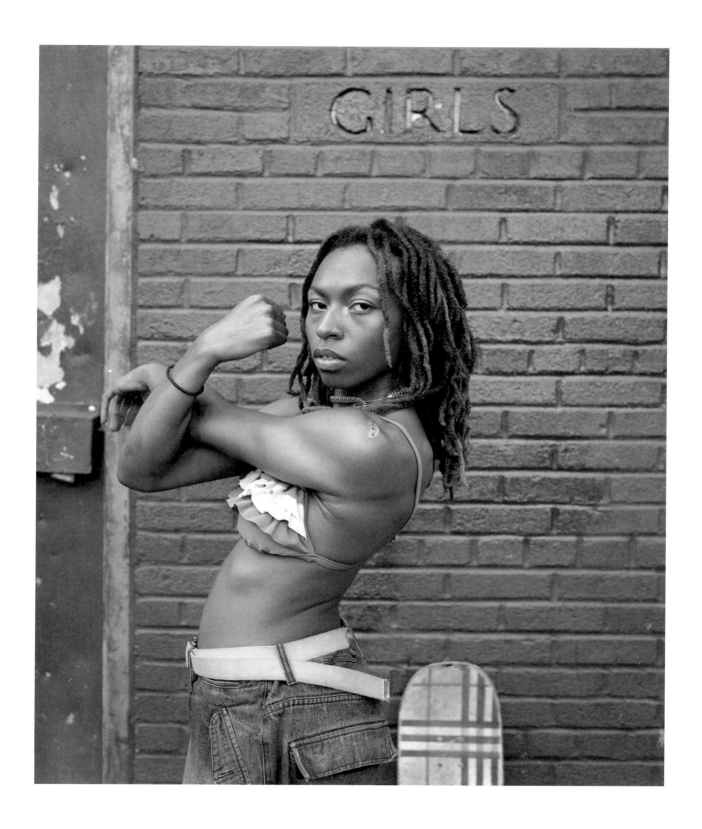

◁ Kennedy Pony at Blue Park (Martinez Playground skate park) △ Yasmeen Wilkerson at Blue Park | Bushwick, Brooklyn, New York City, USA 71

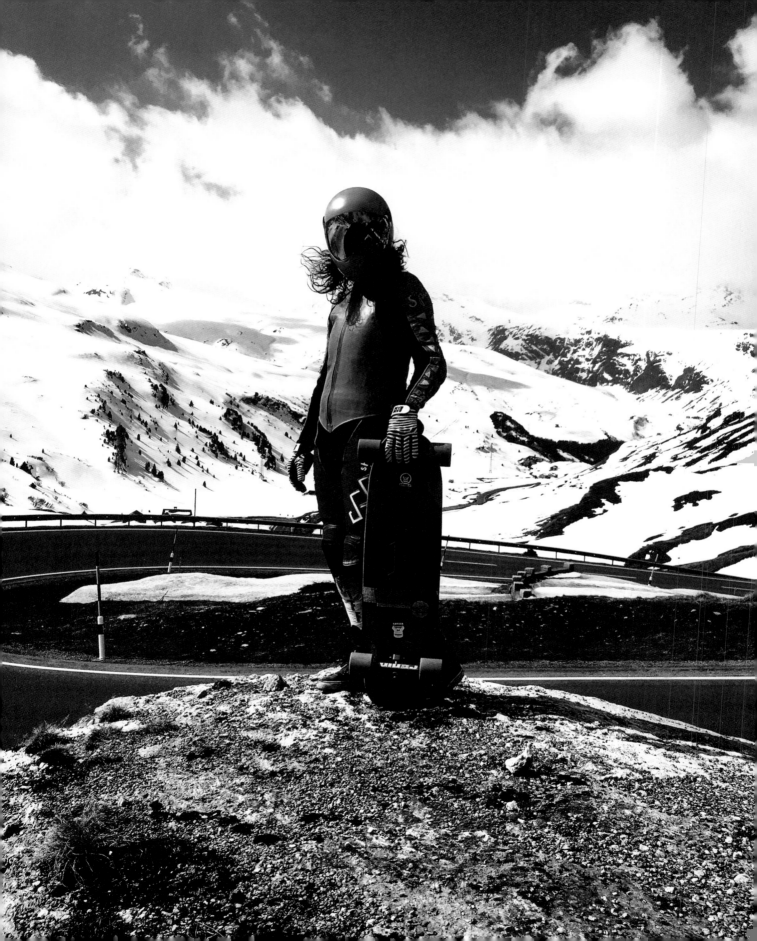

Annina "Ninsk" Brühwiler

Downhill skater

@ninsk_on_tour

I'm Annina, I'm twenty-seven years old, and I'm passionate about downhill skateboarding and traveling the world with my longboard. Growing up in the Swiss Alps, snowboarding was always a part of my life, although it was never as important as longboarding is to me now. I only started skating and longboarding at the age of twenty-three. Previously, I'd thought I'd never be able to do the same stuff on a board as the boys—and that I was too old to learn it anyway. Luckily, I stumbled upon a girls' longboarding community, and after three camps and courses surrounded by inspiring, badass longboard and skate women, today virtually not a single day passes without me standing on one of my boards.

I love downhill skateboarding the most: going down a winding road as fast as possible. I've participated in several races on different continents. Yes, it's crazy; and yes, it can be dangerous. But we do our best to protect ourselves, and the feeling of racing—or even just cruising down a road—is priceless. To me, it's freedom, it's being fully alive, it's living the moment, it's my Zen meditation.

An extremely important part of this sport is the community and friendship it provides. My passion for longboarding is a door-opener to new cultures; it connects me with people from all over the world. It's already taken me to the jungles of Indonesia, to the beaches of the Philippines, to the Austrian Alps, to the Slovenian countryside, and the Peruvian Andes and deserts. Wherever I go and skate with the locals, I'm immediately part of the crew, even of their families. Longboarding builds bridges between people. I'm more than happy to be part of this awesome longboard community, this family. And I'm proud of the decisions I made that brought me here, so that today I'm able to combine my work with my passion for longboarding and travel.

To me, longboarding is a teacher for life; it's something that empowers me and leads to personal growth. Because it's never only about pushing, cruising, and braking. If you want to be a great skater you have to be persistent, try it over and over, go through painful experiences, overcome your fears, trust your intuition, listen to your body, keep the balance, and go to your limit and beyond. This is why I love teaching skateboarding and longboarding to other people, especially girls. I hope they can transfer what they learn from skateboarding to other areas of their lives; use it as an inner compass to take brave decisions. If I feel like I don't have the guts to do or say something, be it at work, in a relationship, or in everyday life, I tell myself: Girl, if you can skate down a road at 90 kilometers an hour, you can also do this!

◁ Julier Pass, Switzerland ▷▷ Kozakov Challenge, Czech Republic

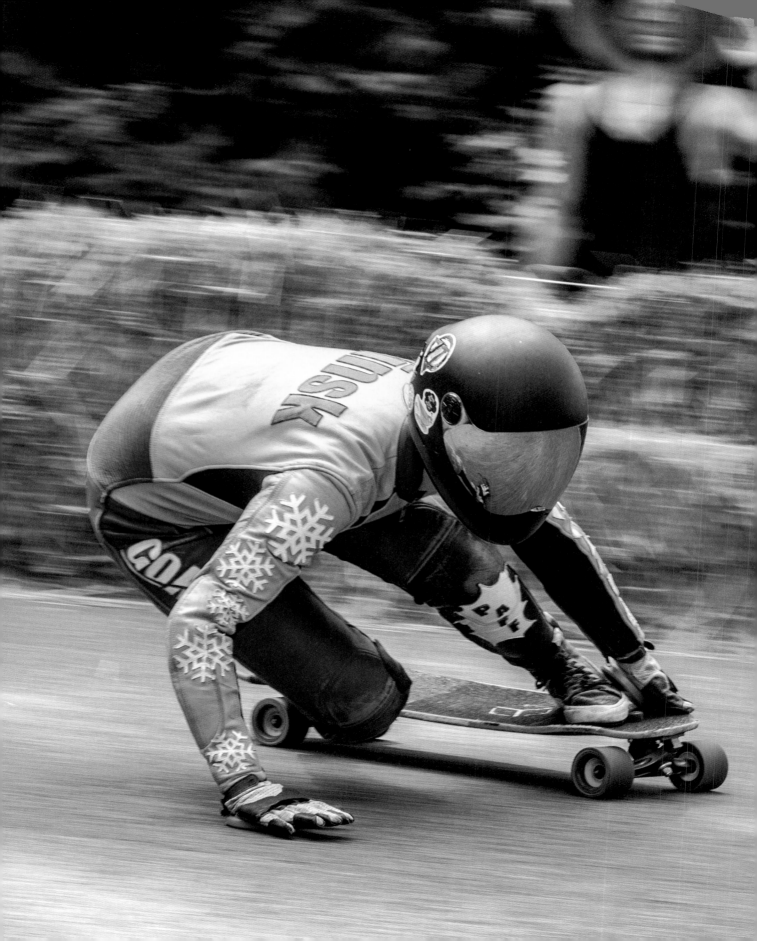

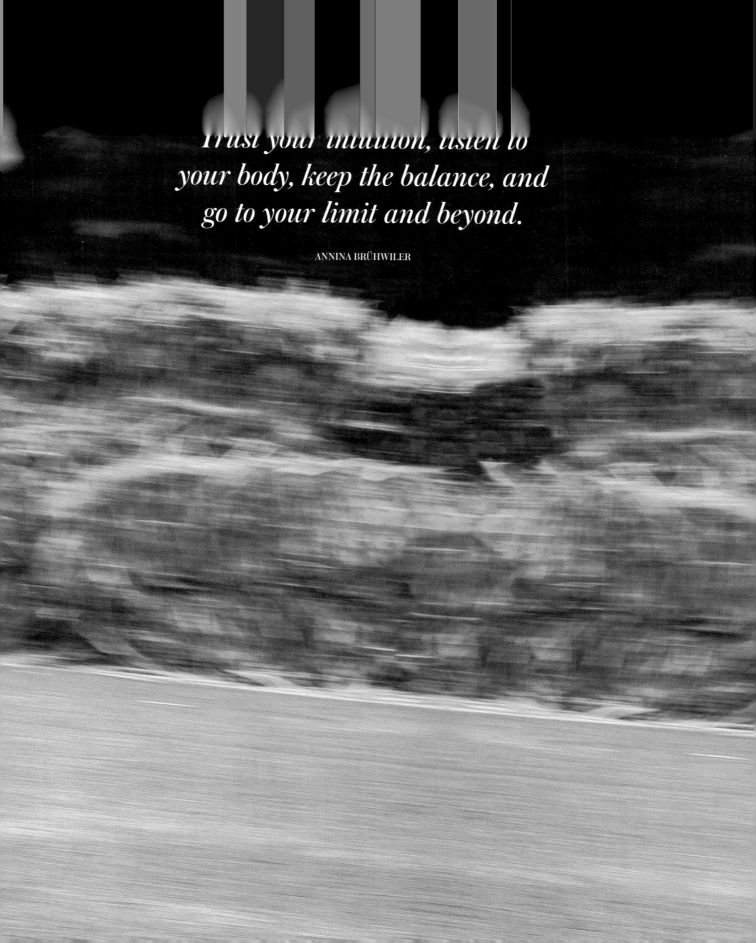

Trust your intuition, listen to your body, keep the balance, and go to your limit and beyond.

ANNINA BRÜHWILER

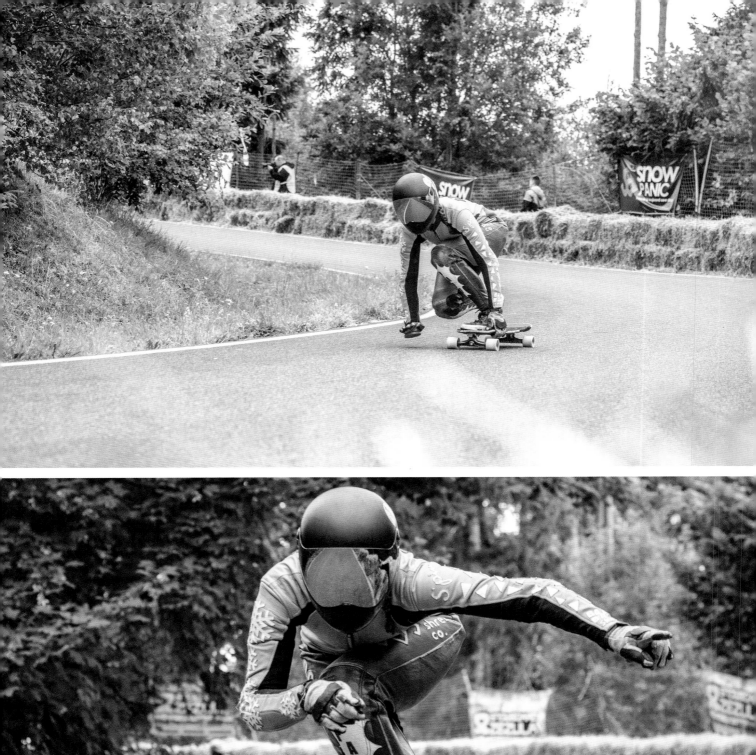
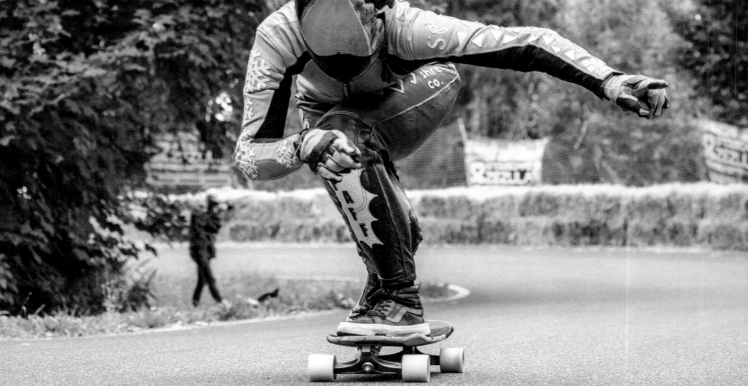

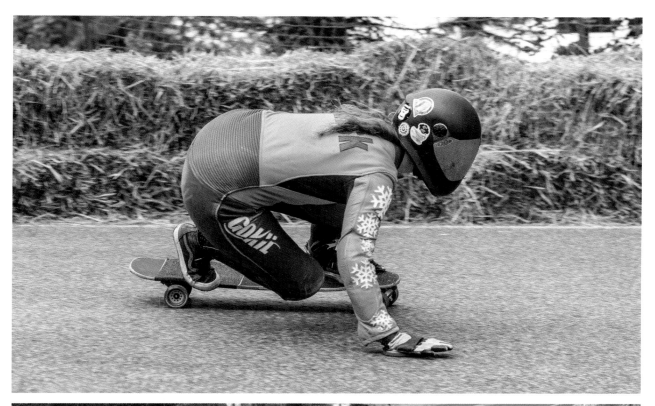

◁ Kozakov Challenge △△ Kozakov Challenge | Czech Republic △ Seaside race, Cavite, Philippines

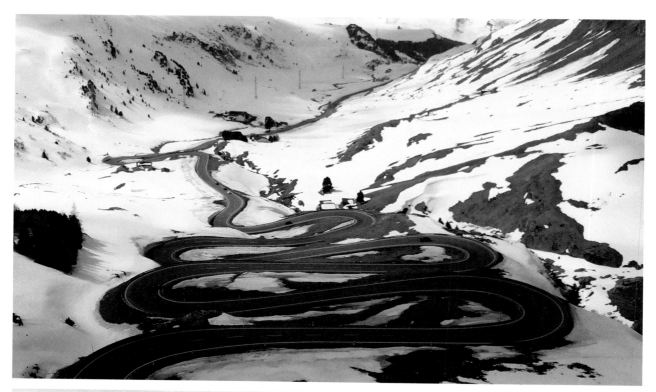

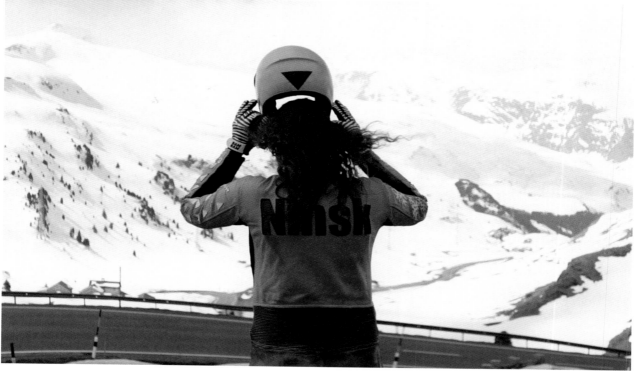

△ Julier Pass, Switzerland ▷ Mirador de los Andes, Peru

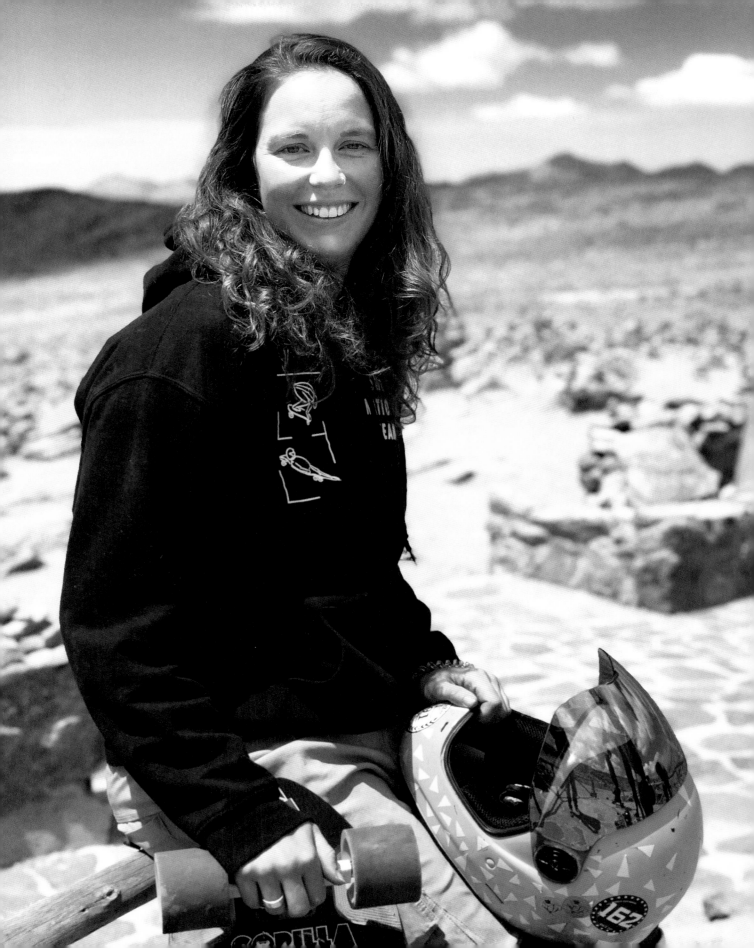

Cassandre Lemoine

Skate, surf, adventure

@cassandrelmn

My name is Cassandre, I'm twenty-three years old, I live in Paris, and I'm a huge fan of ride sports. I started longboarding five years ago with my two best friends, and since then I haven't been able to live without it. I practice freestyle dancing: dance steps based on elegance and fluidity, mixed with aerial and skateboarding tricks. It's pretty to watch!

I've come a little way over the last five years, and now I'm professional. I have several sponsors, I compete, and I realize beautiful projects with my longboard. And yes, my board follows me everywhere. I'm so happy to be able to live my passion and share it with others—believe me, there's nothing better. Besides that, I also love surfing, going on adventures, and traveling. Always with my longboard in hand, of course.

As a woman in a relatively masculine environment, if I had some advice for girls who want to get involved in skateboarding, or who want to find a way to enter the freestyle longboard dancing scene, I would say that no matter what it is you want to undertake, you can do it. Only you decide what you can or can't do. Don't be afraid of other people's eyes.

You're a girl? So what? Run, fall—you'll get there, believe me. Defeat is not in your lexicon. Yes, I have bruises; yes, I experience pain and I get angry sometimes, but I forget the pain when I finally manage to do a trick. And above all, keep smiling and always believe in your dreams. That's what will help you feel alive each day. The more I skate, the better I feel. So don't lose a moment—put yourself out there now. Be brave and skate like a girl!

Musée du Louvre, Paris, France

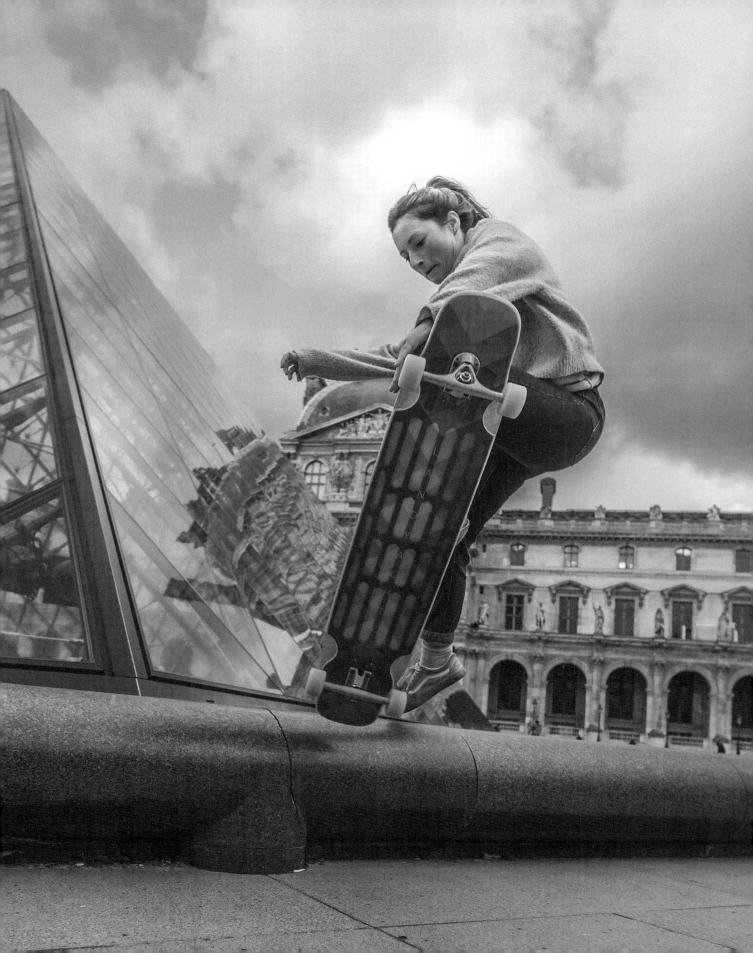

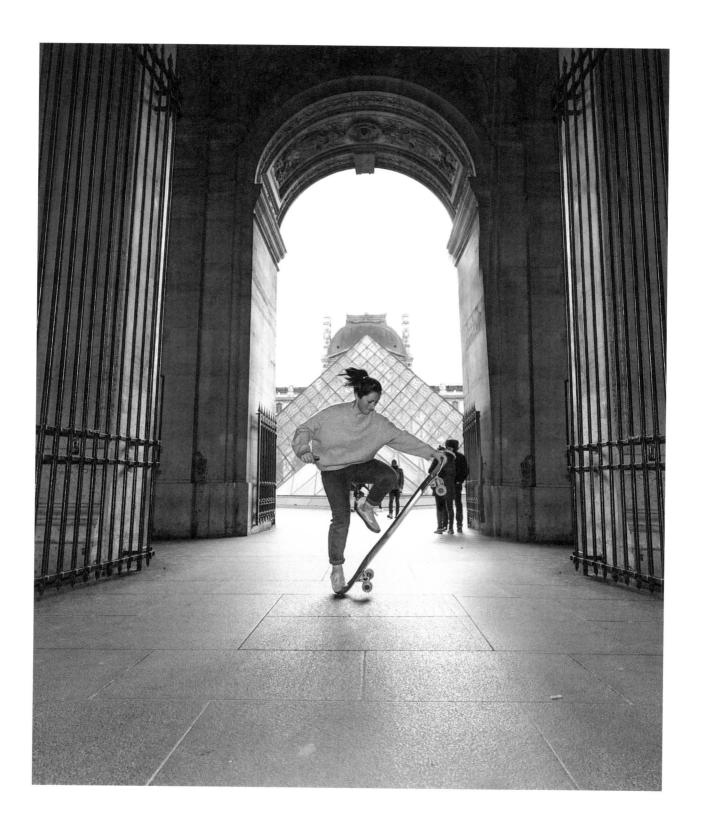

Musée du Louvre, Paris, France

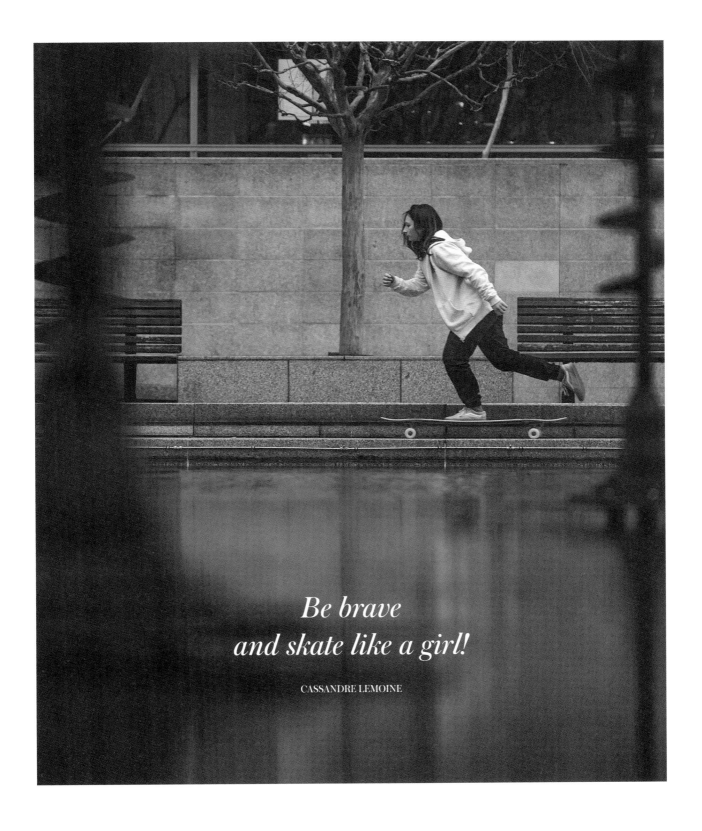

*Be brave
and skate like a girl!*

CASSANDRE LEMOINE

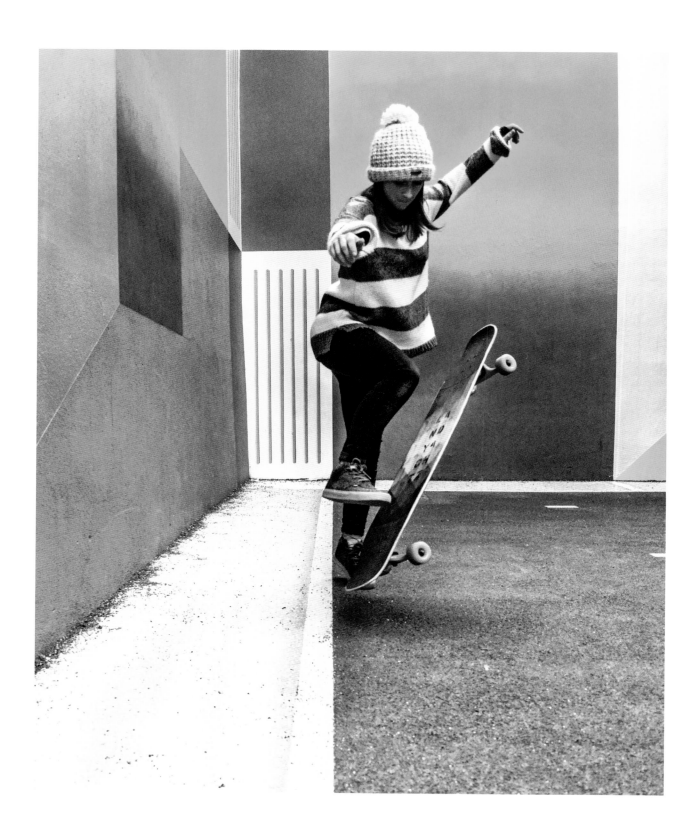

△ Basketball court ▷ Passage des Jacobins | Paris, France

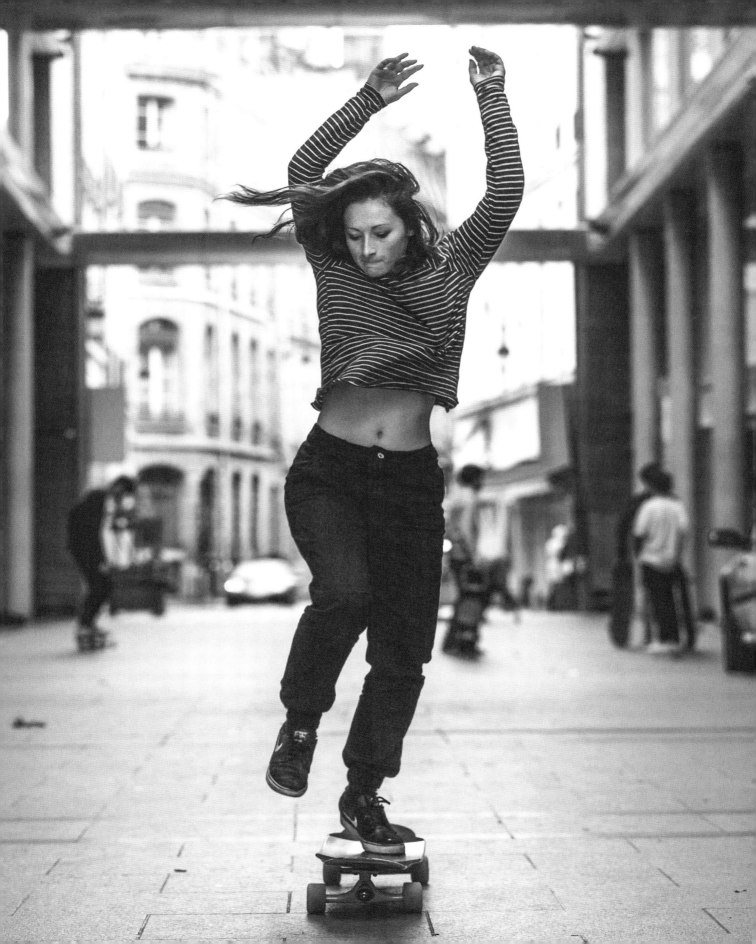

Júlia Amá

Ex-swimmer and mechanical engineer

@jujuama

I'm Júlia Amá, originally from the beaches of Brazil. I moved to Venice, California, a few years ago. I'm an ex-swimmer and mechanical engineer, and I transitioned from working in aerospace to tech, and now I work at GRLSWIRL, which I co-founded with eight other women in 2018. With my background in engineering and athletics, my passion has always been helping others learn new skills while empowering women in spaces that are predominantly male. I can most often be found skating towards the beach with a mug of coffee in my hand.

Growing up, I didn't know any girls who skateboarded; I just had one family friend, a guy, who had a longboard. He introduced me to the sport, but my experience with it at that time was brief and painful to say the least. Concrete, plus a novice skater, plus a big hill don't make the best combo!

After that, I continued to be fascinated by the sport and wanted to learn how to skate properly, but I didn't have anyone to learn with or from. Then, about two years ago, I started dating a guy who had grown up skateboarding. From the start, I begged him to take me to the park in Pasadena, an hour away, so I could learn to skate with him somewhere more private. I was so intimidated by Venice—I never thought I'd ever set foot in that skate park! I remember all the feelings I had the first time I walked into the skate park in Pasadena—nausea, anxiety, uncertainty, and a lot of fear. My legs were shaking, my heart was racing, and I was sweating even before I got on the board. But that day I conquered a lot more than I thought possible. With a lot of determination and patience, I got back on a skateboard, and it was love at first kick-push.

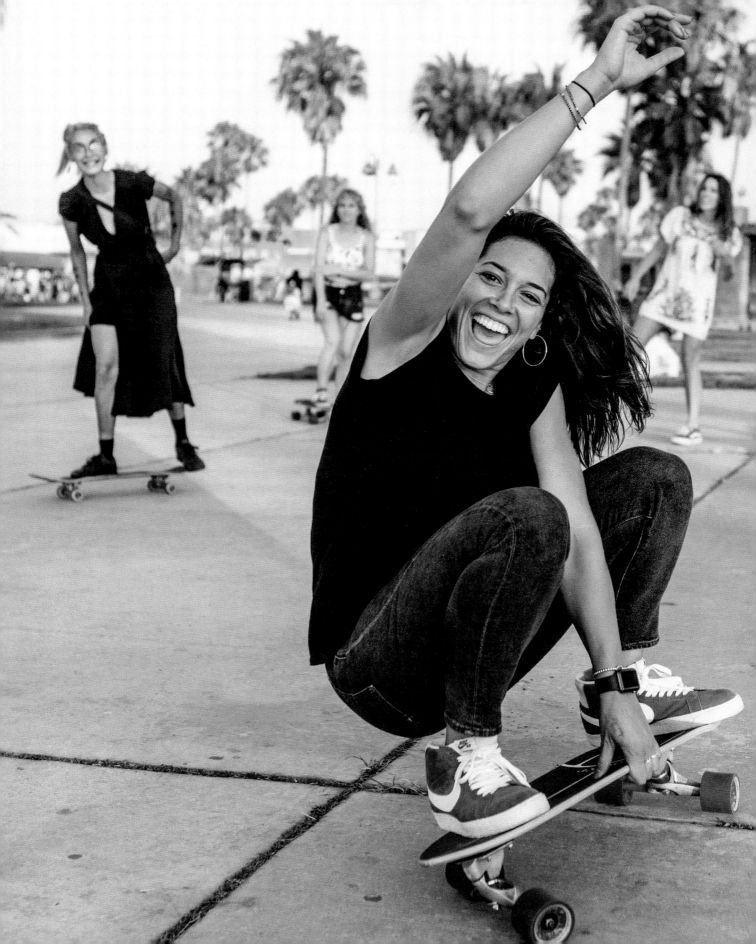

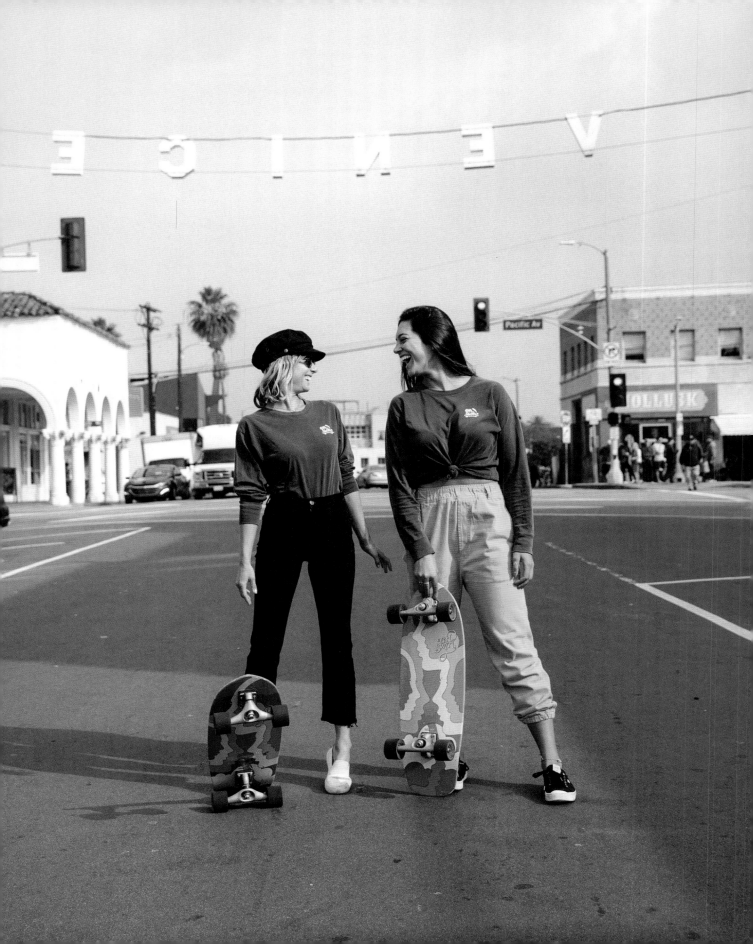

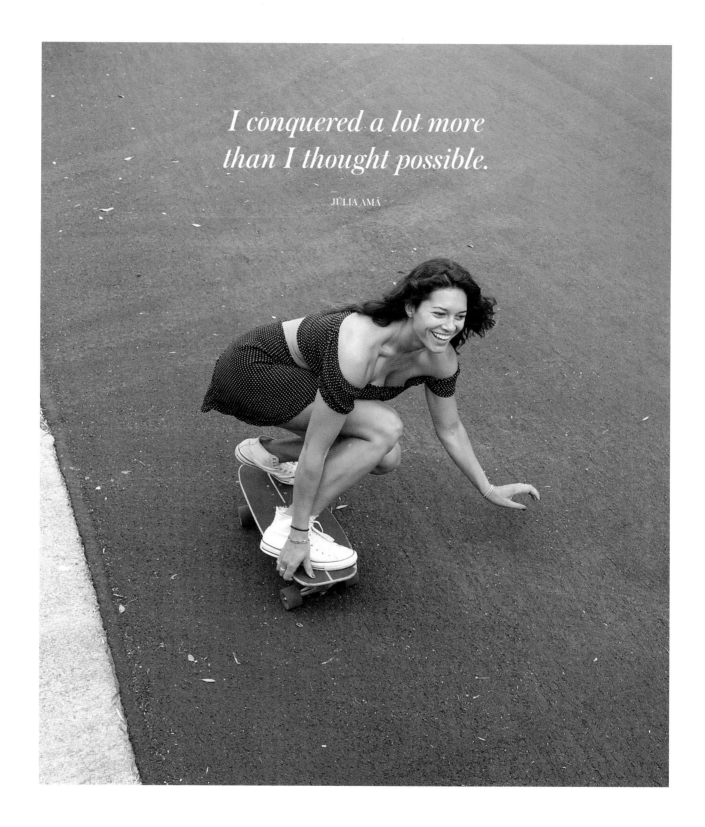

I conquered a lot more than I thought possible.

JÚLIA AMÁ

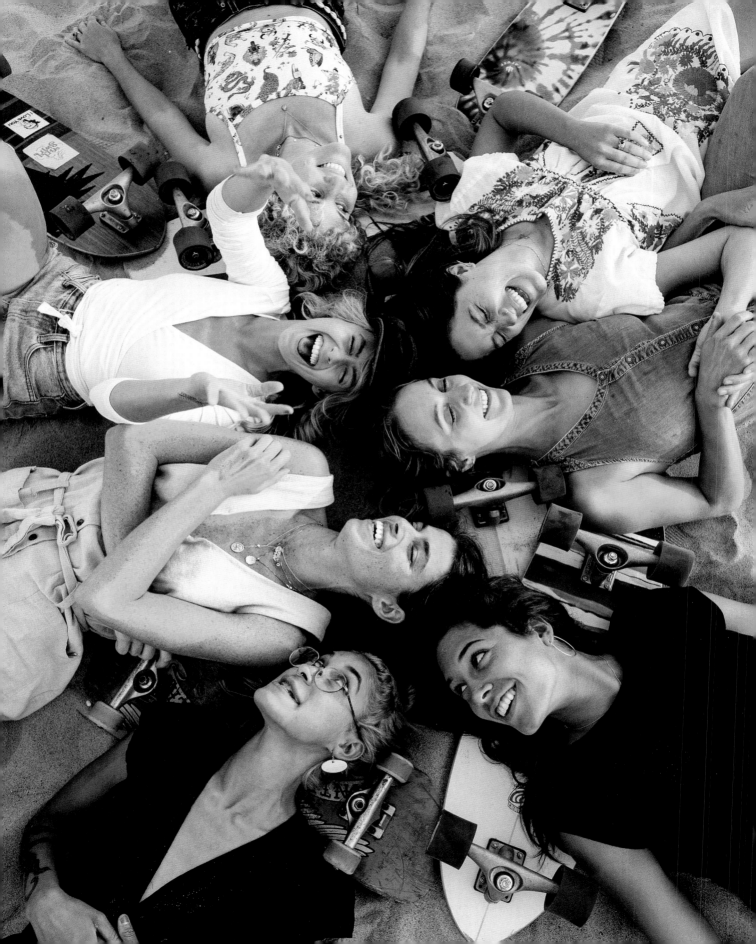

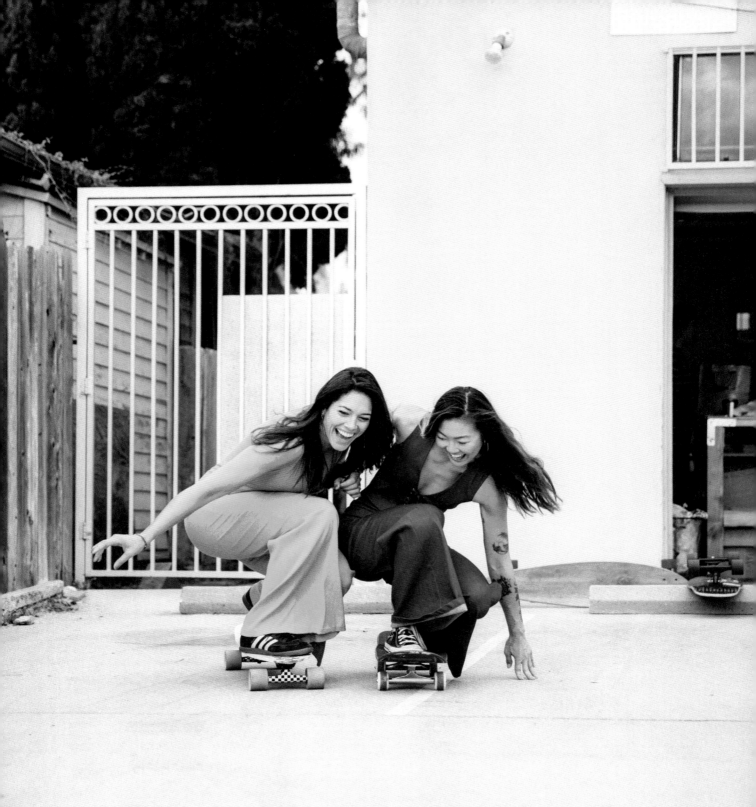

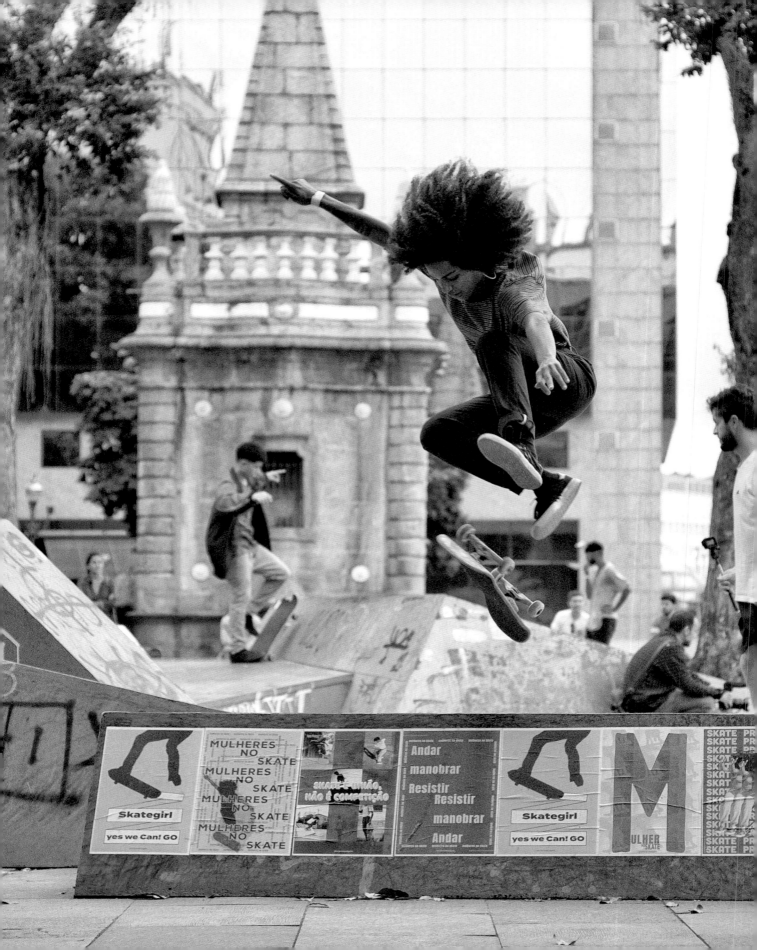

MULHERES
NO
SKATE
MULHERES
NO
SKATE
MULHERES
NO
SKATE
MULHERES
NO
SKATE

Skategirl
yes we Can! GO

SKATE E UNIÃO,
NÃO É COMPETIÇÃO

Andar
manobrar
Resistir
Resistir
manobrar
Andar

Skategirl
yes we Can! GO

M
MULHER
DO SKATE

SKATE PR
SKATE PR
SKATE
SKA
SKAT
SKAT
SKATE
SKATE
SKATE
SKATE PR
SKATE PR

Vitória Mendonça

Dreams become reality

@vimendonca__

My name is Vitória Mendonça, I'm twenty years old, and I've been skateboarding for thirteen years.

Skateboarding came into my life when I was seven years old, when I rode to a square near my family's house, and since then it's been my favorite toy. Skateboarding gave me a new perspective on life, made me see the world in a different way, introduced me to places and people, taught me invaluable things.

Today I ride a skateboard for a living, which has always been my dream—it's so cool that it's becoming a reality now. I recently participated in a new video for Adidas Skateboarding called "Das Americas," celebrating their Latin American team. Taking part in such a major project was awesome and a big step in my career. When I started skating, I would never have imagined that I'd be living everything I'm living now. Always believe in your dreams!

Praça XV, Rio de Janeiro, Brazil

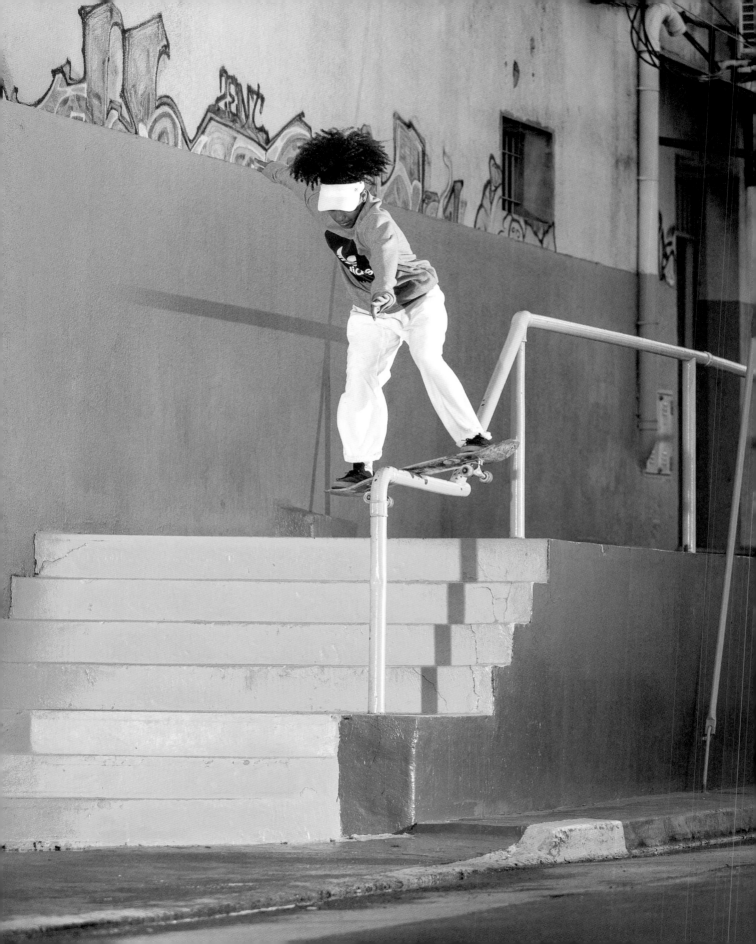

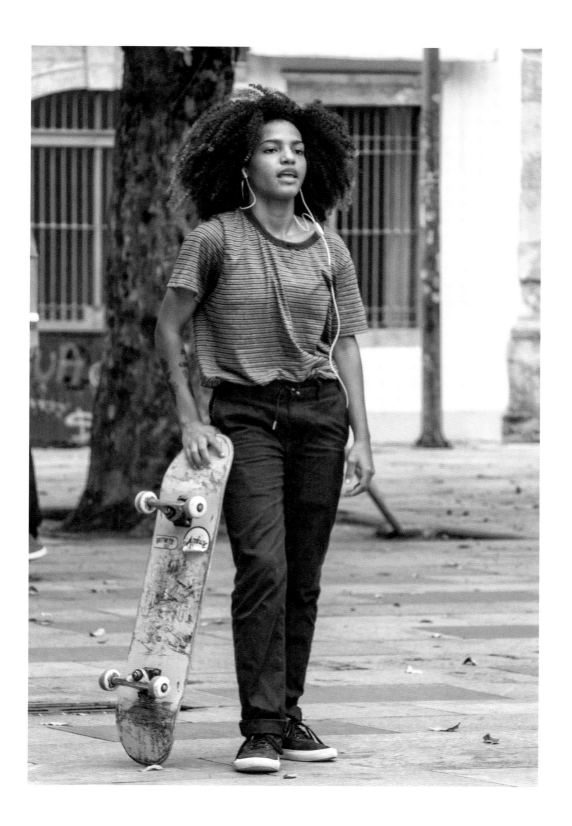

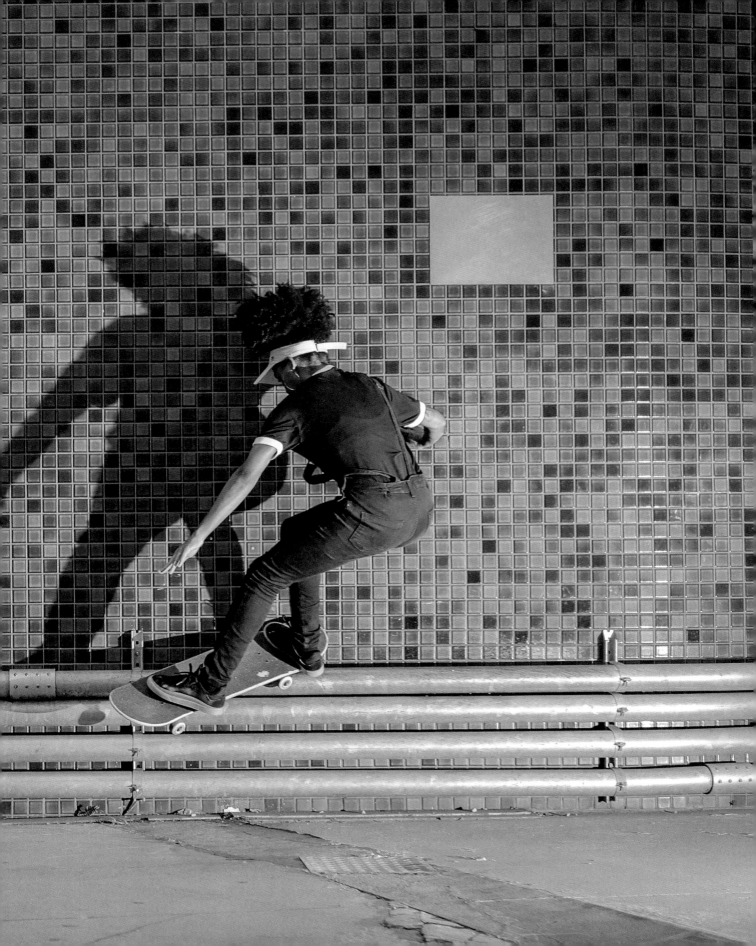

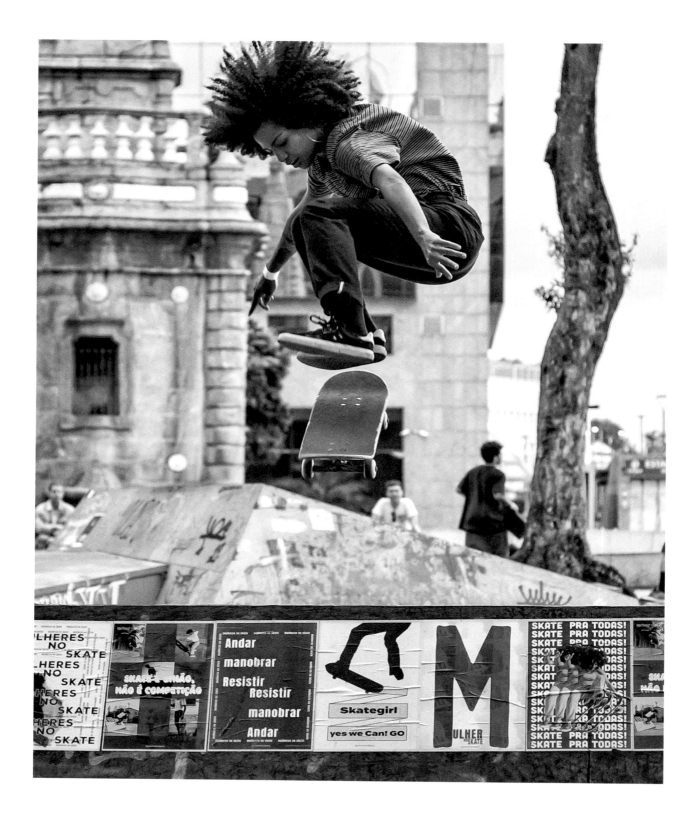

△ Praça XV, Rio de Janeiro, Brazil ▷ Buenos Aires, Argentina

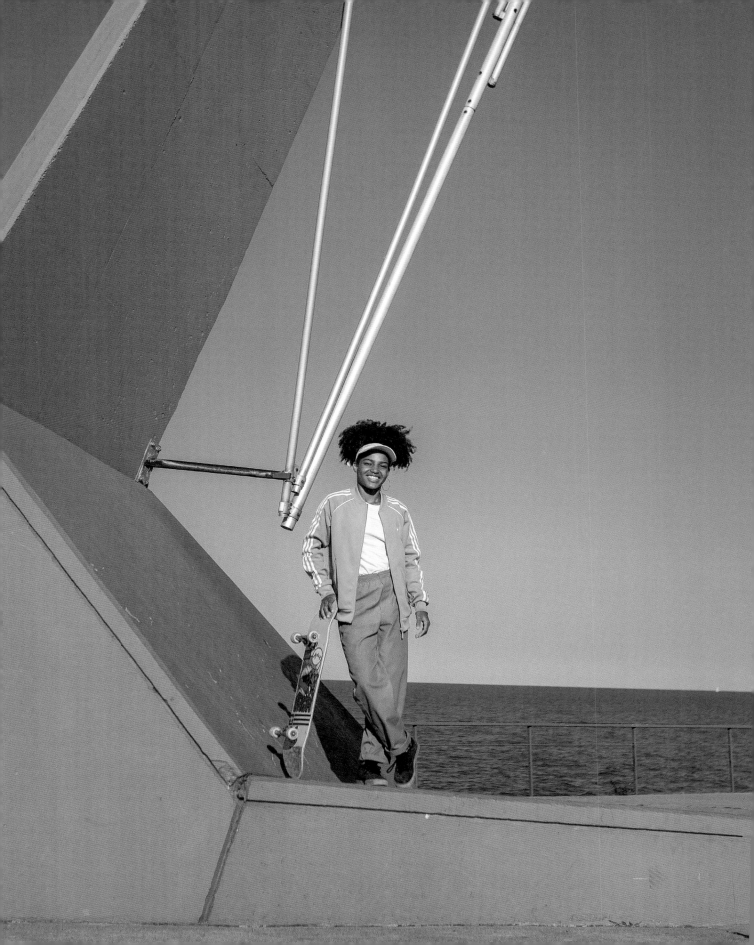

Devon DeMint

Trying to balance babies and boards

@mermaidsightings
@sheskateshere

My grandmother bought me my first skateboard when I was about fourteen. It was a wood, triple-stringer Hobie longboard. I used to ride it in my neighborhood at night with my headphones on, releasing teenage angst and avoiding homework. I surfed after school once I got my driver's license, and skating seemed like a way to keep working on my surf skills when I couldn't get to the beach.

In college, I became very interested in the "sidewalk surfer" skateboards from the 1960s, so I made a few out of some oak cabinets my parents had removed from their kitchen. I took them with me to college and used to skate on the beach boardwalk in Mission Beach, San Diego, between parties. About six or seven years ago, a few new skate parks opened around North San Diego County, where I lived, and I really wanted to learn to ride them. I bought a more traditional board and my husband got me some pads and a helmet for Valentine's Day. I would go to the parks, mostly by myself in the morning to avoid the crowds, but it wasn't

as fun as having someone to skate with. It also didn't seem that safe—what if I got hurt? A year and a half after I started skating parks, I had my first daughter, and I had my second daughter two years after that. I kept coming back to skateboarding despite the risk of injury and the warnings from my own mother not to get hurt, but it was more motivating once I found other women to skate with. I even met some moms who brought their kids to the skate park with them, working around their kids' school schedules and nap and meal times.

It took me give years of skating on and off to find a core group of ladies to skate with. I didn't want it to be as hard for other women, so I started announcing meetups. This is how She Skates Here began. The group includes women of all ages, moms, teenagers, trans women, women in their sixties. We meet once or twice a month at different parks. Skating with these women is one of the most transcendent experiences I've ever had.

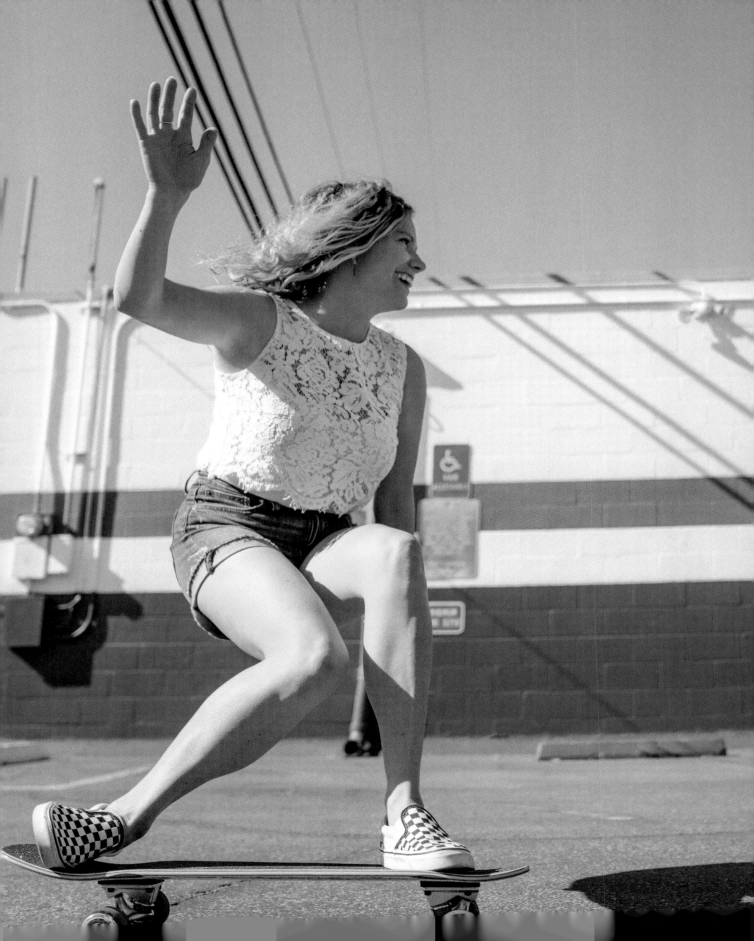

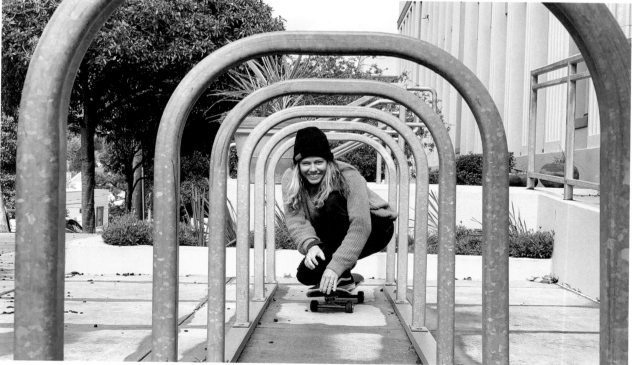

△△ San Juan Islands, Washington △ San Francisco, California ▷ Half Moon Bay, California | USA

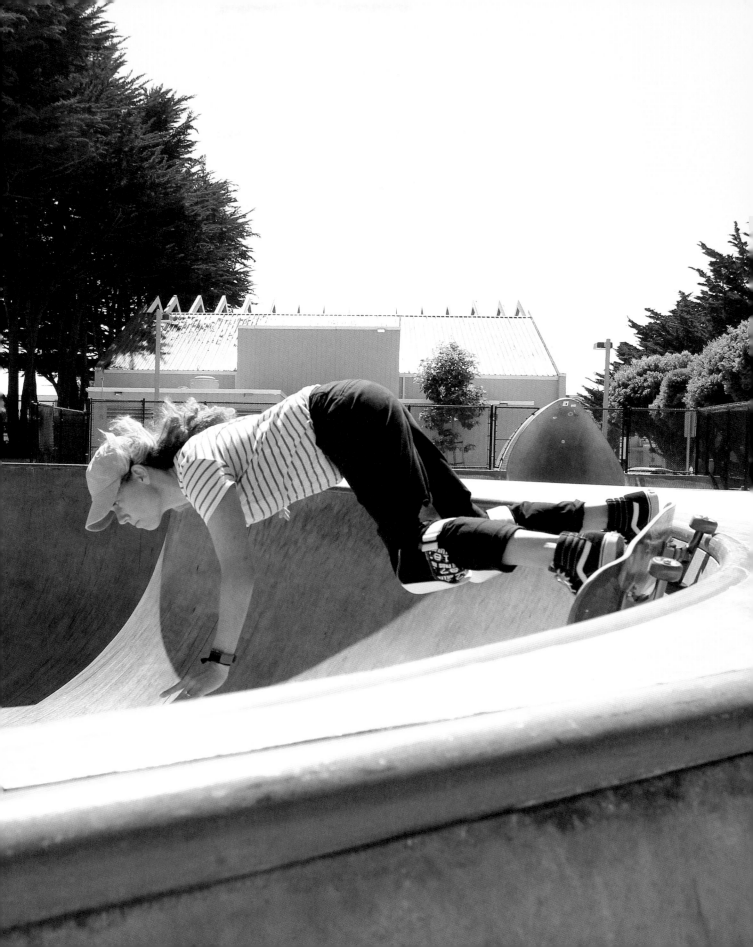

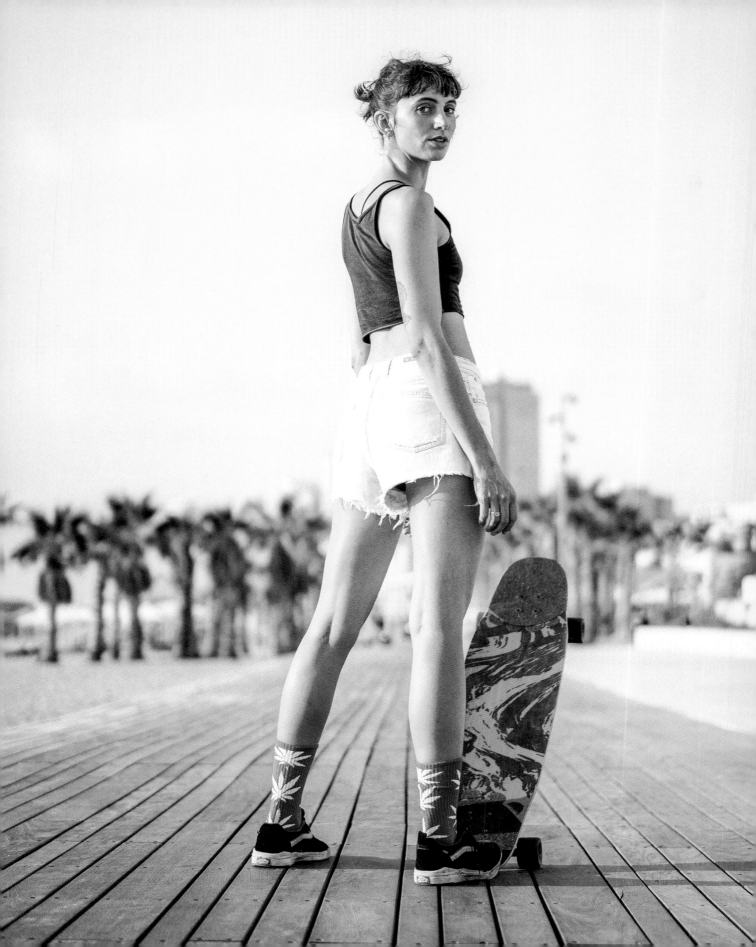

Terri Orel

Psychology student in Tel Aviv

@territheelf

It is so easy to drown in your thoughts. There's so much going on around us, so much we have to do, so many expectations to live up to. If you're anything like me, your mind never stops working. It runs and runs, day and night, doesn't let you sleep at times, haunts you with worries and doubts, visions and dreams of things to come and things that have already happened. I like the complexity of the mind, but sometimes it just gets too much and I get picked up by a whirlwind of thoughts and feel like I can't find my way back to the ground.

But not when I skate. When I skate, my mind is blank. All my focus is directed at the board underneath me, at the way I place my feet on it, at how I balance my body, at the trick I'm planning to do next. The joy I feel when I'm skating is something I've never experienced in anything else I've done in my life so far. It makes me feel light and free of worries.

My first longboard accompanied a life-changing decision. I had just lost my father to cancer and felt heartbroken and lost. I was overwhelmed by family, university, work, and with my life in Germany in general, so, one day, I made the decision to leave all my worries and fears behind and to move to Israel to start a new life. I needed to be alone, away from everything and everyone, in a foreign country where things were less conventional and where I felt at home. My first longboard somehow became the symbol of this new life I was about to start.

For the first few months in Israel I barely used it, as I was busy adapting to a new country, language, and mentality, but after finishing six months of intense language school and moving into my first apartment in Tel Aviv, I started skating by myself, alone at night when the streets were empty and no one was watching. I felt insecure about it at first, but the steadier I got, the more confidence I gained, until one day I finally felt brave enough to join the other skaters of the Israeli longboard community. That day changed a lot for me: skating quickly became one of the most important things in my life. Being outside with my board and with my friends, who became my second family, was something that calmed me down, fulfilled and centered me; while the feeling of being connected to other people by a common passion and a shared goal was just beautiful and empowering.

But skating isn't only about joy—it is also very challenging and frustrating at times. Learning a new trick takes a lot of time and patience and requires endless repetitions of the same thing. You fall and you hurt yourself, your legs are bruised, your knees and elbows are bloody, your feet are tired, and you just want to finally land this one trick you've been practicing for so long. My biggest personal struggle is that sometimes, my feet do exactly the right thing, but my fear blocks me from jumping high enough or committing to a trick all the way, which makes me fail it every single time. In these moments I sometimes feel like giving up, as it simply seems too difficult. But what keeps me going is the knowledge that when I finally land the trick, I'll experience this incredible feeling of pure joy and happiness, and be so proud of myself—and so in the end I succeed, overcoming my fear and breaking through the mental blockade. It makes all the pain and all the frustration worth it.

It might sound dramatic to some people, but I really believe that skating changed my life. Skating is the first thing I've been so passionate about that I simply cannot imagine my life without it. It's so much more than just a sport. It gives you purpose and direction; it gives you friends and a family; it's therapy and an escape from a sometimes harsh life.

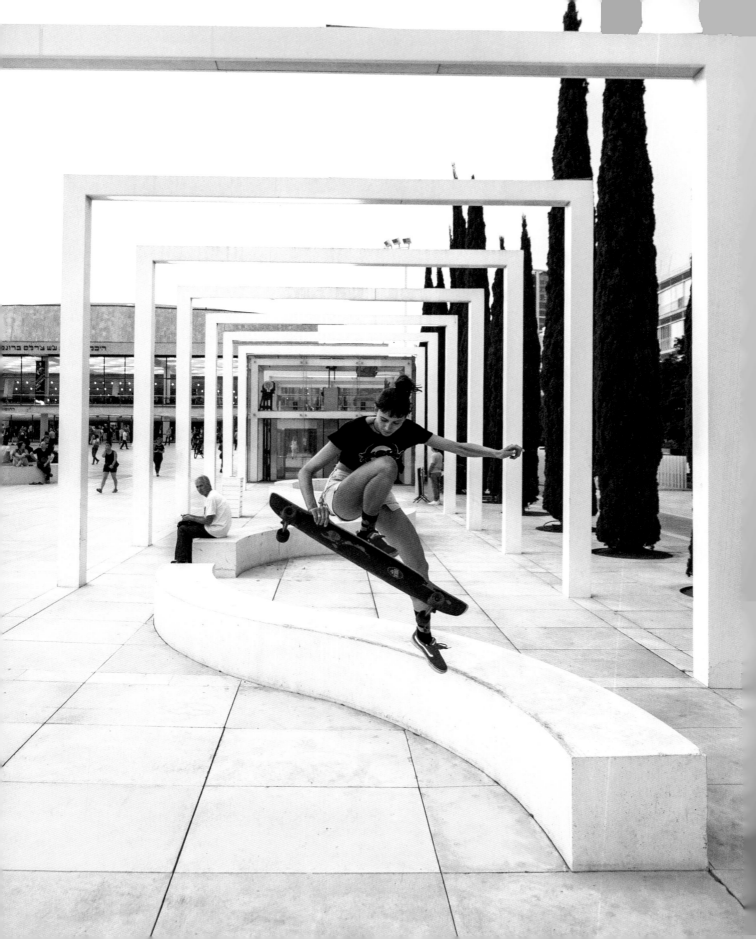

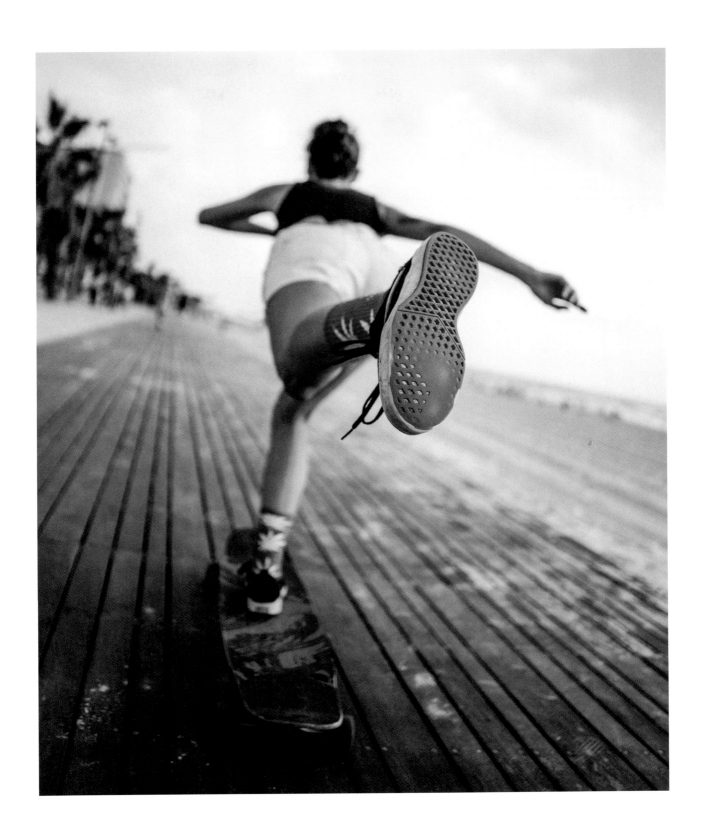

◁ Habima Square, Tel Aviv △ Bat Yam ▷▷ Bat Yam | Israel

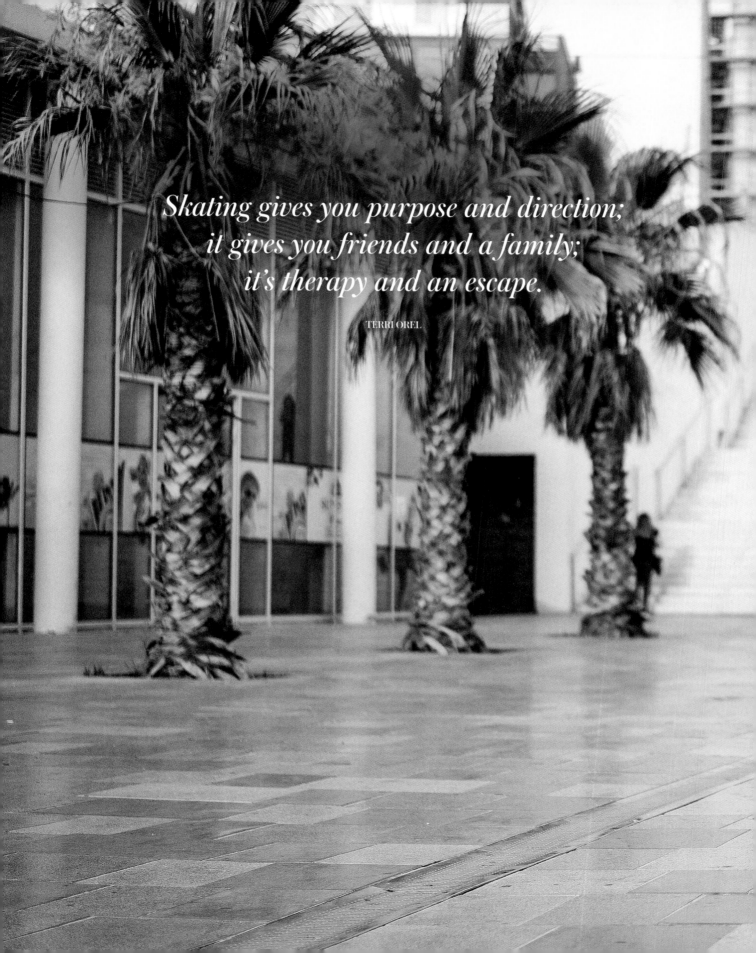

*Skating gives you purpose and direction;
it gives you friends and a family;
it's therapy and an escape.*

TERRI OREL

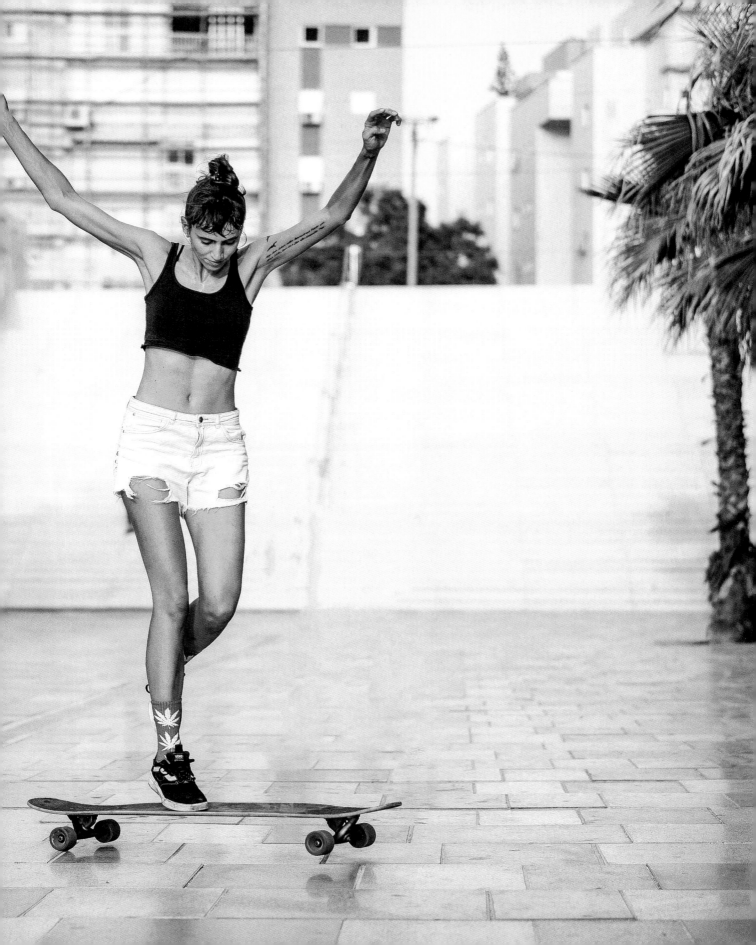

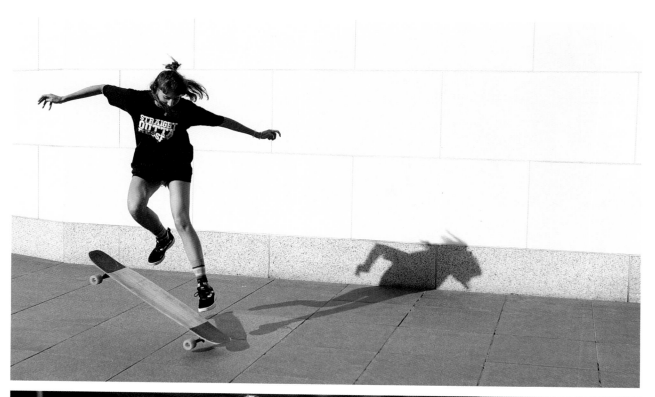

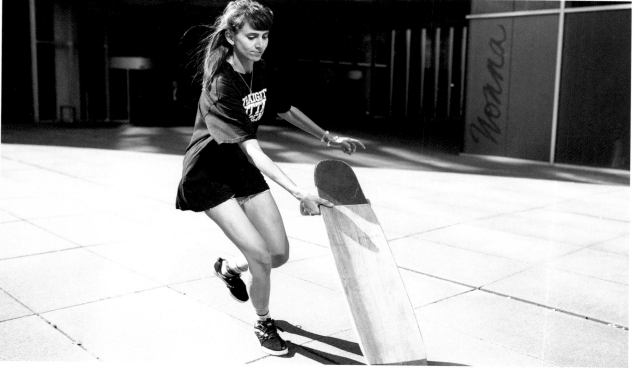

△ Frankfurt, Germany ▷ Bat Yam, Israel

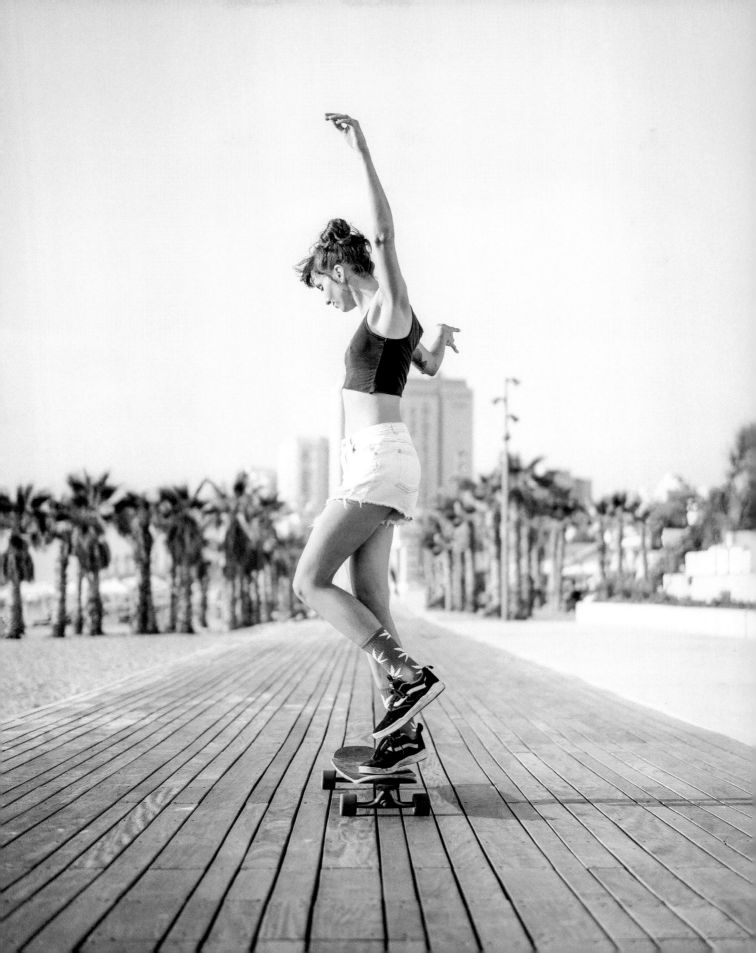

Elise Crigar

Photographer and skateboarder

@elise_crigar

I'm a photographer, skateboarder, and artist based in Southern California. I grew up in a small town in central Florida and was introduced to surfing at the age of thirteen. The experience changed my life; I was soon obsessed with women and action sports. While attending college on the east coast of Florida, I discovered skateboarding. Being a female in a male-dominated sport taught me more about myself than I could have imagined. It shaped my work and motives into what they are today.

I've expressed my passions through art since I was young, and I continued this at college, where I studied graphic design. My experiences with skateboarding gave me a relentless desire to work with women in action sports, and this passion led me to design the first comprehensive hardback book on female skateboarding, *It's Not about Pretty: A Book about Radical Skater Girls*. I relocated to Southern California, where I now work full time for the World Surf League.

Today, as well as my art and photography work, I participate in multiple projects that I'm passionate about, highlighting women in action sports, in addition to working with some of the world's best surf athletes.

▷ Dana Point ▷▷ Janthavy Norton in Los Angeles | California, USA

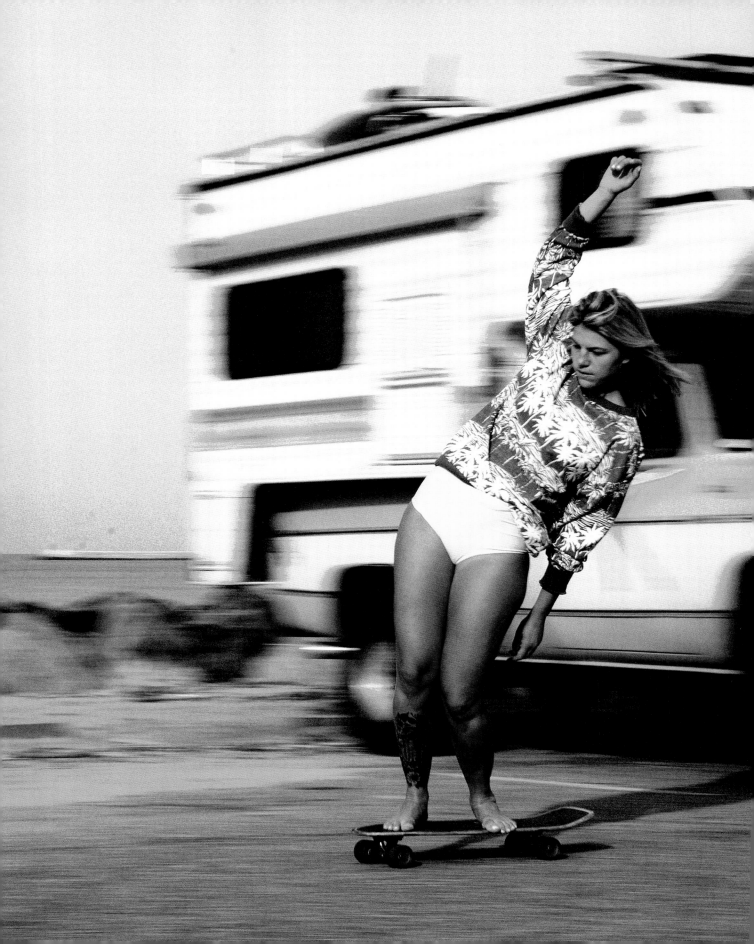

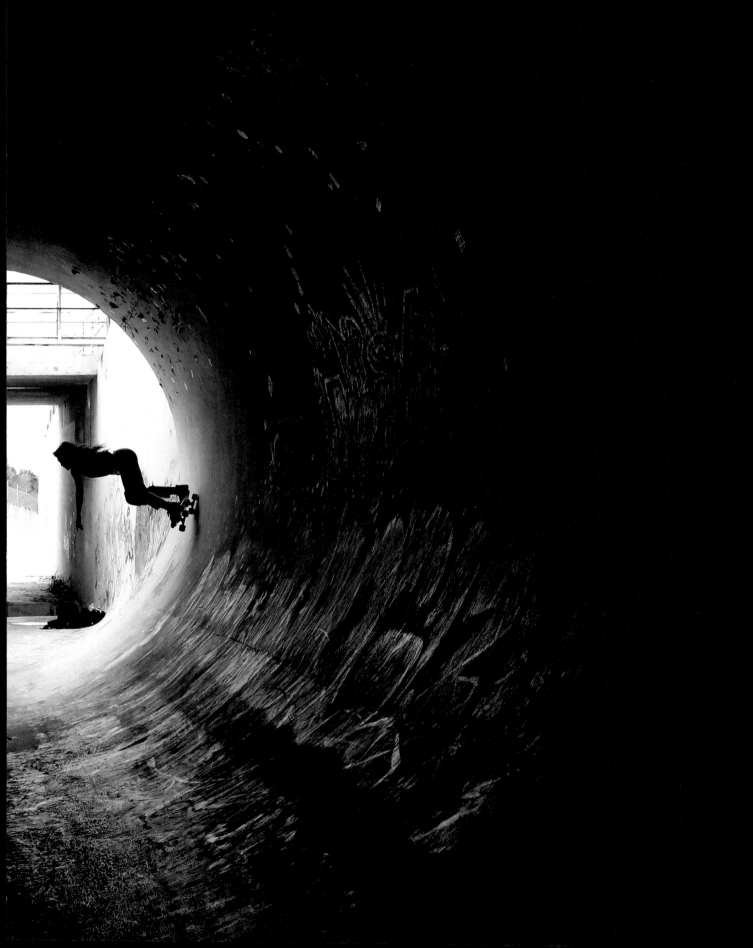

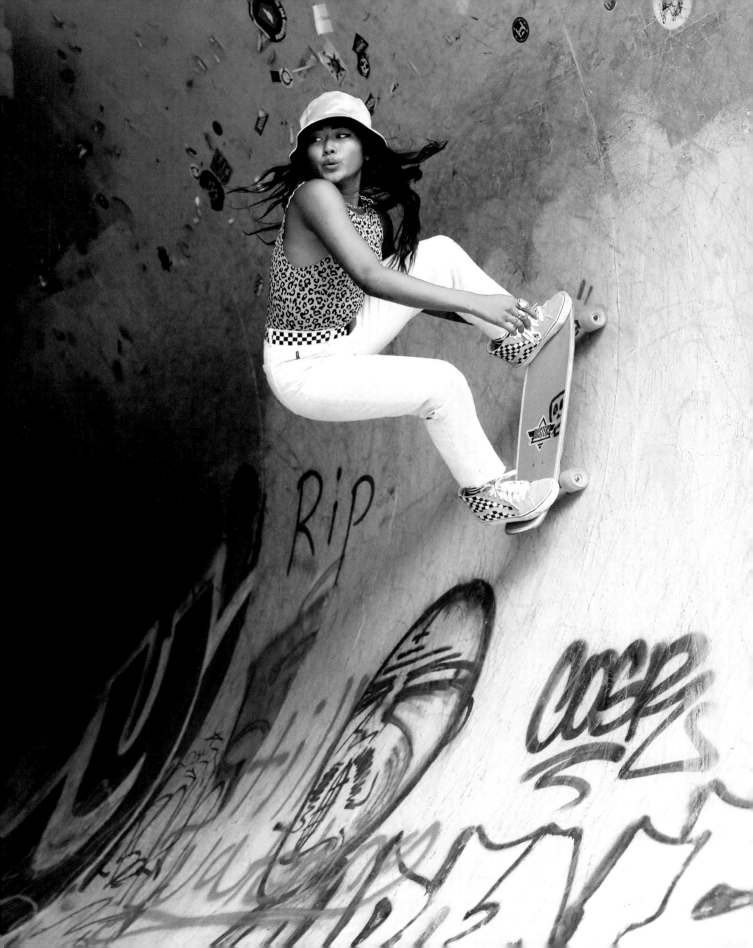

Skate attitude.

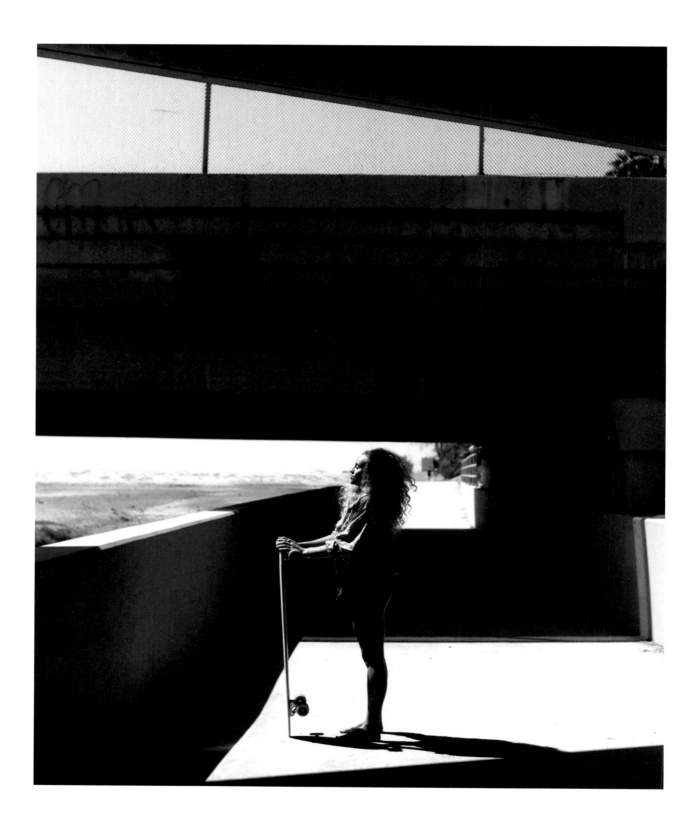

△ Malia Ward in Dana Point ▷ Bryce Wettstein in Encinitas ▷▷ Stephanie Allen in Oceanside | California, USA

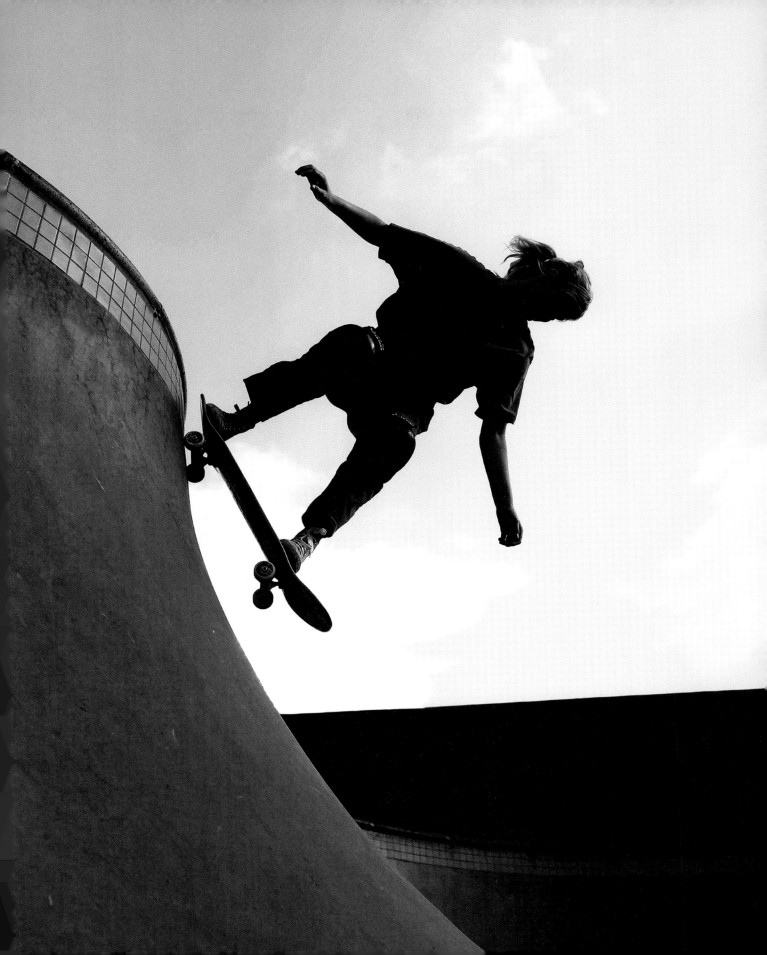

Skateboarding is a state of mind.

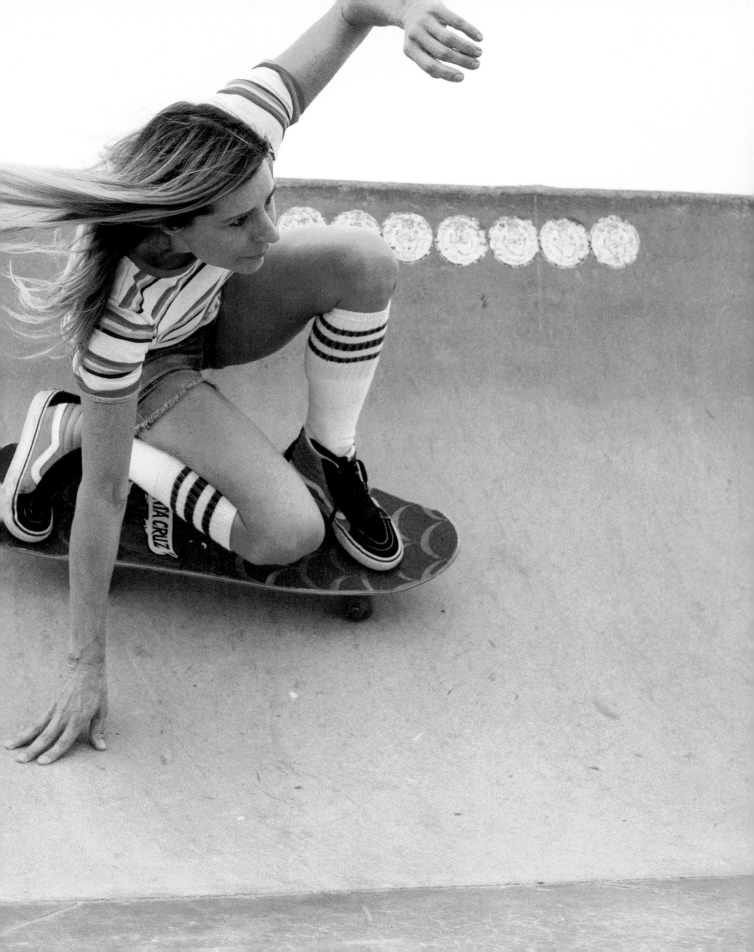

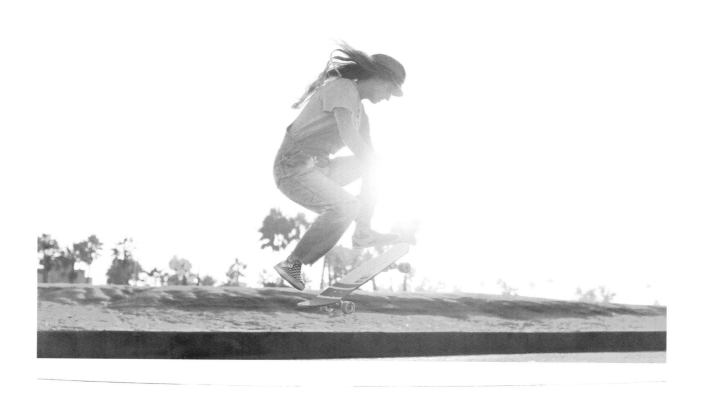

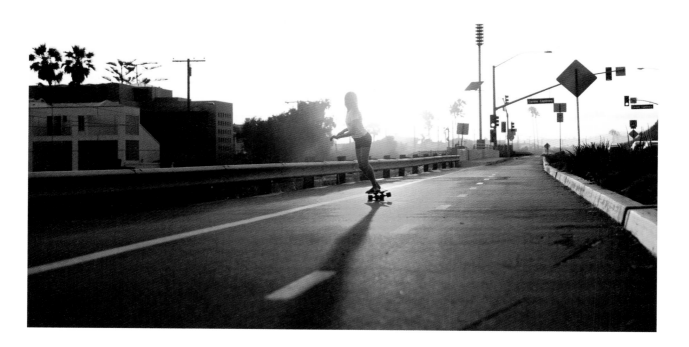

△△ Maddy Beachamp in Oceanside △ Zoe Herishen in Dana Point | California, USA

Sierra Prescott in Dana Point, California, USA

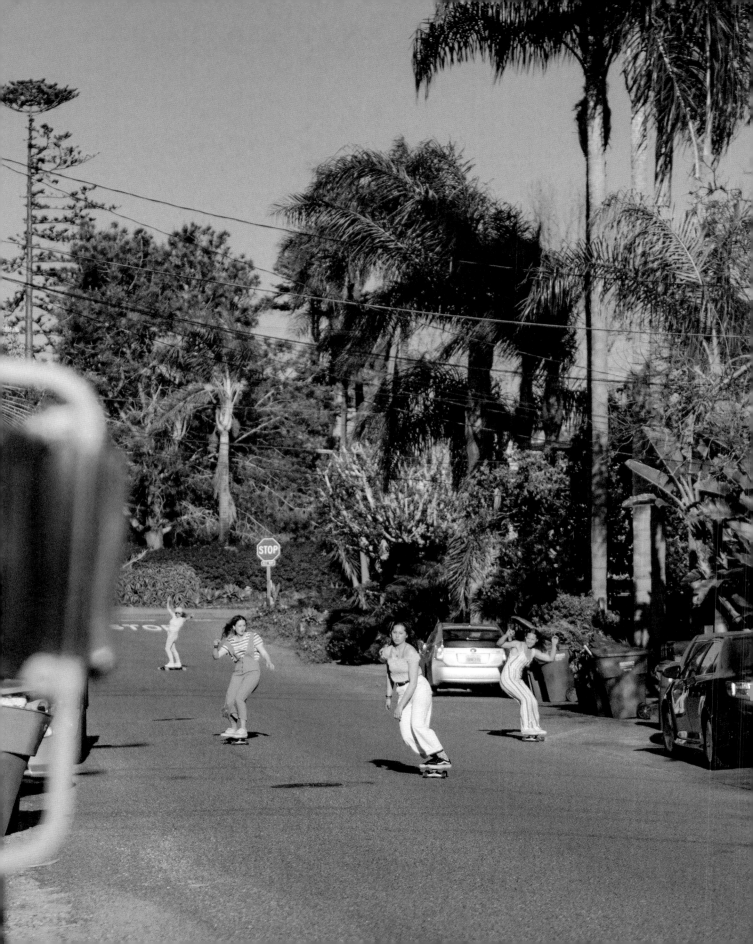

Jo Savage

Commercial and adventure lifestyle photographer

@jo_savagephotography

I enjoy skating perhaps above all my other interests. There's a freedom of being, expression, and creativity when I ride a board. The majority of my time on a skateboard is spent in a flow state, often with eyes opened wide and a smile that spans the width of my face. This luxury of life can be savored anywhere in the world with pavement—alone, or laughing and carving alongside friends, or meeting new ones. I love to observe how each person possesses an individual, unique style and relationship to skateboarding. Skating is a free pleasure that can bring fulfillment for life.

Being on a board completely immerses me in the landscape, demanding that I be present in the moment and in tune with the environment. Steep, twisted roads in the mountains, long and scenic stretches through the desert, suburban neighborhoods, sprawling urban centers, and coastal paths surrounded by warm, salty breezes and palm trees provide empty canvases to explore on a board.

I primarily focus on shooting womxn skating because the skate imagery I've seen throughout my life tends to be male-dominated. My girlfriends and I make skating an integral part of our lives and I want to showcase that passion, as well as the femininity and style womxn bring to skate culture. I believe that, even on a subconscious level, if people don't see other people who look like them portrayed doing certain things, they won't always know that those things are an option for them. I hope my imagery can inspire and empower womxn and girls to feel more comfortable getting on a board and offer the feeling that they also have a community. The growth, catharsis, health, and happiness an individual can gain from skateboarding should be accessible to everyone.

My biggest takeaway from capturing womxn skating is the female community I've built, connecting with womxn around the world. Womxn supporting womxn is powerful, refreshing, and invigorating. My *Skate* series is born of these things.

Bella Glickman, Emma Early, Devon DeMint, and Kaelie Fisher Cobian in Encinitas, California, USA

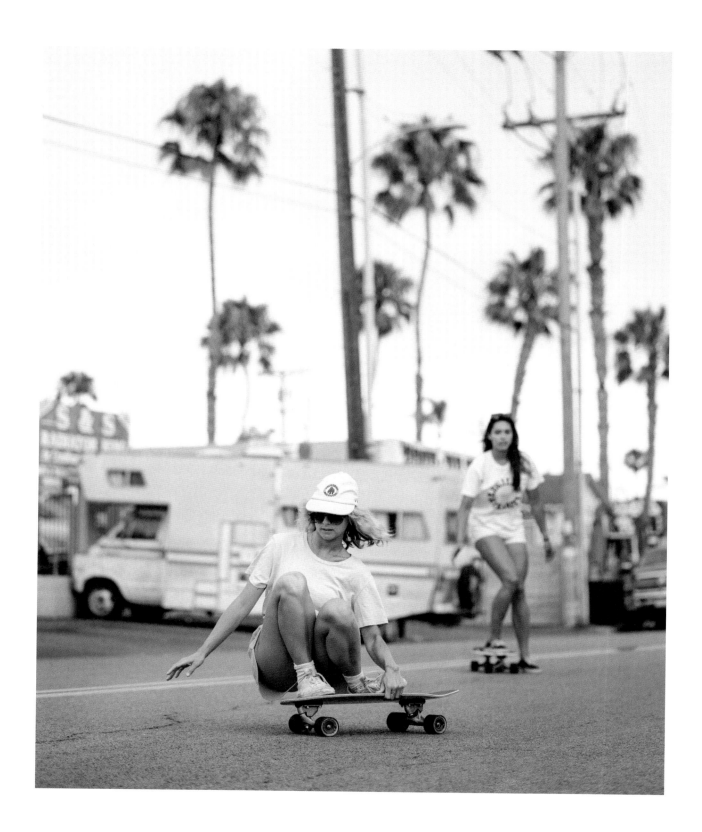

△ Lucy Osinski and Júlia Amá of GRLSWIRL in Oceanside ▷ Manon Lanza in Huntington Beach | California, USA

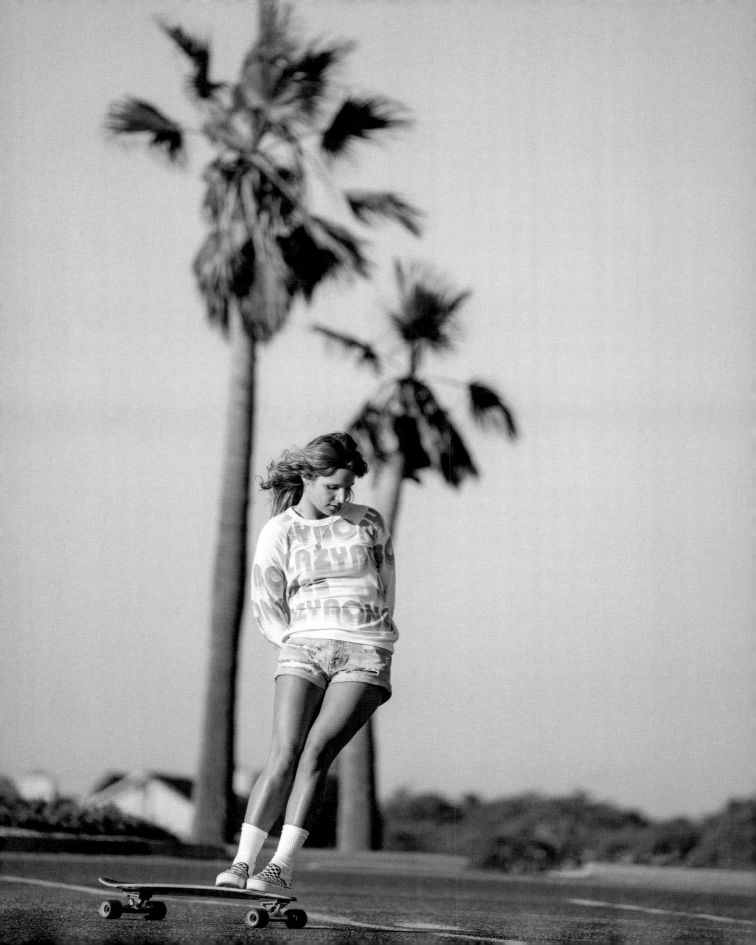

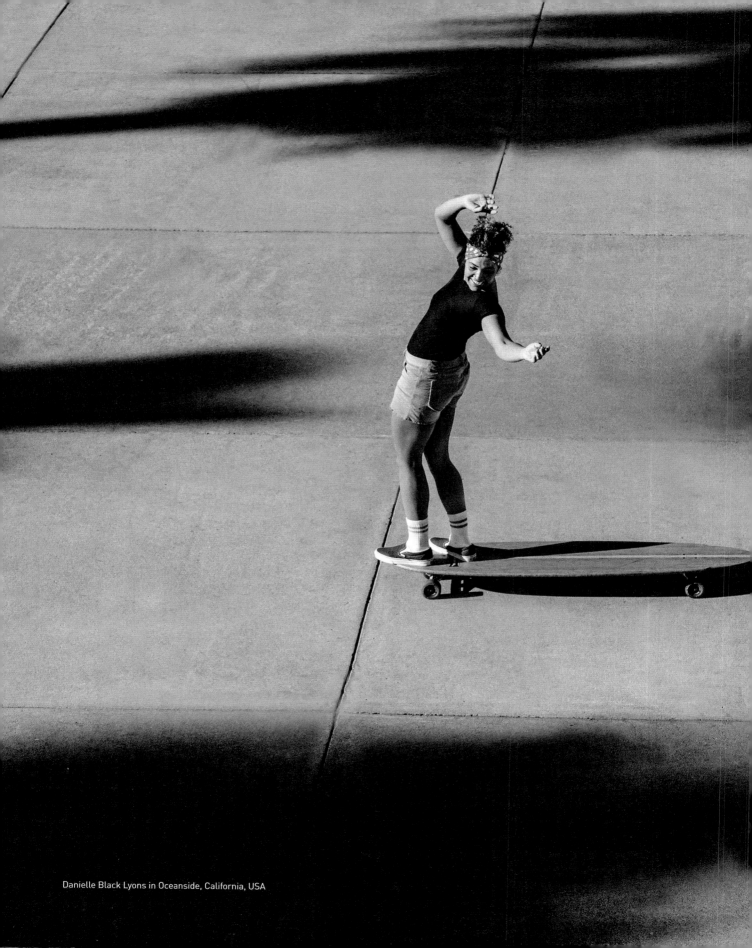

Danielle Black Lyons in Oceanside, California, USA

Skateboarding is not a crime.

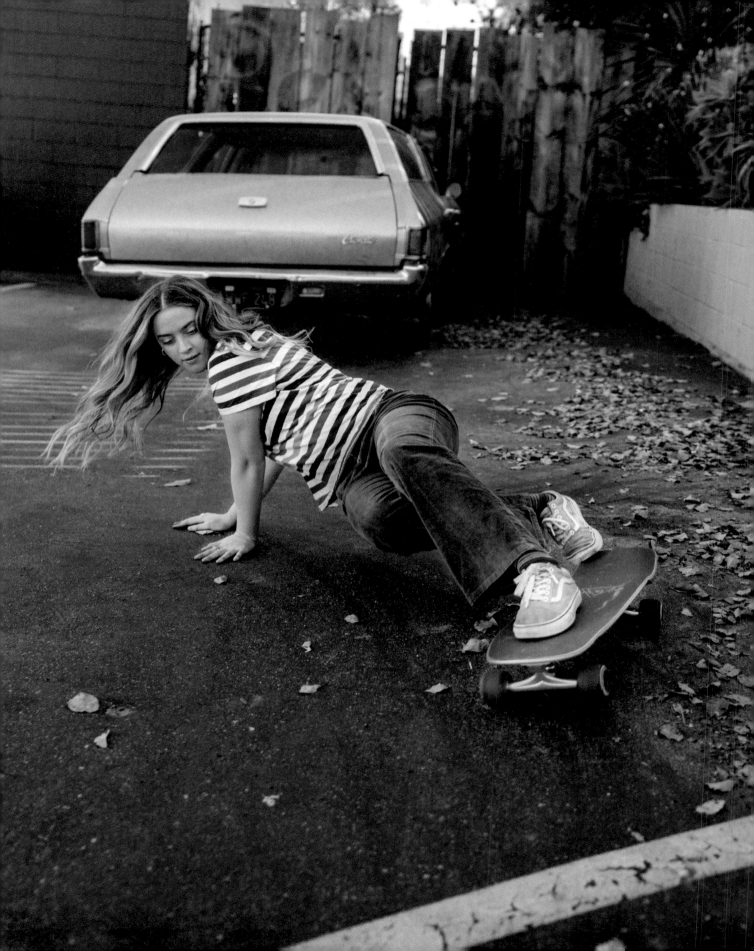

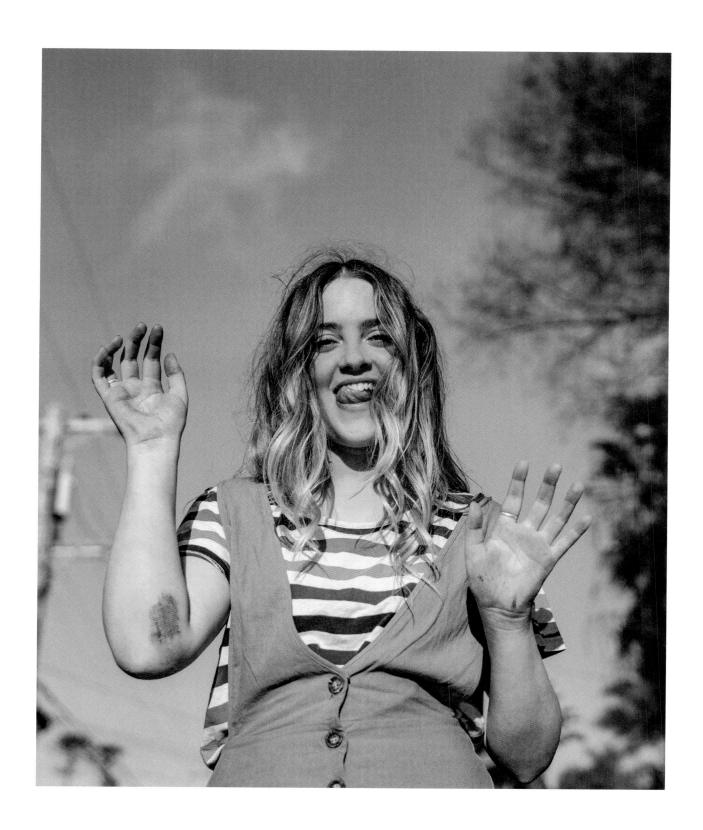

◁ Bella Glickman in Leucadia, California　　△ Bella after hitting a rock at speed

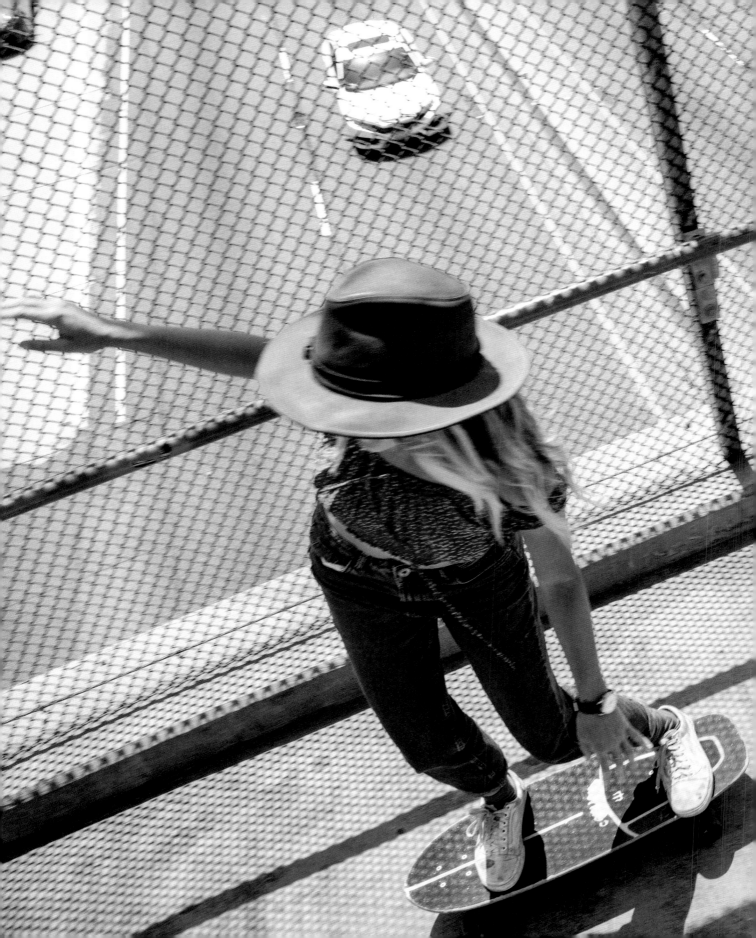

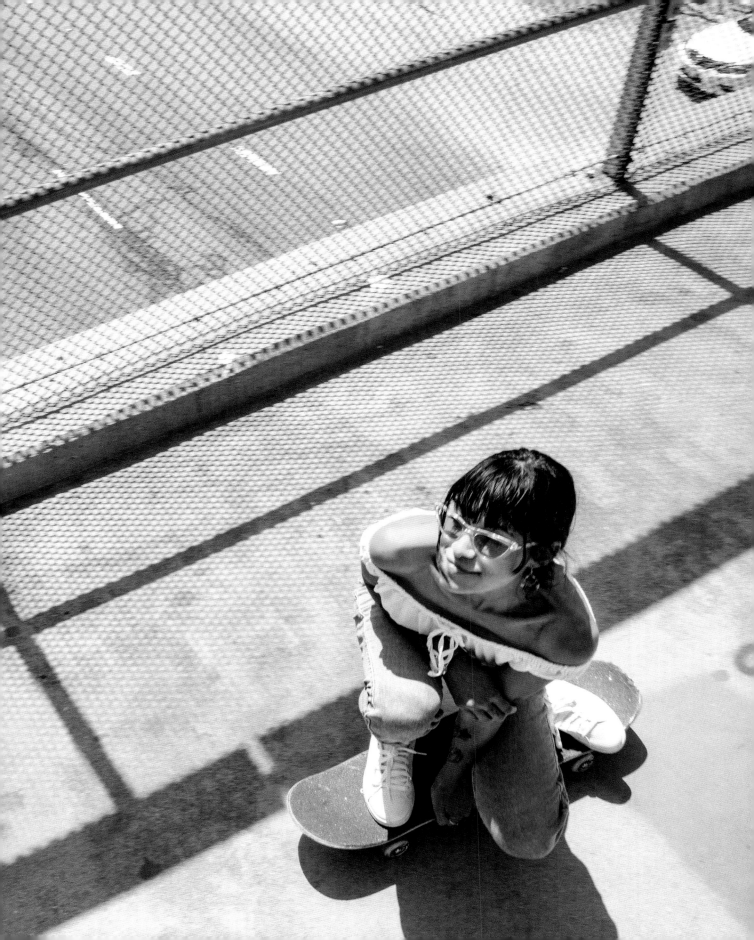

Myriah Rose Marquez
Always with a skateboard in hand

@myriahrose_

My name is Myriah Rose Marquez, and I'm originally from the Louisiana/Texas border. At the age of eleven I became very ill, and that led to numerous hospital visits, a wide variety of medications, and finally, at age seventeen, a major operation to remove some of my organs.

It was back when I was eleven that I picked up skate-boarding. The medications had made me gain weight and when I returned to school the bullies took notice. My parents had to move me to another school, and skateboarding was my way of being perceived as tough. Little did I know then how truly life-changing the sport would be for me. At eighteen, after my surgery, I decided to hit the road for the opportunity of experiencing as much of life as it had to offer. With a skateboard always in hand, I became more and more comfortable, and I found it an efficient way to sightsee quickly as I passed through new cities.

With my illness, most of the time, even to this day, I feel weak, tired, and not my highest self. But when I get on my skateboard, all my ailments fade away. I don't say that to be cheesy—I truly mean it. My spasms stop, my thoughts stop, my pain stops, and I'm just there. Present.

Before moving to California I lived in Seattle. Things arose there safety- and health-wise, and I had to move. I wound up in Venice, California, living out of my car (I live in my van now). It was on my sixth day in Venice that I met the girls from GRLSWIRL, the organization we would later co-found. We met up at the Venice Beach skate park and had such a blast that night that we wanted to share the experience with others and keep meeting up. There was a text chain going, but we thought that making an Instagram might be better. I had no idea what was going to come of that night.

As time went on, GRLSWIRL began to grow. In the community and on our social platform we had unintentionally started a beautiful grassroots movement. There are so many details and beautiful little moments that have led GRLSWIRL to become what it is now. We focus on empowering others through skateboarding. We host biweekly skate meetups, we throw parties in our community to bring people together and raise money for local non-profits (over $10,000 so far), and we also partner with after-school programs to do skate mentorships with the kids.

Recently we had the opportunity to visit a migrant shelter as well as a middle school in Tijuana, Mexico. We passed out boards, which the children got to keep, and taught them how to skate and, most importantly, how to help each other skate. GRLSWIRL has become something truly beyond my wildest dreams, and I'm so thankful to be part of it.

Venice Skatepark, California, USA

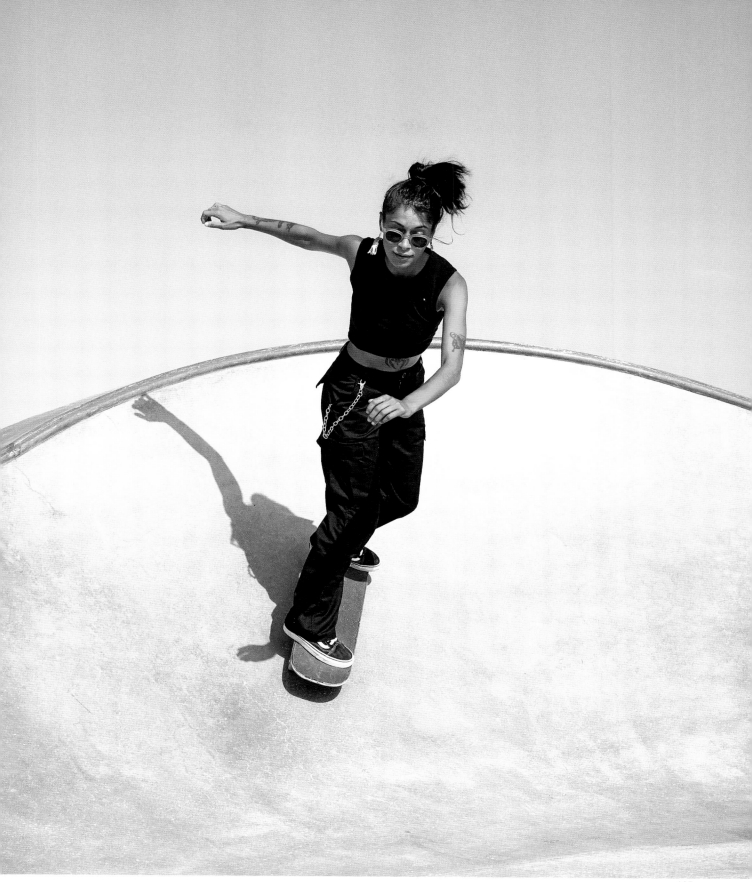

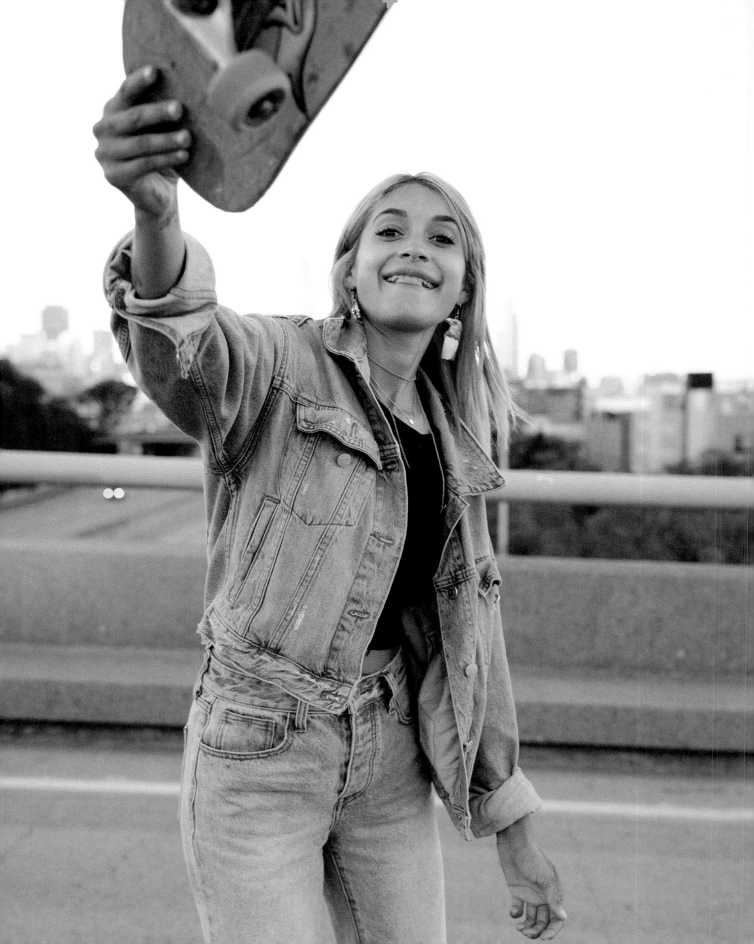

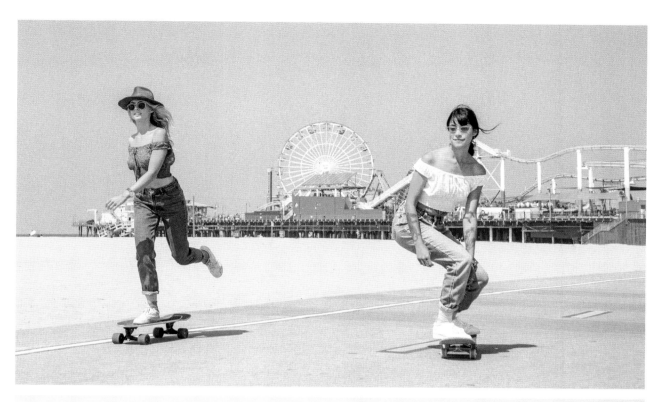

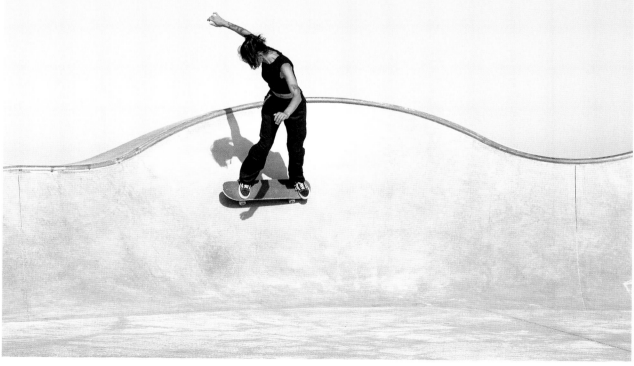

Skateboarding
is freedom defined.

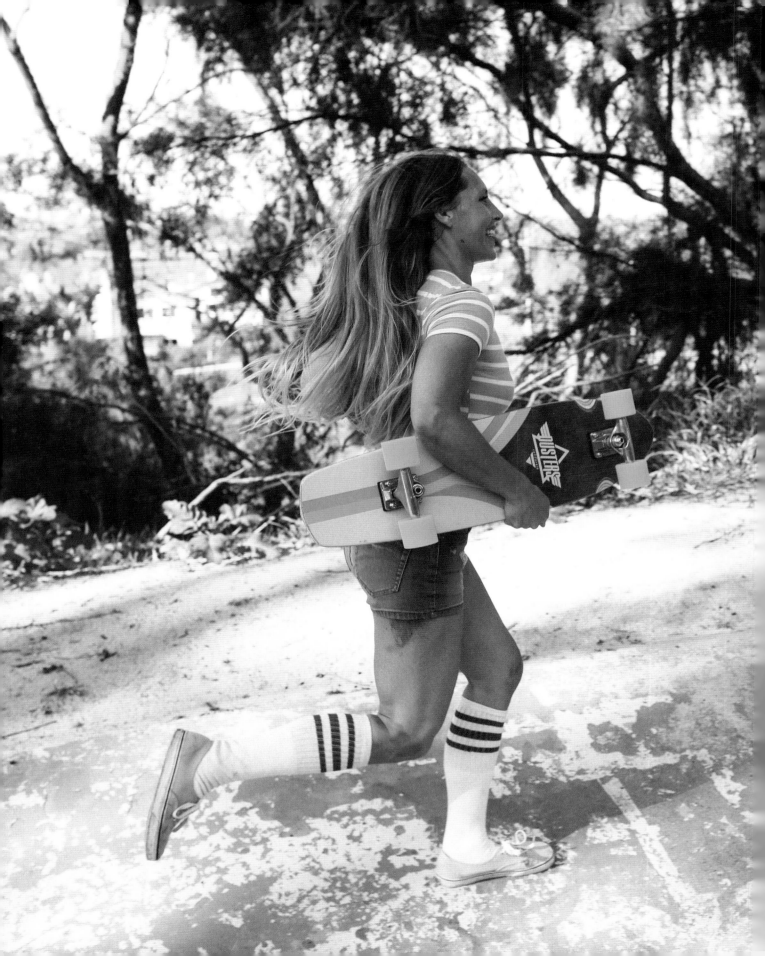

Kaelie Fisher Cobian
"One of the guys"

@fish_kiss

For me, it wasn't about skateboarding, it was about being "one of the guys." I grew up in Fresno, California, with four brothers and was constantly surrounded by countless males. Being the only girl was my comfort zone. I thrived in this position and did anything I could to make the boys proud. Girls scared me—in my (little and immature) experience they were catty, mean, and weak. I hated being a girl; my parents would set different rules for me (they were obviously wiser) and at that point in my life I didn't want to be set apart from the boys. So the tomboy phase never left me—it was who I was, and a part of my female self that made me feel empowered and stronger than other females.

Then, I grew up. I had always had girlfriends but would never have associated with a "girly-girl." As I got older, however, I started to appreciate fashion, being pretty, and the opposite sex (romantically). But I still took pride in being at the top of my class in physical fitness, beating all the boys in arm wrestling.

When I was twenty-seven I met a pool skater, and I was mixed with feelings of intrigue and fear. I also heard about the Z-Boys and loved their whole vibe and 1970s image. But I was hesitant to try it myself: I wanted to be good at it immediately and knew there was no way that was possible. Despite that, the little girl inside me, who would do anything to make the boys proud, started pool skating. I was back in my comfort zone: one of the guys. We would wake up and look for empty pools around our town. I never started slow—I always pushed the limits and was constantly bleeding and hobbling at the end of a session. I got hurt a lot, but I knew this went hand in hand with skateboarding.

You have to put the work in. There are no exceptions—the expression "you gotta pay your skate taxes" is very real. Eventually I met a couple of other women who also skated, and I felt like I'd met my soulmates. I loved my childhood friends, but I'd always felt different. For the first time in my life, I had found females who lived on the same wavelength as me. Everything changed from there on. I no longer cared to skate with the guys and instead sought out other female skateboarders. I would see another girl at the skate park and immediately ride up to her and introduce myself. I'm sure I seemed socially awkward, but I was just so excited to find other like-minded women! Once social media hit, so did the female skate world. It wasn't nearly as big as it is now, but it still blew my mind! My girlfriends and I would travel to different cities to meet up with other girl skate crews, and skateboarding became a way of life.

Fast-forward a few years. I met a sexy surfer who lived in Oceanside, San Diego, and we got married. It took me a fairly long time to start skating there, but when I did, to my surprise and delight the only other person at the park was female. She was so cool and friendly, and I felt at home again. I started connecting with more and more women—I couldn't believe how many females down here skateboarded—and began cultivating incredible friendships. I was so inspired and empowered by these women. They were gorgeous, kind, and hilarious but also vulnerable. We'd meet up to skate but would find ourselves sitting on our boards for the first hour, just sharing and talking about our lives. It was at this point in my life that I truly fell in love with skateboarding. It wasn't about making other people proud anymore: it was about myself, and being continually inspired by my friends. I found that encouraging and loving on other females was almost more fulfilling than landing a new trick. We were a true sisterhood who also skated, and this is when I realized how to "skate like a girl." It wasn't weak, it was powerful; and I've never been so grateful to be a woman. I now beam with pride when I'm told I "skate like a girl."

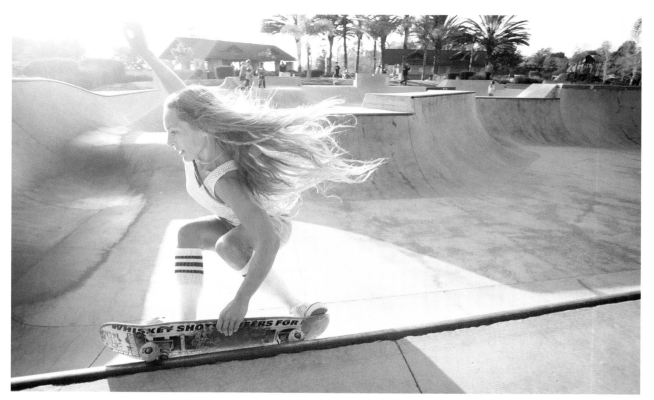

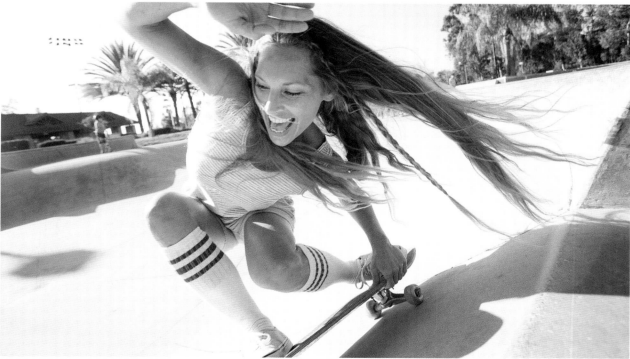

Martin Luther King Skatepark, Oceanside, California, USA

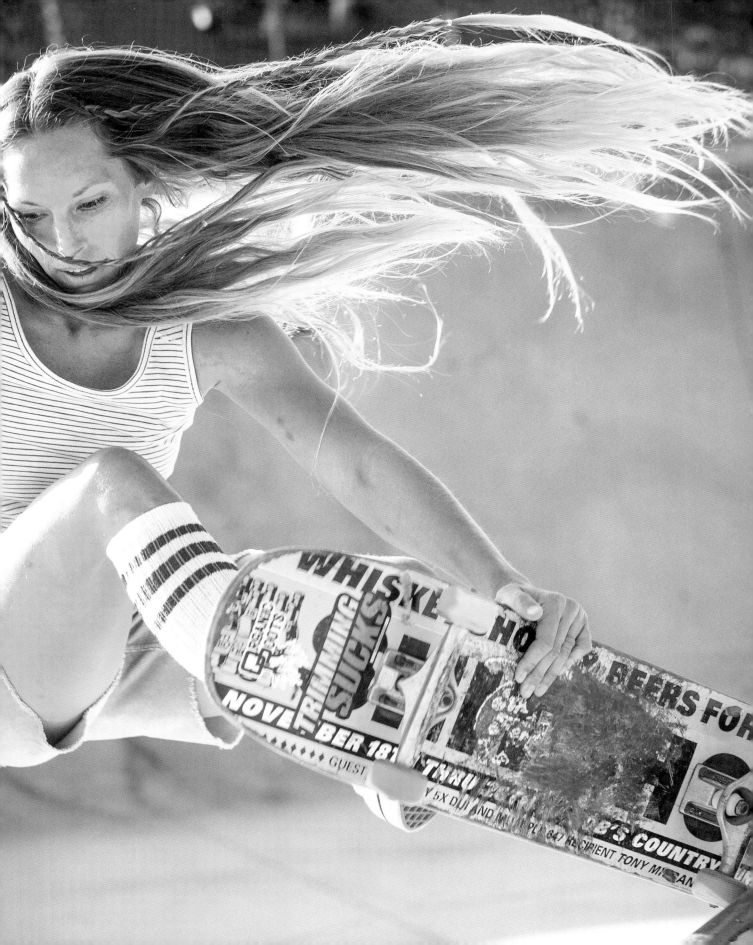

Skaters gonna skate.

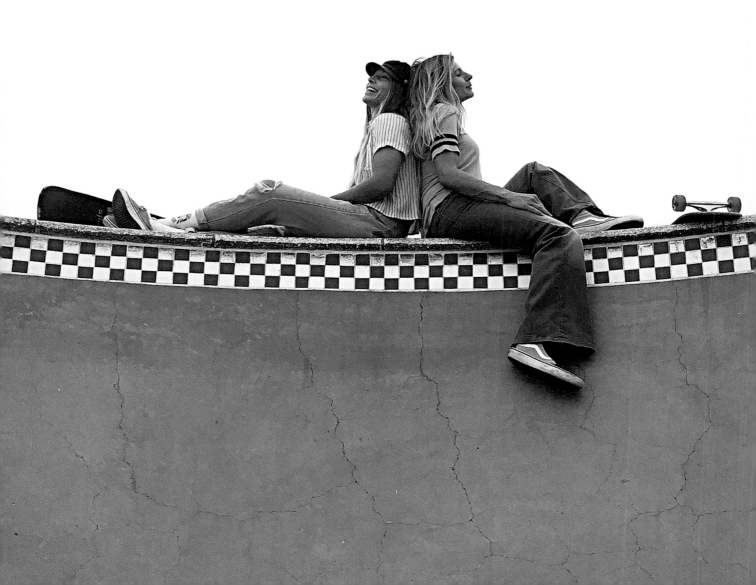

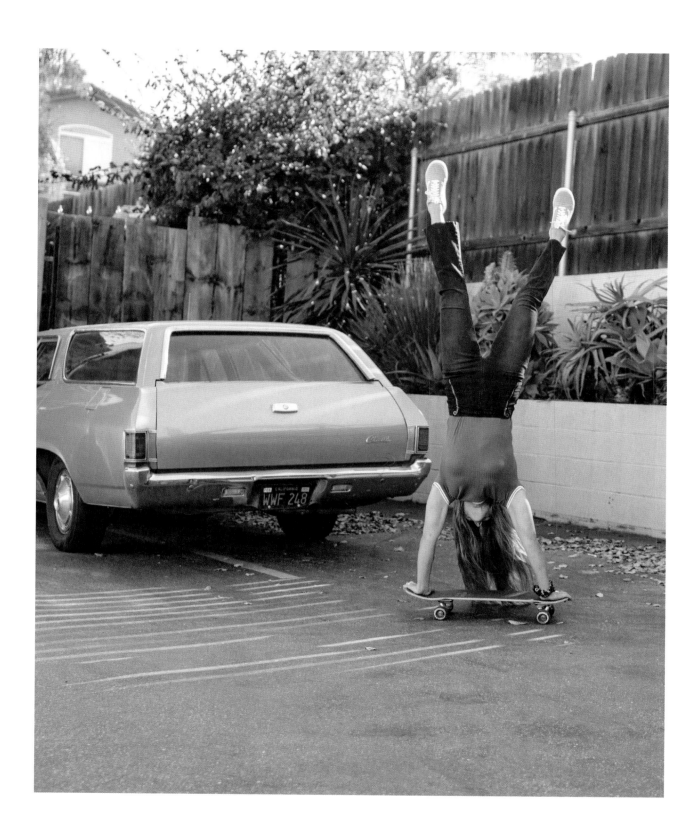

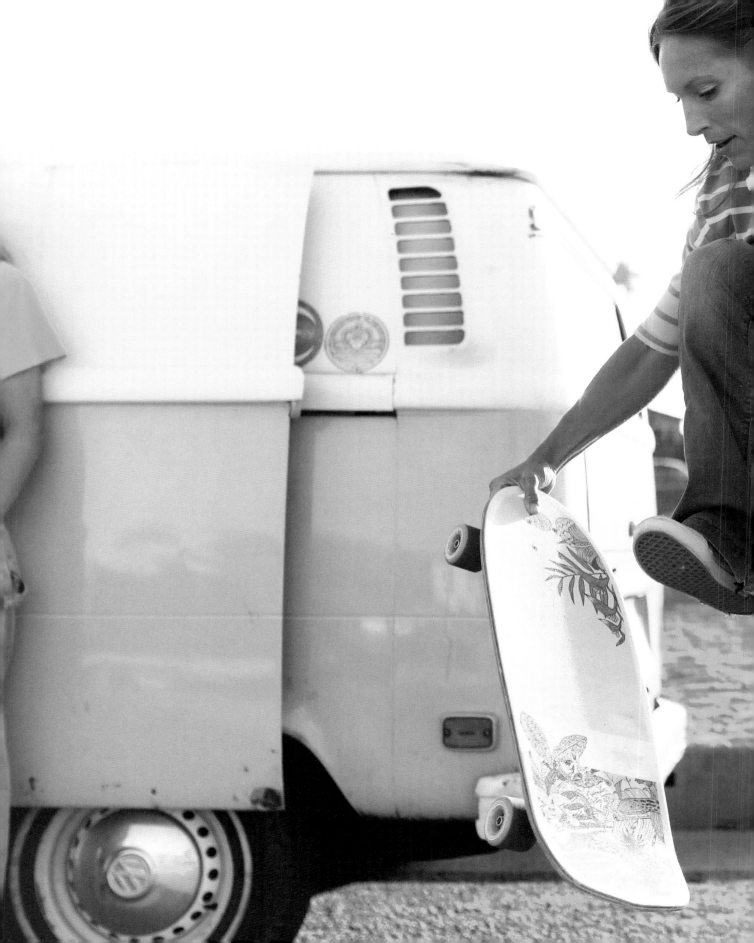

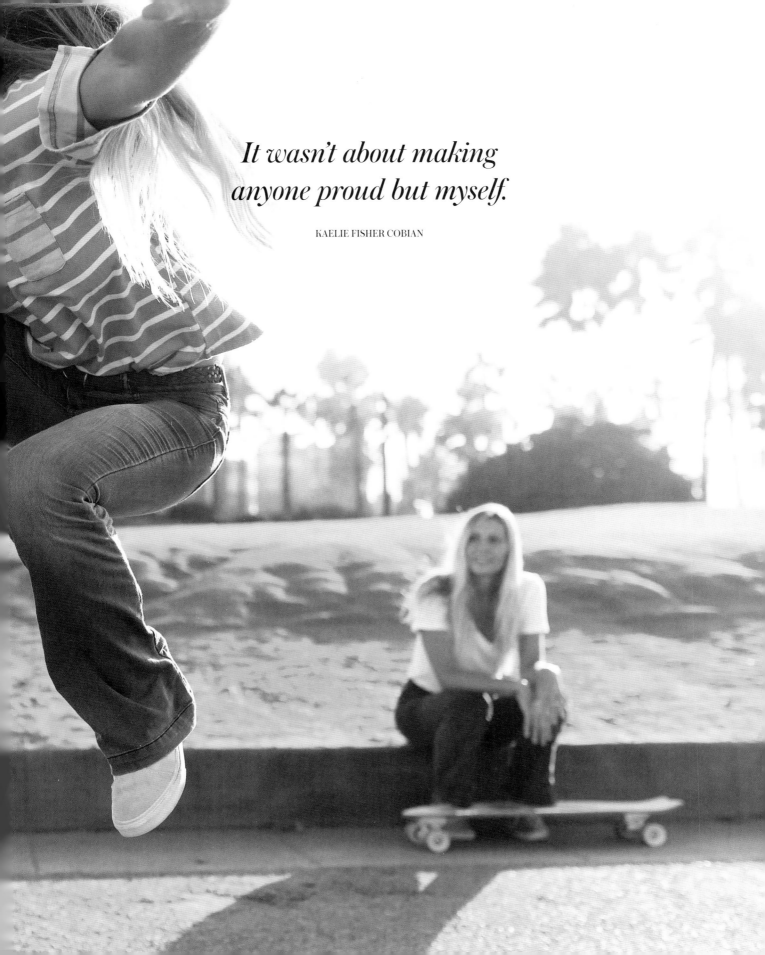

It wasn't about making anyone proud but myself.

KAELIE FISHER COBIAN

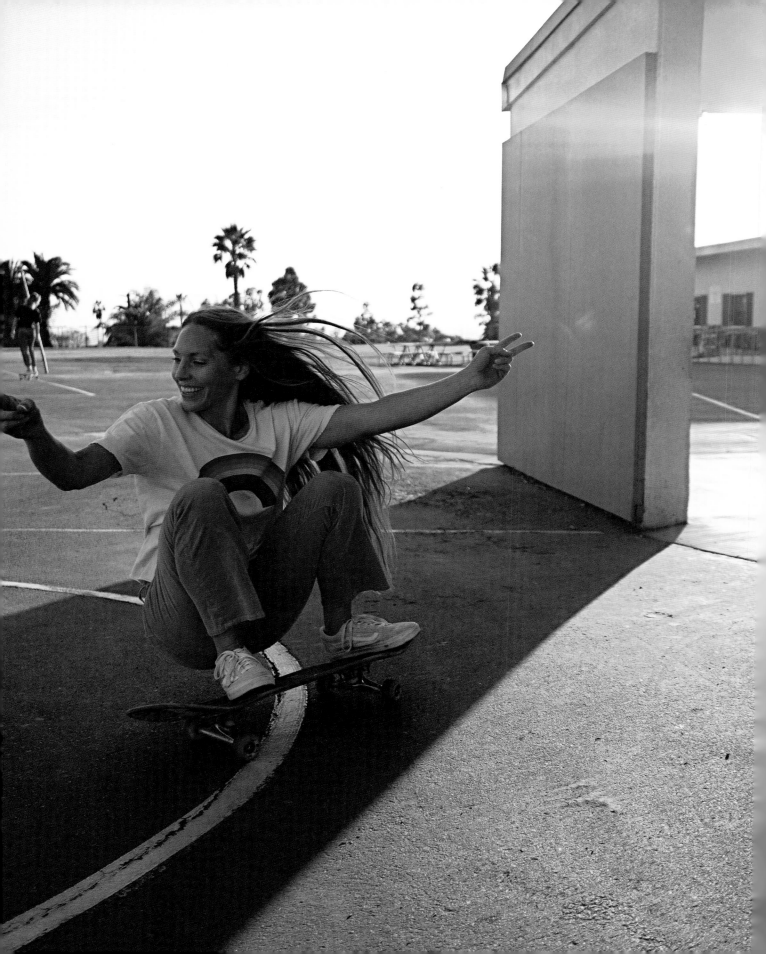

Noemi Zonta

Quit everything to skate

@noemi_zonta

I grew up on the coast of Slovenia surrounded by the Adriatic Sea. As a child I was into art and music, and my parents encouraged in me a love of nature. I've been attracted to skateboarding for as long as I can remember—I saw some cool dudes shredding around my hometown and dreamed of being like them. Then my brother and I got secondhand skateboards from the 1980s, and I learned the basics on that. Later, I got my first "real" skateboard, as a gift for a successful school year, and I started learning basic tricks on it. But then the old skate park shut down, and so I switched to a longboard. I spent every day riding it, but after a bad crash I thought, That's it, I'm done. Then I fell in love with watersports. I became obsessed with them, but our little area on the Adriatic rarely has waves, and the wind isn't consistent. I started searching for satisfaction in sports like running, cycling, and hiking—but it wasn't the same.

After a month spent in the Basque country, surfing every day, I hit rock bottom. I found myself back home, dreaming about waves in a land that doesn't have them. I had two options: leave everything behind, or find something that could satisfy my soul while I wasn't in the ocean. The next day, I bought my first surfskate. Suddenly, all my feelings and dreams from the past were alive again. My fear slowly faded. I was riding more and more, learning day after day. I realized how much skateboarding fulfills me and brings me happiness. And I didn't miss surfing as much; every time I stepped off my skateboard, I found myself smiling.

I wanted to try different boards and setups. I made a huge longboard out of a flat piece of wood and fixed surfskate trucks to it. It was so fun to ride. Then I took some photos of me riding this thing and uploaded them to Instagram, and everything exploded: people loved the board and the idea of making something at home, and they started asking me all sorts of questions. And people would send me pictures of the longboards that they'd built. I know I'm not the first person to make a long surfskate at home, but I hope I can still inspire others to try this beautiful sport. I'm so grateful to the sport; sometimes I just can't believe its force—the way it connects people from all over the world. How beautiful is that?

Eventually I decided to quit everything and follow my dreams: to pack as much into life as I can. To skate, to surf, to travel, to be wild and free. I'm just beginning my journey, and I feel that I've chosen the right path. Or maybe it chose me.

Skateboarding helps me see and experience the world differently, to challenge myself and feel good in my own body. It teaches me to be patient, persistent, and, most importantly, stronger after every fail. I'm not a professional—I do this for my soul. I often wonder why we judge others on their level of knowledge, the gear they have, or the sport they choose. We should share good vibes and support each other—instead of making fun of someone else's discipline, switch gear with them and learn something new! We should build community, not competition.

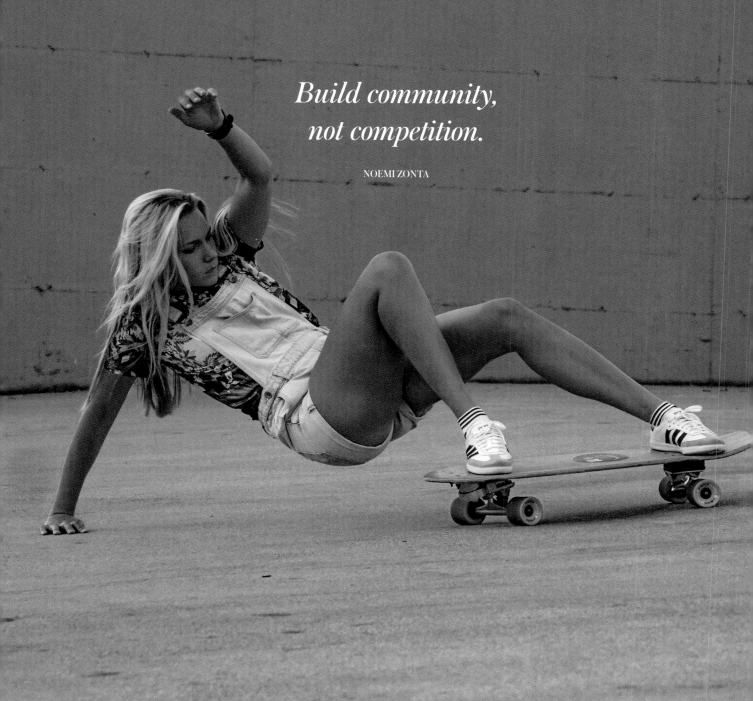

Build community,
not competition.

NOEMI ZONTA

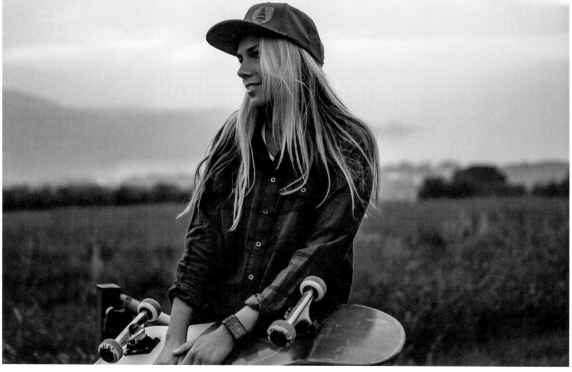

◁ Trieste, Italy △△ Soo, Lanzarote, Spain △ Strunjan, Slovenia

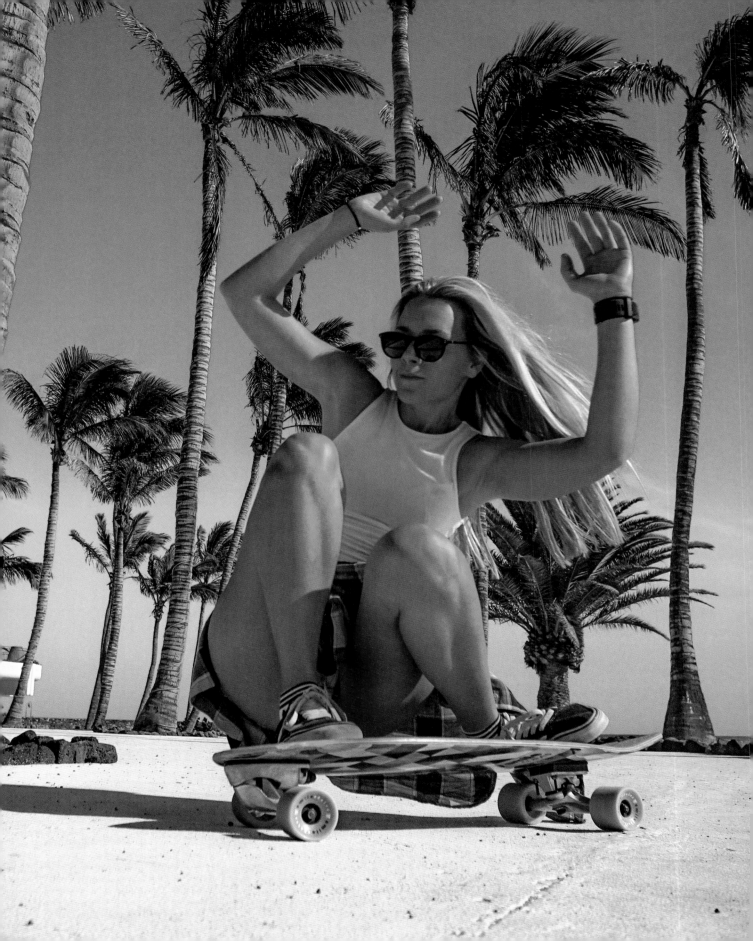

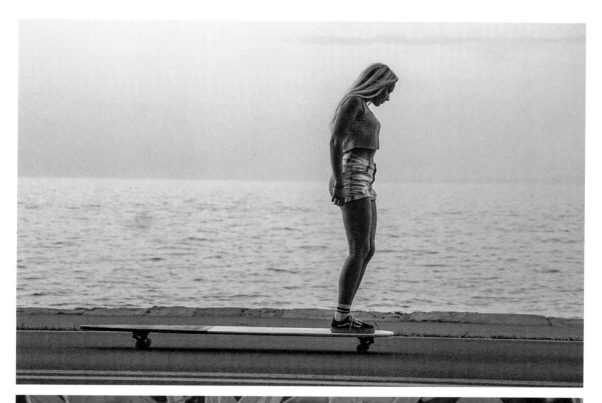

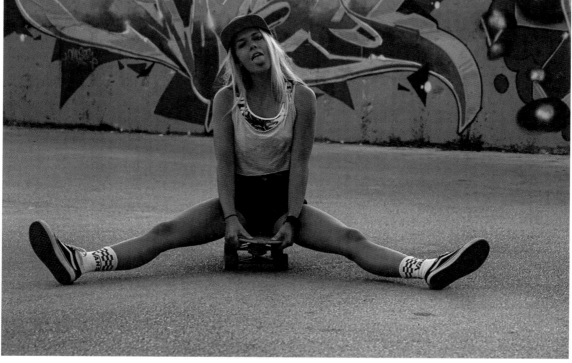

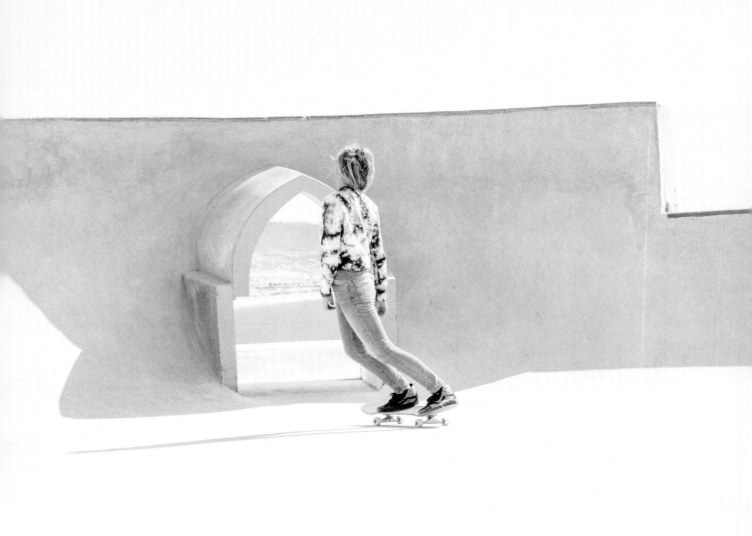

Claudia Lederer

Photographer and filmmaker

@claudia__lederer

I'm a French photographer and filmmaker. I started my professional life in the finance industry in London, but I was quickly drawn away, distracted by sports, photography, the urge to travel, and especially the desire for freedom. I settled in Biarritz, surrounded by nature, surfing, and the ocean, which fueled my inspiration like nowhere else.

I've never been taught photography or video, or been to art school, so I never thought I would one day be making a living from what I create with a camera. It happened through instinct, desire, and hours of practice to learn the technical aspects.

I don't know if it was the ephemeral dimension of the waves, the softness of the oceanic light, the graphic shapes of the surfboards, or simply the fact that surf culture is globally very photogenic, but it felt to me as if capturing these moments was an absolute necessity. I'm also captivated by architecture, lines, and graphic composition, so skateboarding and the urban environment have always attracted my eye. I'm impressed by the sheer toughness of skateboarding and have boundless respect for girls who practice it. That's also why it's become increasingly important for me to put them forward through my photography and film.

I want my photography and film work to go beyond simple aesthetics: I want to channel messages through it. To show girls what they can do, what they can become, how far they can push it. Capturing action shots of a girl skateboarding can be more meaningful than we think—those images can have a real impact on the girls who see them. I see photography, film, writing, surfing, and skateboarding as channels of expression. You can use whichever channel you choose in order to tell the story you want, and you can practice and learn any of them. When you find yours, you'll be surprised by how much you can achieve when you put your heart into it.

◁ Lucie Curutchet in Taghazout Skatepark, Agadir, Morocco

*I'm impressed by the sheer toughness
of skateboarding and have boundless respect
for girls who practice it.*

CLAUDIA LEDERER

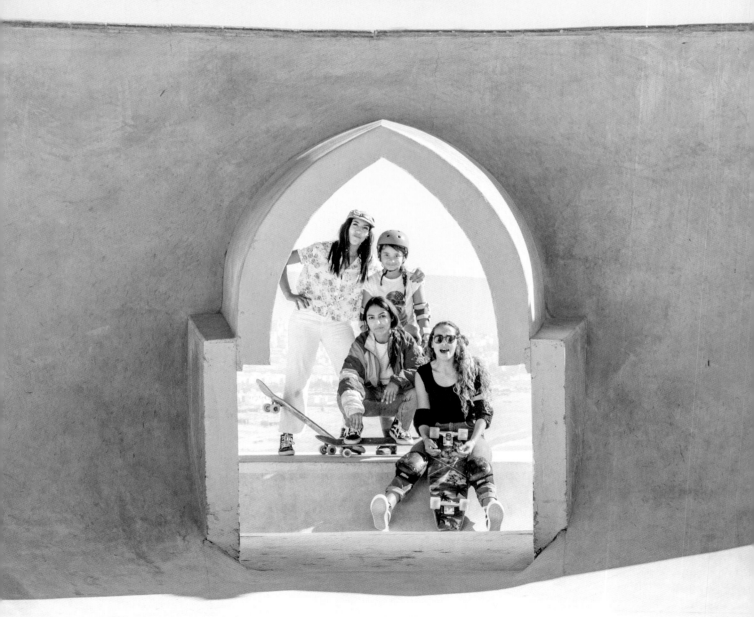

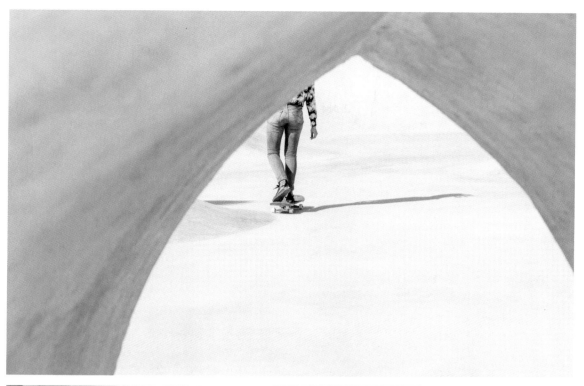

◁◁ Wafa Heboul, Faiza Moumane, and Meryem El Gardoum in Taghazout Skatepark, Agadir, Morocco

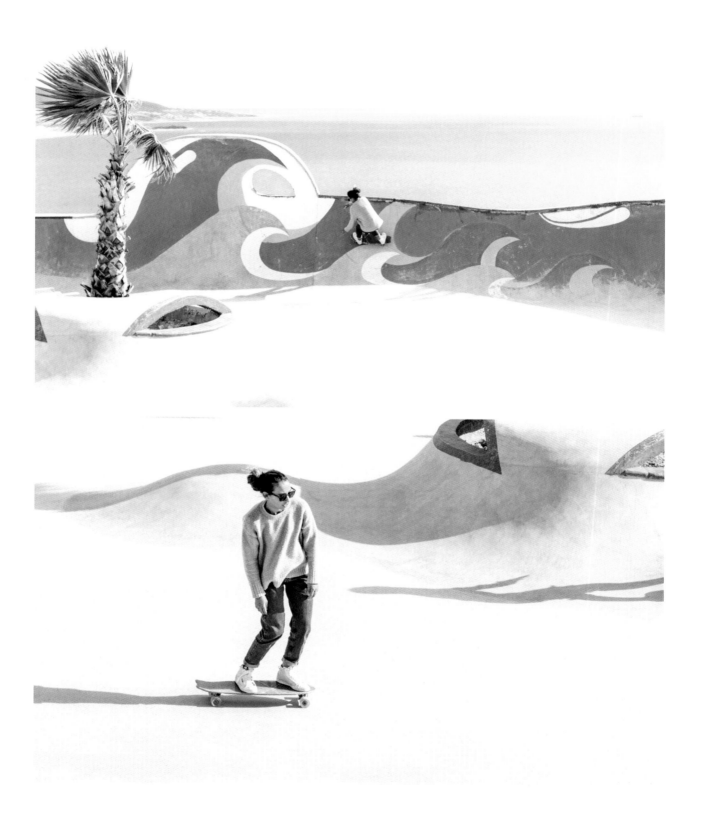

△ Meryem El Gardoum at Taghazout Skatepark, Agadir, Morocco ▷ Jeanne Duval in Paris, France

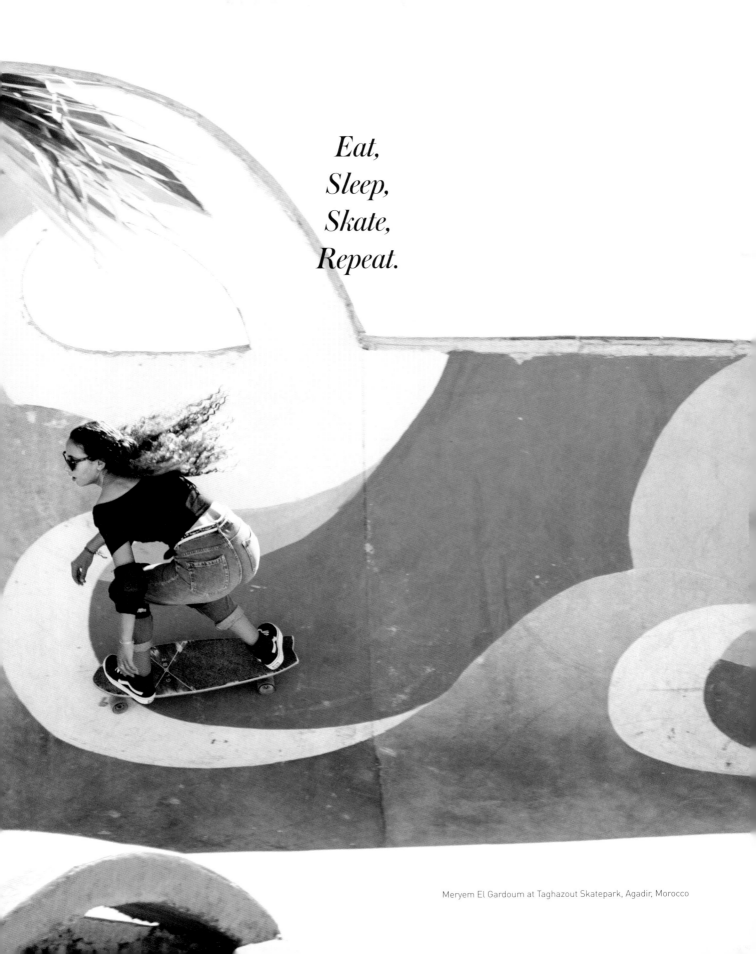

Eat,
Sleep,
Skate,
Repeat.

Meryem El Gardoum at Taghazout Skatepark, Agadir, Morocco

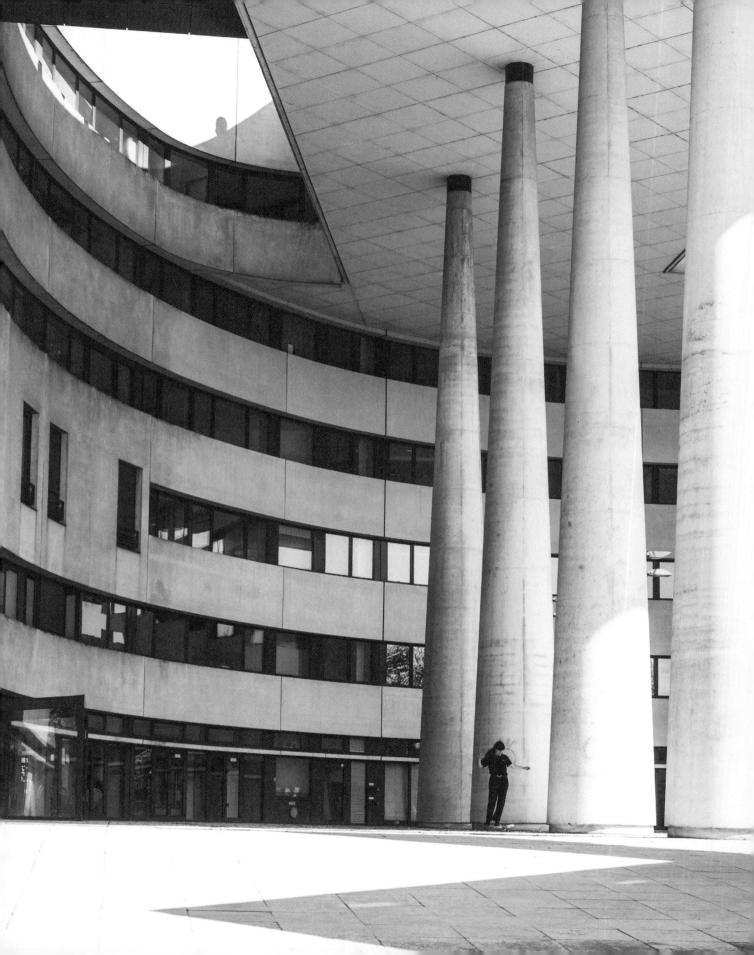

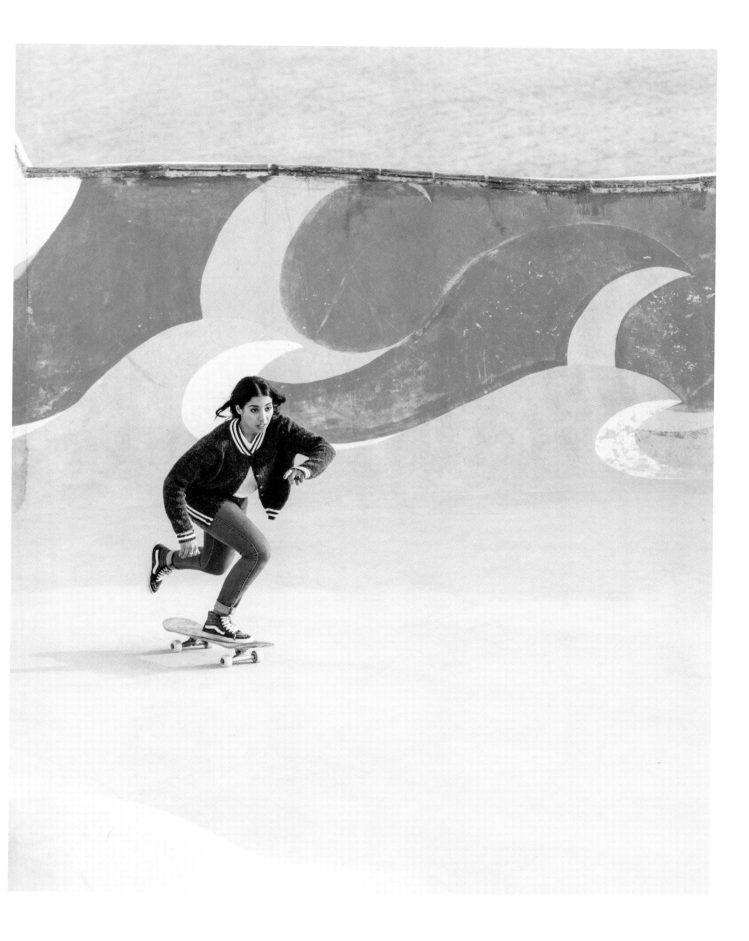

Magdalena Wosinska

Skater and photographer

@themagdalenaexperience
@magdawosinskastudio

I grew up in Poland and moved to Arizona at the age of eight, in the early 1990s. I didn't speak English when I came here, so for the first few years I felt like an outsider. Then I found skateboarding. It became my comfort, and I found a family in it. At the age of fourteen I started shooting photos of all the kids I'd skate with, and from the minute I started taking pictures it became part of my life. I've felt the same way since. It's like breathing to me.

A few years ago, I was road tripping down the West Coast when I stopped at my friend Max Schaaf's place in Oakland to check out some motorcycles he was working on. In the corner of his garage I spotted a skateboard with a hand-painted male and female form on it, and underneath it said "UNITY." I asked Max where he'd got the board. He said that a few weeks earlier there had been fliers all over town promoting a queer skate day. It turned out that Jeffrey Cheung had started putting on events as part of a project called Unity, and that's where Max had got this board. These days, a lot of people know about Unity, but this was maybe a month after the get-togethers started. I was so excited to

learn more, so I asked Max who I could get in touch with to possibly document this crew in its early stages. So Max put me in touch with Mae Ross.

I reached out to Mae as I was heading back down the coast and asked if she and her friends had any plans to come to LA to skate. A few weeks later Mae came down to LA with Cher Strauberry. I picked them up in my 1969 Chevelle and we went and skated the Home Depot parking lot. Afterwards, we got tacos and talked about life, the world, how people see us. Cher's story, as one of the few trans girls at the park in the mid-2010s, resonated with me. I learned a lot that day from Mae and Cher and wanted to have their stories be seen, so I asked if I could come up and visit one day and shoot some stuff. I finally made it up to Oakland in July 2017 with my friend Dan Dealy, who filmed a twelve-minute mini documentary about Cher and her life. The few days I spent with her, seeing her transition and what she was doing in life with art, music, and skating, were inspiring. I'm so grateful to be able to make projects where I learn so much and can inspire others by giving a visual of what people are living, and just to be able to create and collaborate.

Mae Ross and Cher Strauberry in Oakland, California, USA

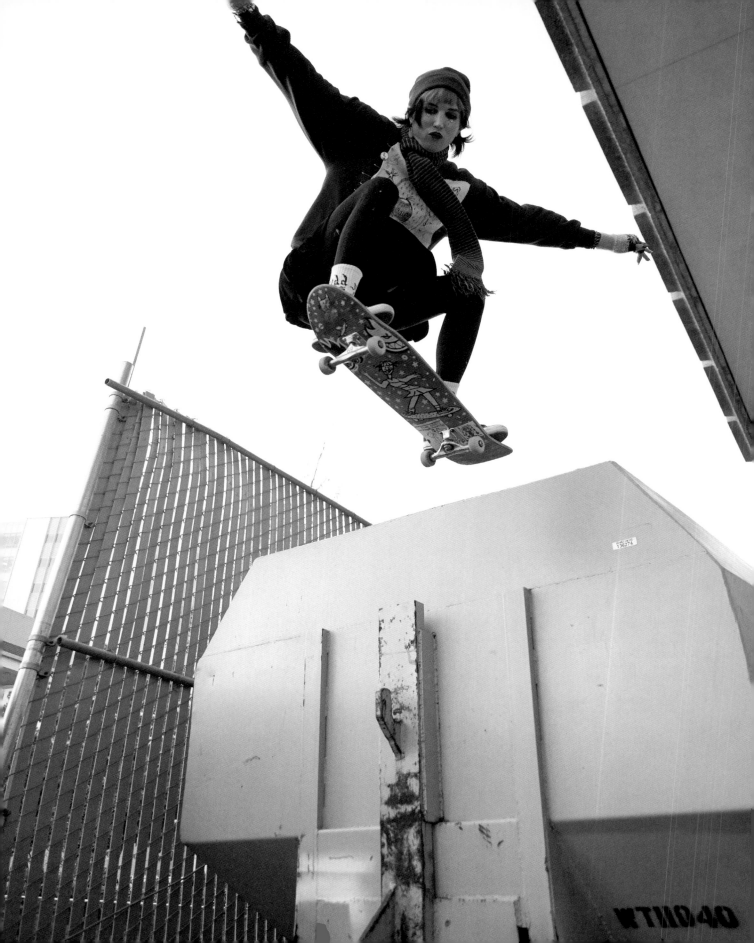

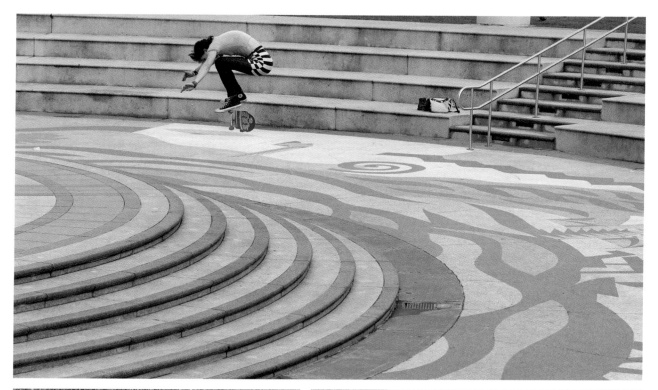

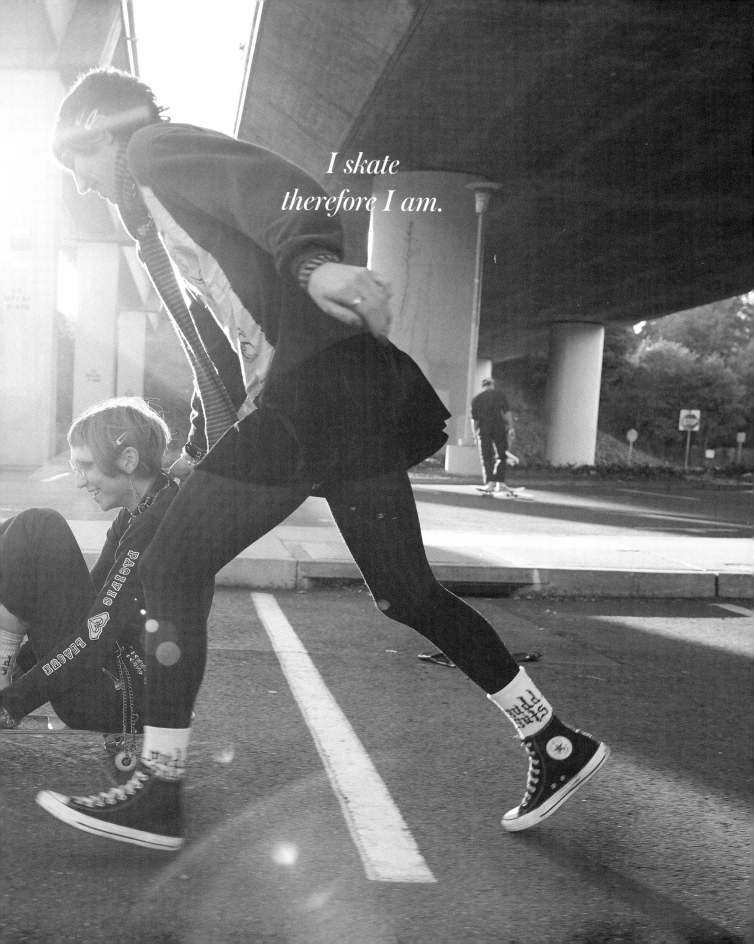

I skate
therefore I am.

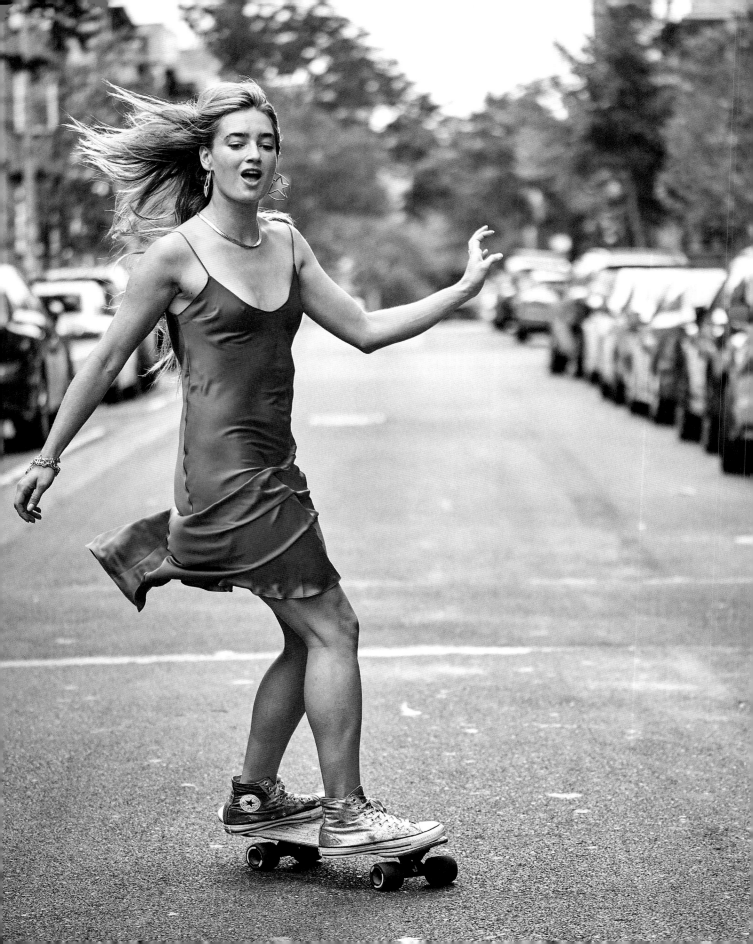

Sierra Quitiquit

Professional freeskier

@sierra

I'm originally from Park City, Utah. I started ski racing when I was four or five years old and went on to become a professional freeskier, but there was always something magical about skateboarding—it brings you into the present moment. To me it's a dance and it's about flow. Skateboarding gives me freedom—to play, to explore, to adventure and see where life takes me.

Sports gave me a sense of strength and purpose as a young girl. As a ski racer I learned to work hard and to manage the emotions of fear and competition, and ultimately I drew a deep confidence from knowing that my body was strong and capable. When I started to model as a teenager my confidence wavered. Suddenly I was looking at my body through the lens of completely unrealistic media standards. I couldn't even live up to the standards of my own photoshopped images. Flying from city to city to work, I felt like a mountain girl lost in the concrete jungle. Until I found skateboarding. Skating brought those cities alive—suddenly I was able to explore, cover new ground, and challenge myself athletically.

Skateboarding reminded me that my body is not merely a hanger but a powerful tool capable of incredible feats and abundant joy through movement and play. I hope that when I'm an old lady I'll still be skating the streets, laughing and hooting with joy.

Right now there's nothing more important than protecting our planet. Mother Nature has given everything to us. It's time to give back to her. I'm the founder of the nonprofit Plastic Free Fridays and also an ambassador for Protect Our Winters. This is a special moment in history right now. We all have the opportunity to make a difference in this world, and there's no greater joy than giving back to the planet that gives us life.

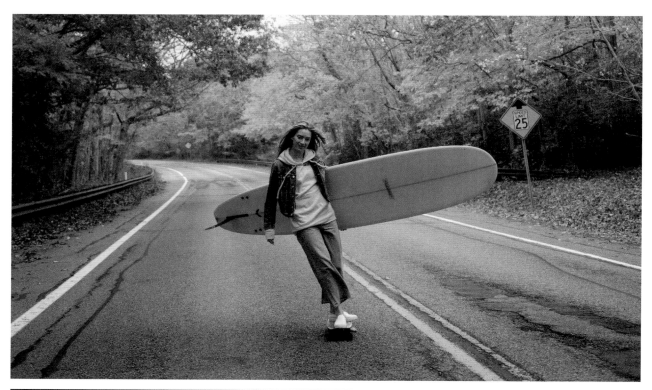

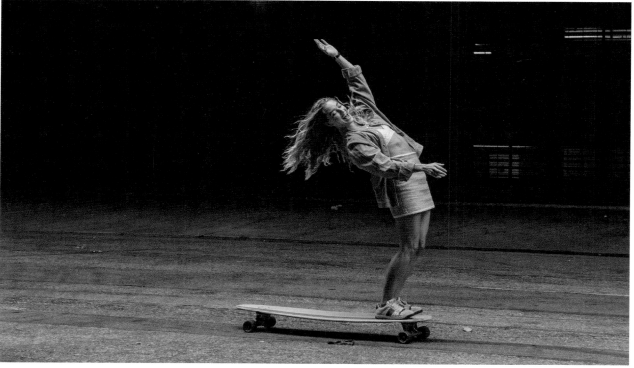

△△ Montauk, New York △ New York City ▷ New York City | USA

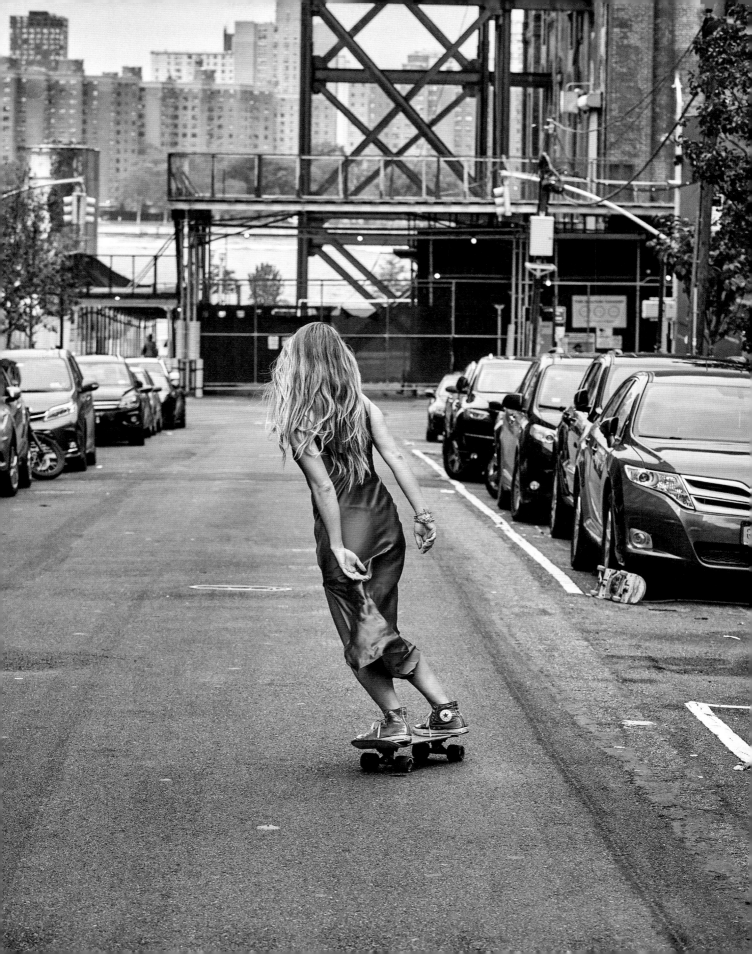

Sandy Alibo
Skate Gal Club founder

@rooky_rider
@surfghana

Almost four years after the launch of our sport collective Surf Ghana, I noticed that at all our events, 95 percent of attendees were men. As a female entrepreneur, I started researching, trying to understand why it was so difficult to rally women around skateboarding activities. That's how I discovered the many successful initiatives in both the US and Europe that encourage women-only sessions.

With my best friend, Kuukua Eshun, an amazing filmmaker and mental health advocate, we decided to launch the Skate Gal Club. Through this initiative we want to inspire, educate, support, encourage, and empower; to give women a voice and defy stereotypes through sports. We're determined to provide a support system that doesn't already exist in Ghana, and, most importantly, create a safe network for women of all backgrounds, sizes, and colors..

The main goal is to connect creative women and improve their wellbeing. Access to the club is free, and the organization offers skateboarding lessons as well as creative workshops (tie-dyeing, watercolor painting, gardening, nail art) and activities like yoga, hula-hooping, and Soul Sister

Circle. We now count more than sixty active members who come regularly to our monthly meetups. We've received so much support for and positive feedback about our initiative.

The number of attendees at the Skate Gal Club continues to increase, which proves how necessary women-only spaces are. They provide an opportunity for women to talk—whether it's about skateboarding, mixology, fashion, or domestic violence—in a safe space. We aren't attempting to change Ghanaians' minds about feminism; we're creating a space where all women can talk about whatever it is they're most passionate about, without fear of being mocked or judged. Where they don't feel threatened, hit on, talked over, or mansplained to. Where they can learn from each other, feel positive, and be inspired. We hope with this project that we can enable more equal representation of women and men.

Through engagement with extreme sports, women are able to practice being open and authentically themselves. We hope that we can help give women the courage to feel more comfortable in Ghana—knowing that a Skate Gal Club is here and that we've got their back.

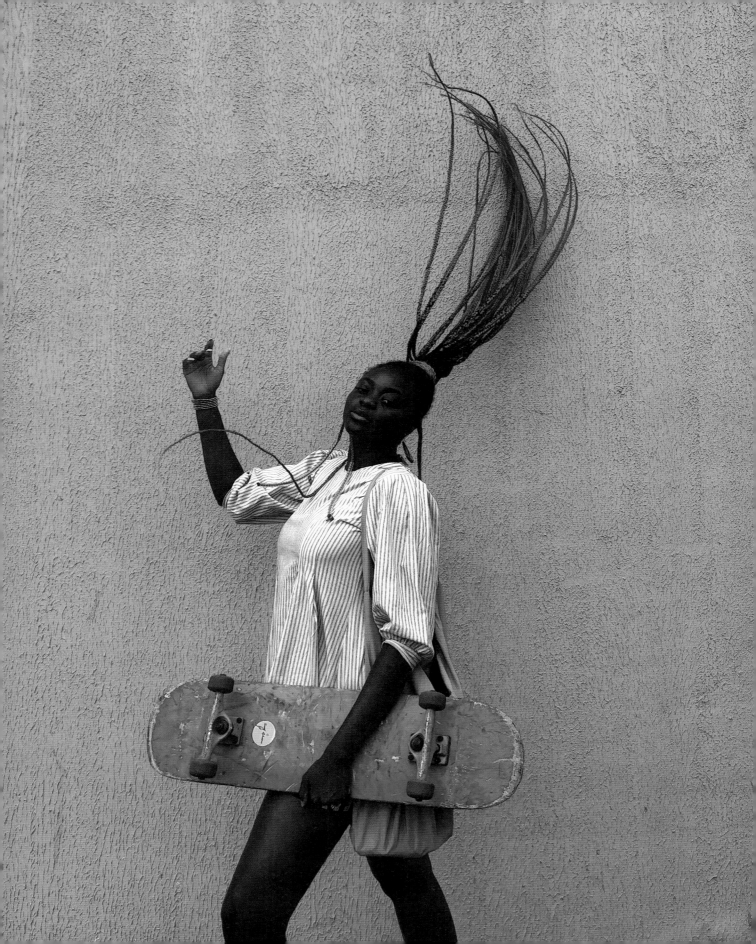

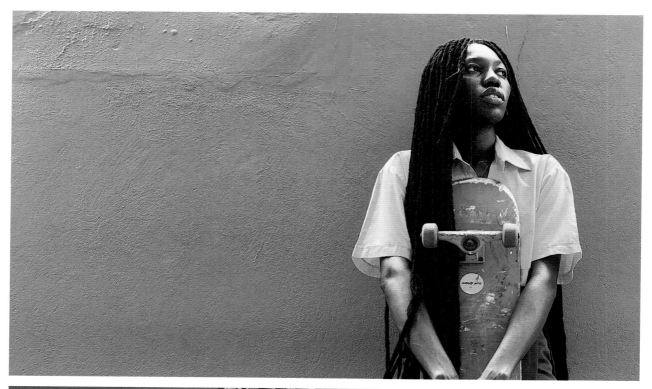

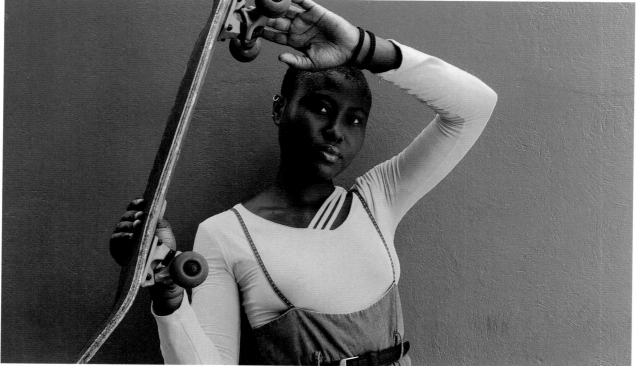

178

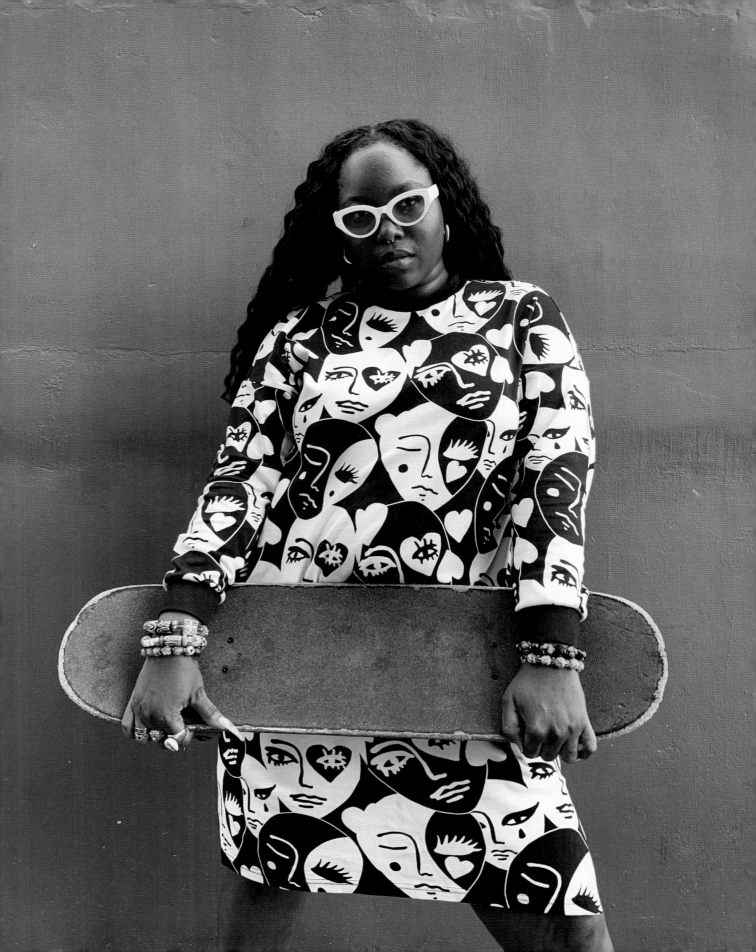

*My board takes me
where I want to go.*

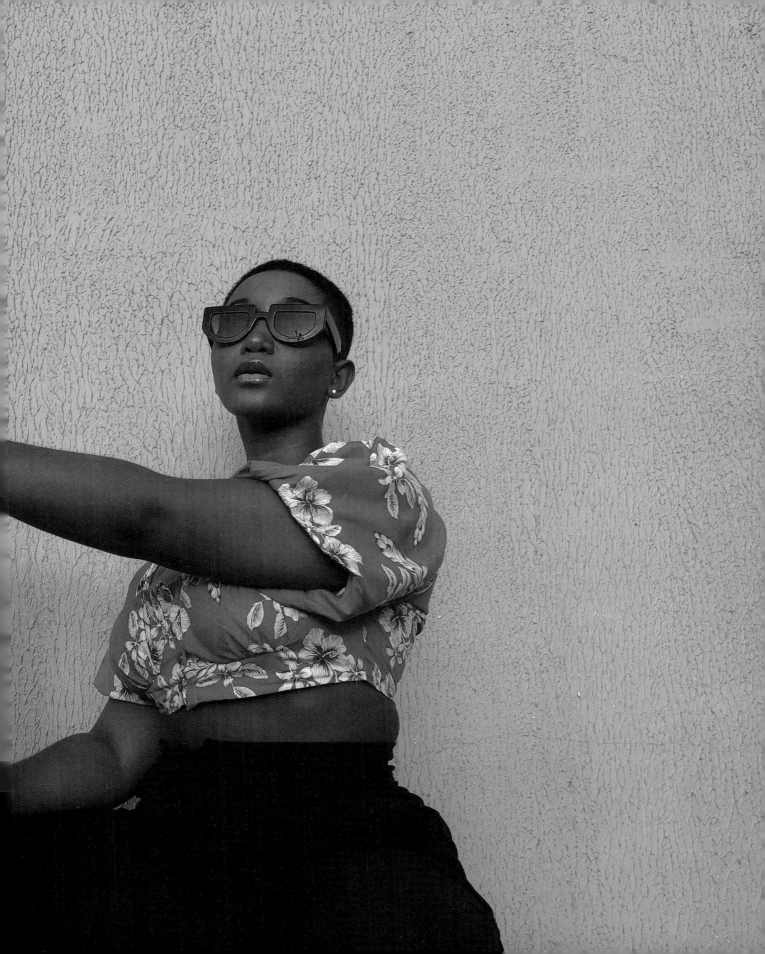

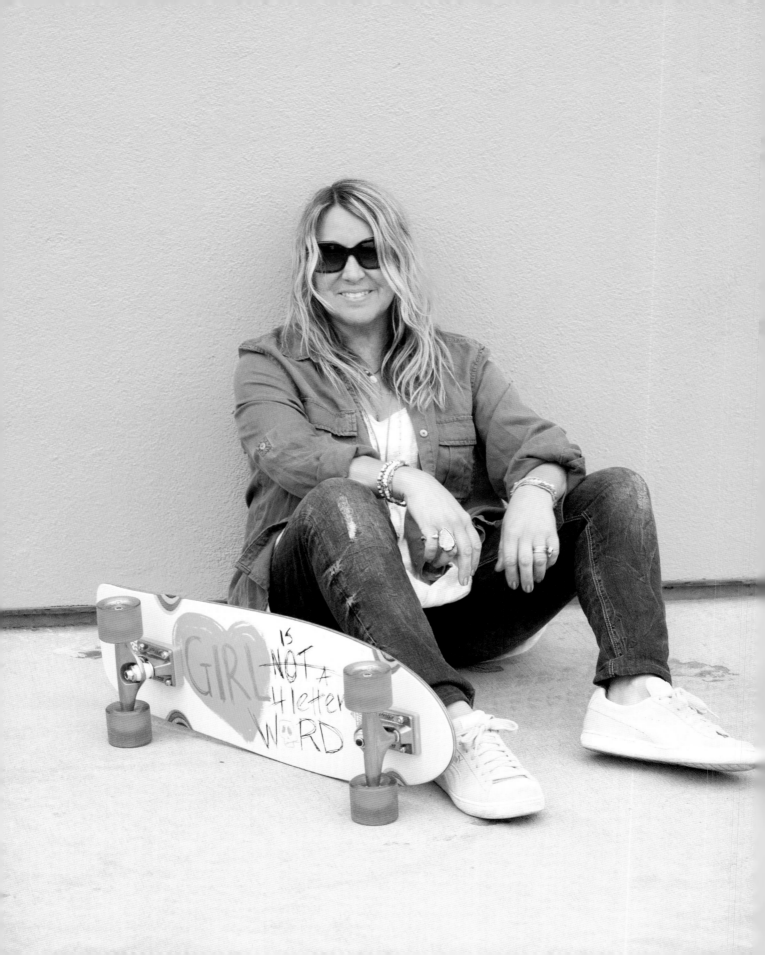

Cindy Whitehead

1970s pro skateboarder

@girlisnota4letterword

We all have our own specific journey in life. For me, skateboarding at a young age influenced me greatly. It taught me to be outspoken and to ask for what I want. It showed me that falling doesn't mean you stay down—in order to ride you have to get back up—and it taught me that everyone is different, so don't imitate. You create your own style, one that's uniquely yours.

I grew up in the small, sleepy beach town of Hermosa Beach, in Southern California. I rode my first skateboard with clay wheels when I was about eight years old. When I was nine, my mom, brother, and I left Hermosa to travel in a Volkswagen camper van through Mexico and Guatemala for a year. I learned to surf on the beaches near Mazatlán. And I learned that being a green-eyed, blonde kid in Mexico was not the norm—so I became used to being "different" and being okay with that.

I started skateboarding seriously in the mid-1970s, first on the streets and on the strand by the pier in Hermosa. Eventually, a skate park opened up nearby, and I spent every waking minute in the half-pipe there. I loved the feeling of skating up and down the huge vertical walls and seeing how far out of the pipe my board and wheels could get.

Sometimes I'd overhear comments from male skaters or people watching—some positive, and some wondering out loud why a fifteen-year-old girl was skateboarding hard like the boys surrounding her. I wanted to be free in my own head, so I got a pair of headphones, duct-taped them to my helmet, and flooded my ears with music so I could stay in my own little world while I skated.

I turned pro while still in my teens and traveled the USA for skateboarding. It was a magical time, skating every day, staying in hotels with my skate friends and very little supervision. I learned to be outspoken and stand up for myself, and not to ask for permission or wait for an invitation: if I wanted to drop into a pool, I would do what the boys around me did—I just did it. Skateboarding and the people in it shaped my life and helped me become the person I am today, and I'm so thankful for that.

Fast-forward to many years later, and here I am still on a skateboard. People often ask me why I'm still doing it. Skateboarding is in my soul. It's freedom. It allows me to be creative and expressive, and it always clears my head. I like the rush of it, and I hate to admit it but sometimes I even like the feeling of slamming hard, as it makes me feel I've done something challenging and am alive and living life to the fullest.

Now I have a movement, Girl is NOT a 4 Letter Word, that supports female skaters visually through our website and social media so people can see that girls skate too. We use funds from our collaborative products to help girls in skate to train and get to contests, and to create more media about girls skateboarding—we've even put up billboards in Times Square, New York, to draw attention to it. Because when a girl sees another woman or girl skateboarding, she knows that she can too. And in that way, we keep inspiring and spreading the stoke to the next generation. Skateboarding has always been about "family," and now, with more and more girls getting on a board, it's also a sisterhood of sorts.

△ Los Angeles ▷ The Broad, Los Angeles | California, USA

It's hard to be the only girl at the skate park, but who knows? There may be a girl watching you from the sidelines who's now been inspired to skate too.

CINDY WHITEHEAD

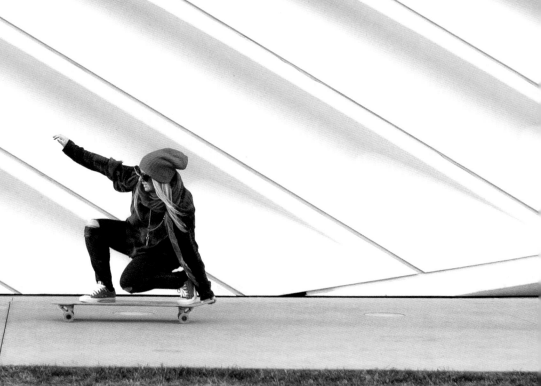

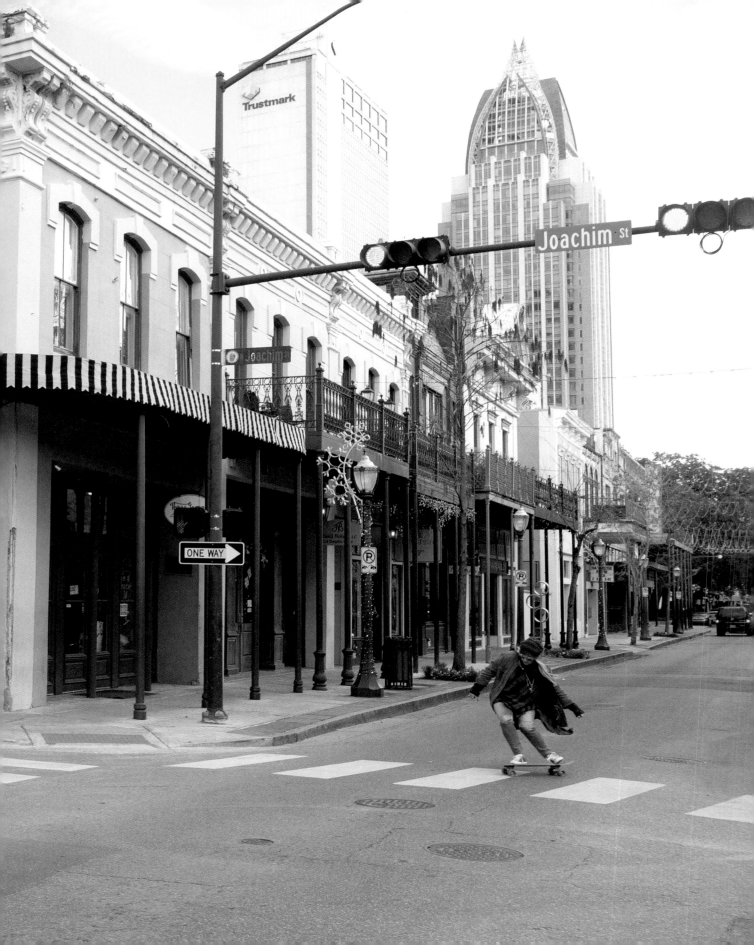

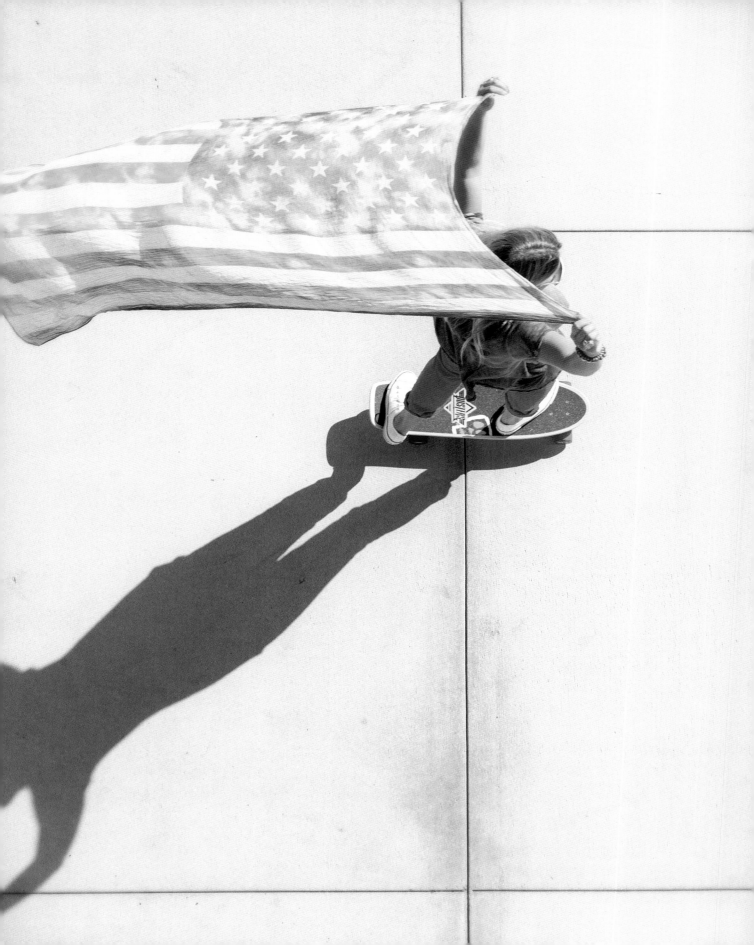

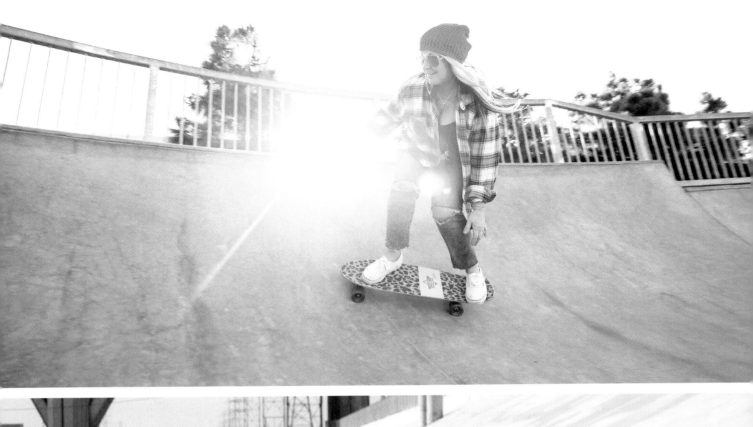
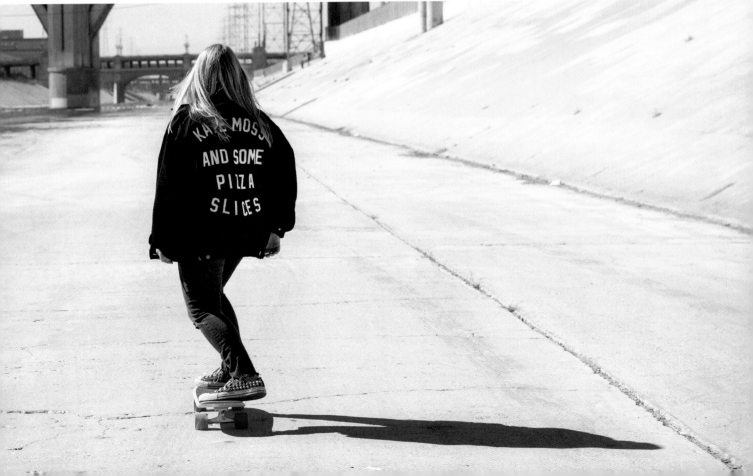

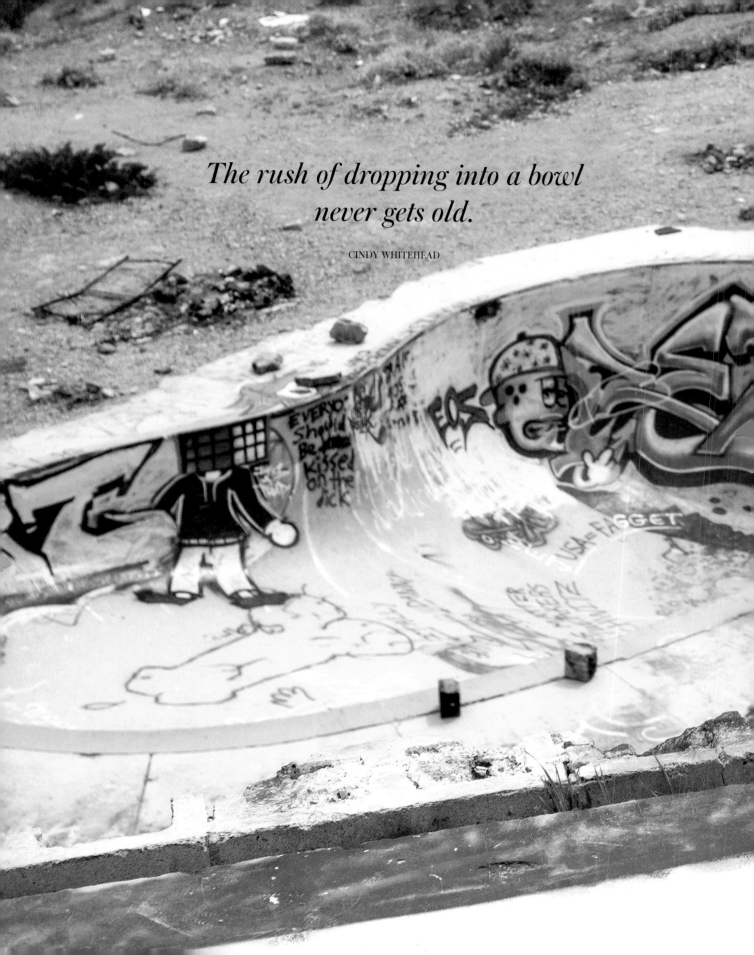

*The rush of dropping into a bowl
never gets old.*

CINDY WHITEHEAD

The Nude Bowl, Desert Hot Springs, California, USA

Lina Ruess

Professional longboarder

@lina_ruess

I've been crazy about sports all my life, and was always looking for the one that would fit me perfectly. Growing up in Moscow, I tried all sorts—soccer, table tennis, basketball—but my biggest love was volleyball. I spent a lot of time on the court and was quite successful, but unfortunately, due to my height (170 cm), I couldn't play professionally.

Later, I bought a Penny board, but I was still looking for something else. By chance, I went to a longboarding event in Moscow with one of my volleyball teammates. At the time, I didn't even realize it was possible to do tricks on those huge, heavy boards. After seeing those longboarders, I spent the whole winter practicing tricks in the same building where the event had been held. I didn't know whether I was any good, and I felt way too shy to compete, but it happened. And it turned out that I wasn't too bad at it. I thought, Maybe this is the thing I've been looking for.

This culture has changed my life completely. Today I long-board professionally, which means I travel a lot, and I've started doing skimboarding professionally as well. I also create videos (I direct and edit all my Instagram media myself), and I've established a longboard community in Russia called Skate and Chill. I also promote longboarding at big Russian festivals like KFC Battle through my event agency Maverick. I can't imagine what I'd be doing now if I hadn't gone to that longboarding event five years ago.

To those who've just started longboarding, I'd say: Skate more and keep putting the effort in. Just keep trying, and soon you'll find than you're way better than you were. And one more thing: it's easier to skate with a community—that way, you always have friends to support you and help you improve your skills.

Galle Fort, Sri Lanka

◁ Brussels, Belgium △ The Hague, Netherlands

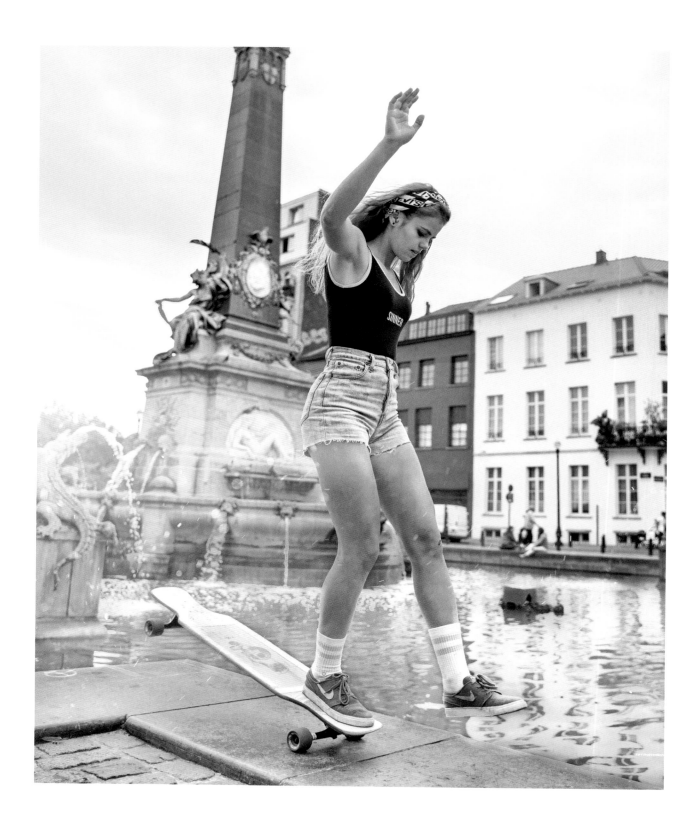

Brussels, Belgium

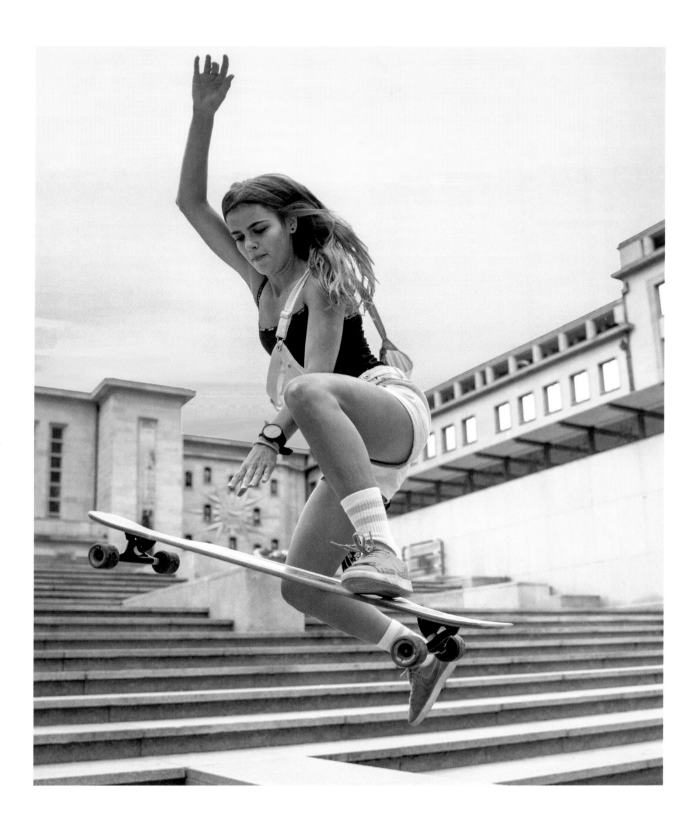

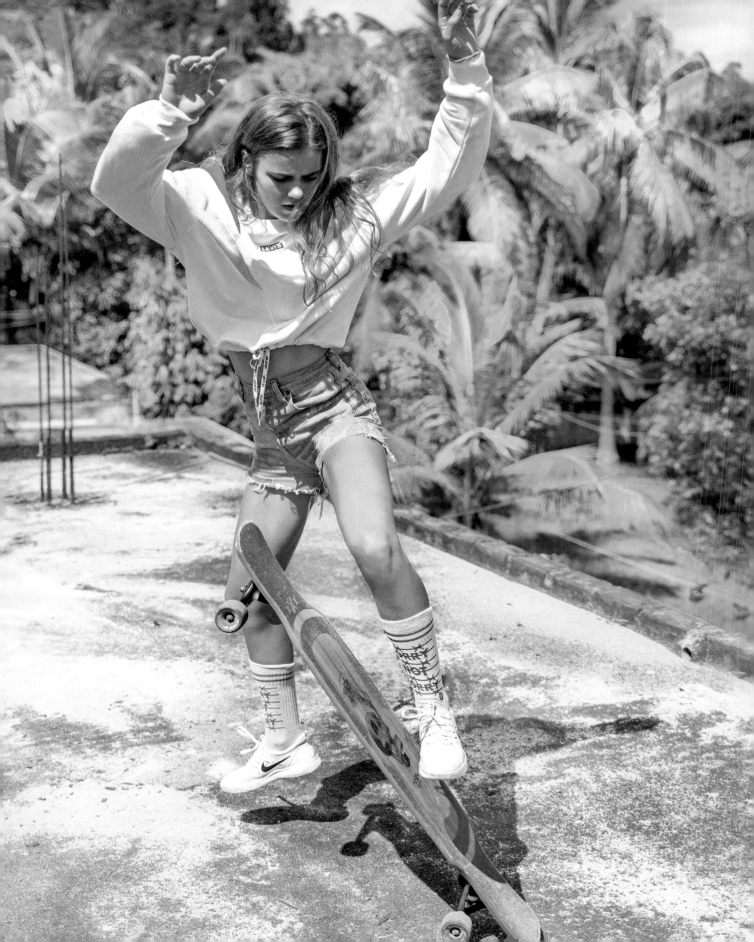

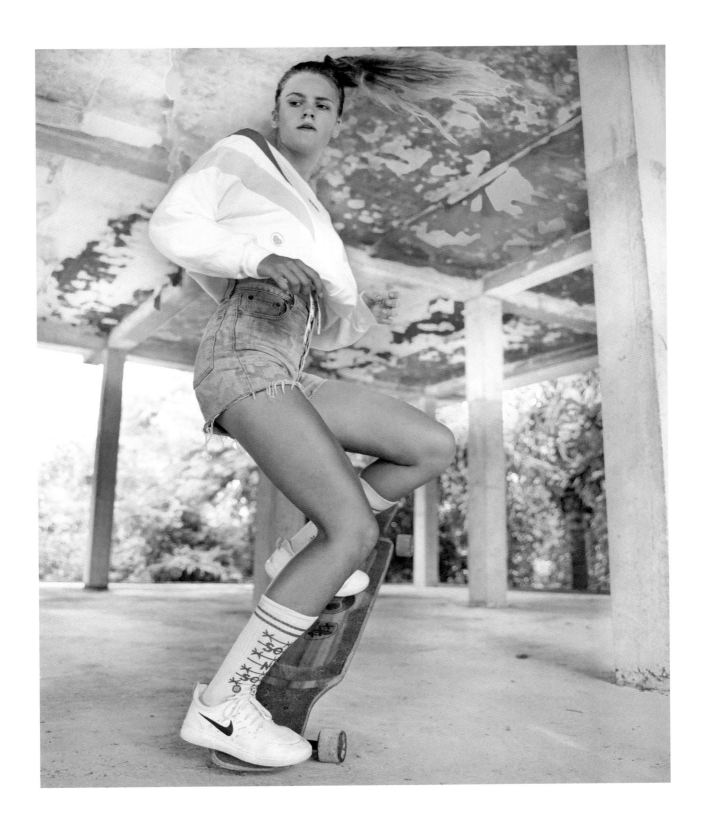

Mirissa, Sri Lanka

Chelsea Aaron

Family of seven

@chelsea.jean
@chelseajeanpresets

We're a family of seven living on the beautiful island of Maui, Hawaii. We take pride in our simple life, where we try to slow down and enjoy the little things, but we also love traveling, staying active, and getting creative. And our favorite way to get around is on a skateboard.

I've loved skateboarding since I was a little girl. I started dating my husband, Ryan, in high school, which is when I began skating on a daily basis—I was totally hooked! I didn't realize the impact it had made on my life until much later. We've been able to carry on our love of this sport through our children, who love it just as much as we do. Through my experiences on a skateboard I've learned to let go of fear and follow my dreams. It's also taught me to take risks, and it inspires us to lead our own path and be confident in all that we do. I want to instill my kids with the knowledge that they can achieve whatever they set their minds to.

I started photographing my family skateboarding around the globe. Word spread about our photos, first among friends and family, then beyond. We started to draw attention on social media, and that's when we began receiving interest from companies wanting to work with us. My passion for photography and skateboarding means we're now able to travel and see the world. We're constantly stepping out of our comfort zones, and we continue to challenge ourselves and take positive lessons from every experience.

▷ Keopuolani Skate Park, Maui, Hawaii, USA

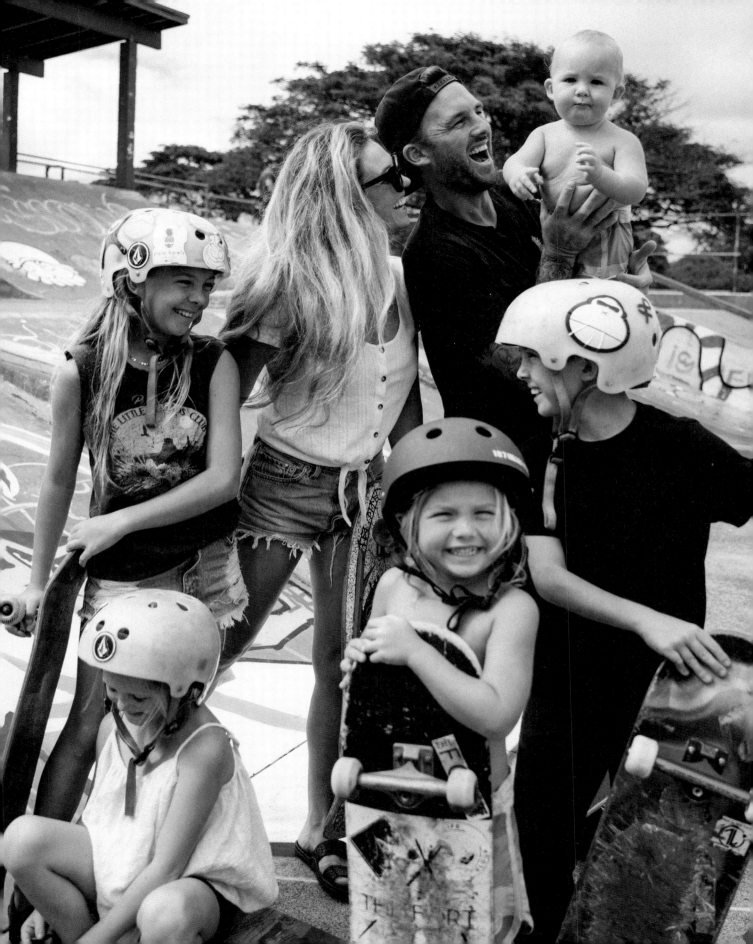

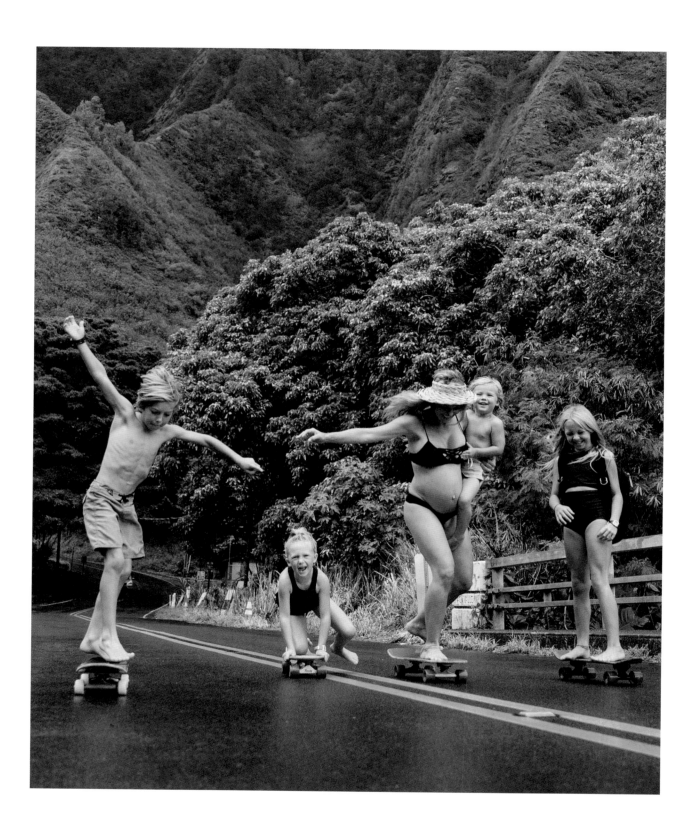

△ Iao Valley ▷▷ Lahaina Skate Park | Maui, Hawaii, USA

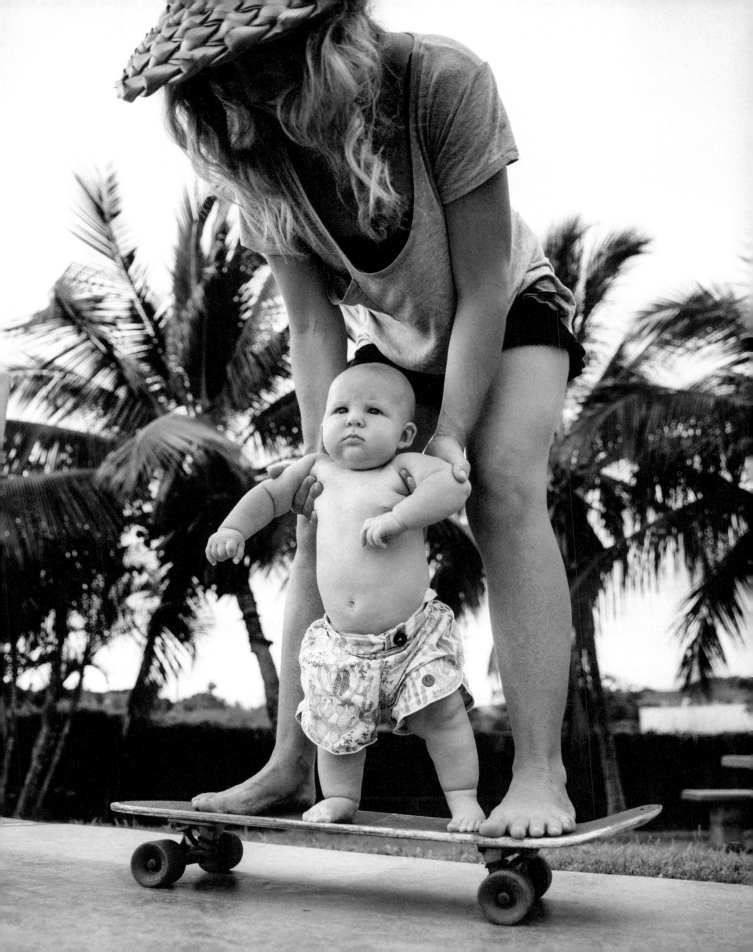

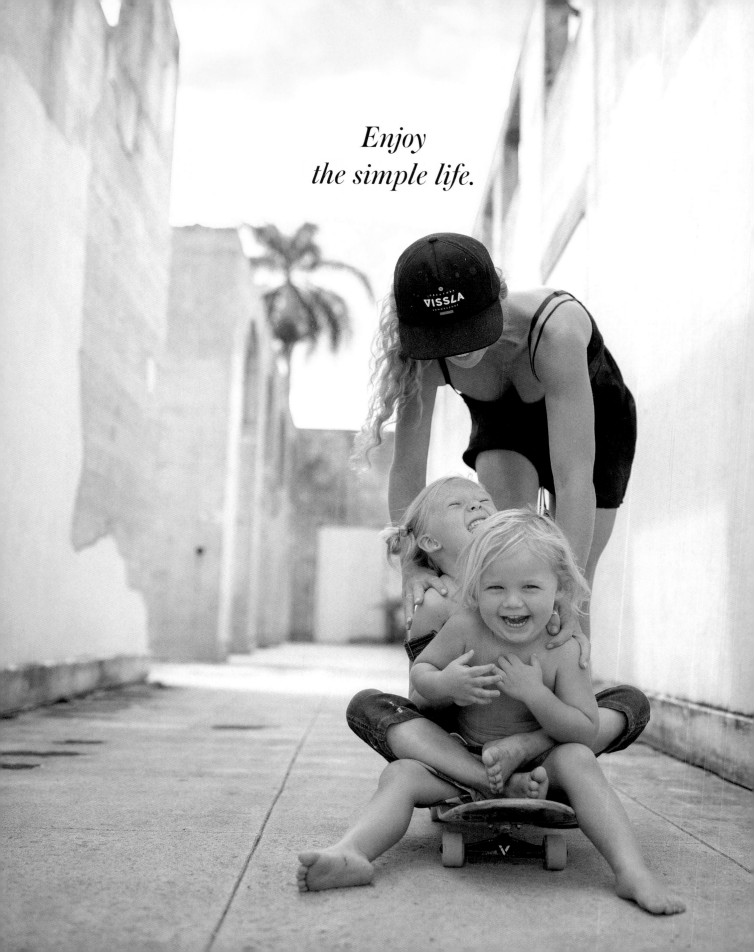

*Enjoy
the simple life.*

Carla Di Mambro

A mini California in France

@carladimambro

My name is Carla Di Mambro and I'm twenty-five years old. I was born in Paris, but two years ago I moved with my boyfriend to Hossegor in the Landes, on the southwest coast of France. It's our mini California.

I started skateboarding through my boyfriend. At first I spent most of my time just watching him skate, and taking pictures. I was reluctant to skate as I was worried about bothering people, so I'd wait until there was no one around before getting on my board. So my beginnings in skateboarding were quite complicated for various reasons: I was shy; I didn't want to impose on others; there were very few girls at the skate parks in the Paris area; I felt uncomfortable having all these masculine eyes on me; and I had the famous beginner's fear. Thankfully, I was determined to learn—because I loved it.

After moving to Hossegor my vision of skateboarding changed completely, thanks to the mentality of this region,

which values "the ride." My boyfriend also helped me to progress at my own pace—I want to thank him for being by my side. At the beginning he would say things like, "Come on, Carla, there are only two guys here, don't worry about them. I'm here. It's okay." And here I am today, having so much fun.

Now I can say that skateboarding has become a passion. All my apprehension and negativity about it is finally gone—after so long being "uptight," I've managed to let go! I love meeting girls who skate and I find it so encouraging to be with them; it's so helpful to have one another around when we get disheartened.

For girls who are hesitant to try skateboarding, ask your brother, sister, or friend to go with you to the skate park or the street. It's much more fun and reassuring when you're not alone. But the most important thing is to have fun—that's the basis for advancing in this sport.

Capbreton, France

208

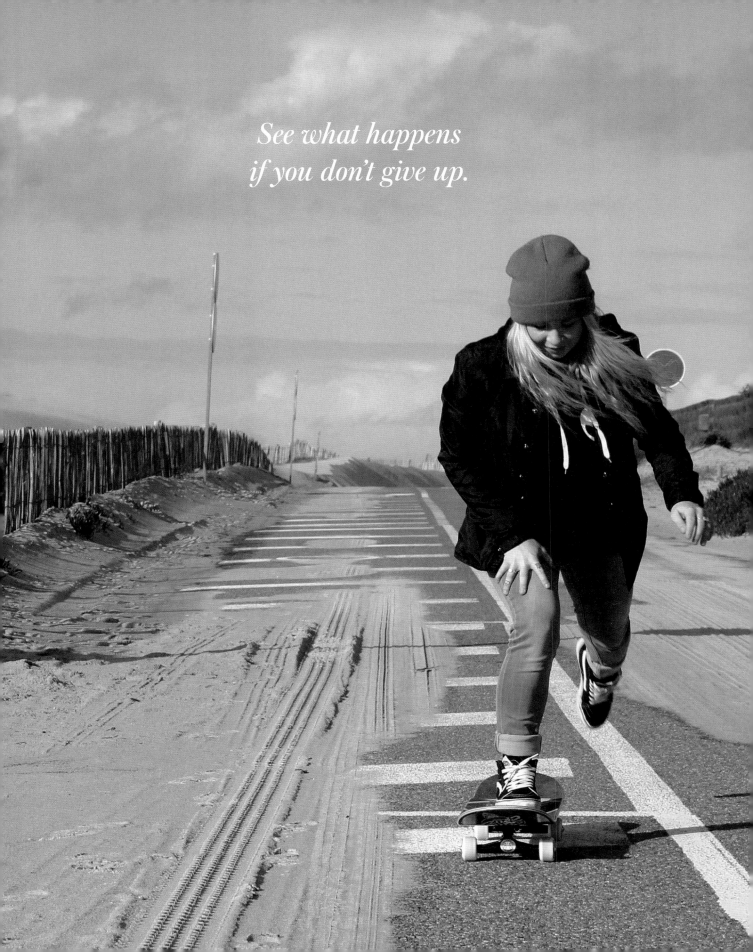

*See what happens
if you don't give up.*

Nyimas Bunga Cinta

Gold medalist

@nyimasbungacinta

I'm Nyimas, I'm from Indonesia, and I've loved skateboarding since I was eight years old. I'm so inspired by Tony Hawk—he has a huge house with cool cars and a skate park where you can spend your day skateboarding. My family doesn't even own our own house; we've always lived in a rented one. So my dream is to succeed with my skateboarding and be able to buy a house and car. The road to my dream seems wide open in front of me.

One of my favorite skater girls is Lizzie Armanto. She's so humble and down-to-earth. My father and I have a favorite phrase: "Skate with attitude." So we sometimes put #skatetitude and #sk80ttude on my Instagram posts. I ride for Vans Global—I was the first Indonesian skater to be picked by them directly, when I was attending the 2019 VPS World Championships in Salt Lake City, Utah. And a few months ago, on 17 August 2019—the same day as Indonesia's independence day—I won a gold medal at the VPS Asia Regionals in Singapore.

Amplitude skate park, Kerobokan, Bali, Indonesia

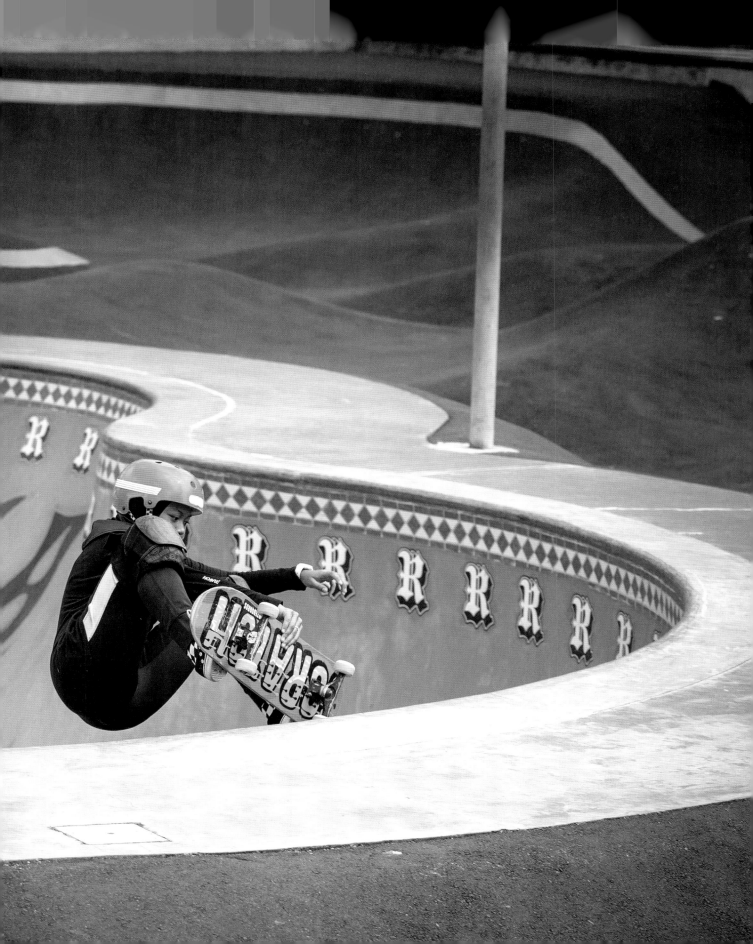

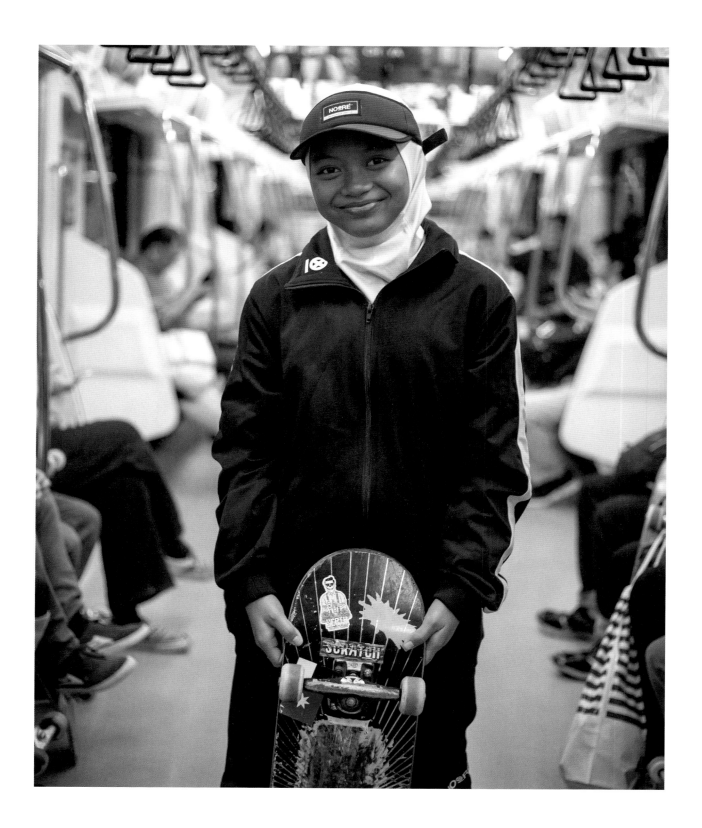

△ Japan ▷ BSD Xtreme Park, Tangerang, Java, Indonesia

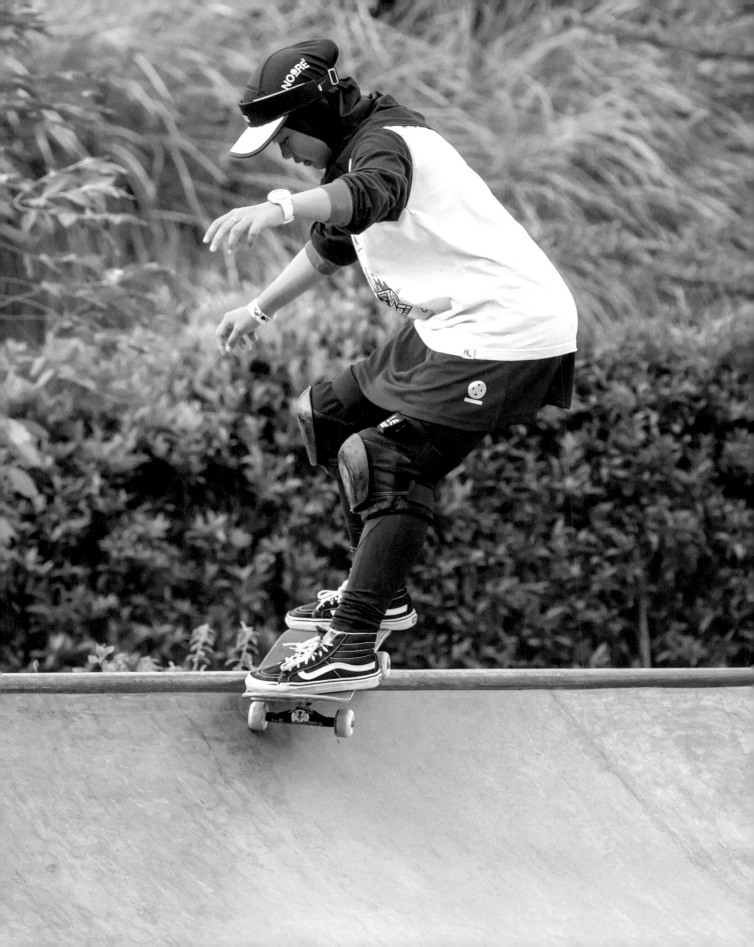

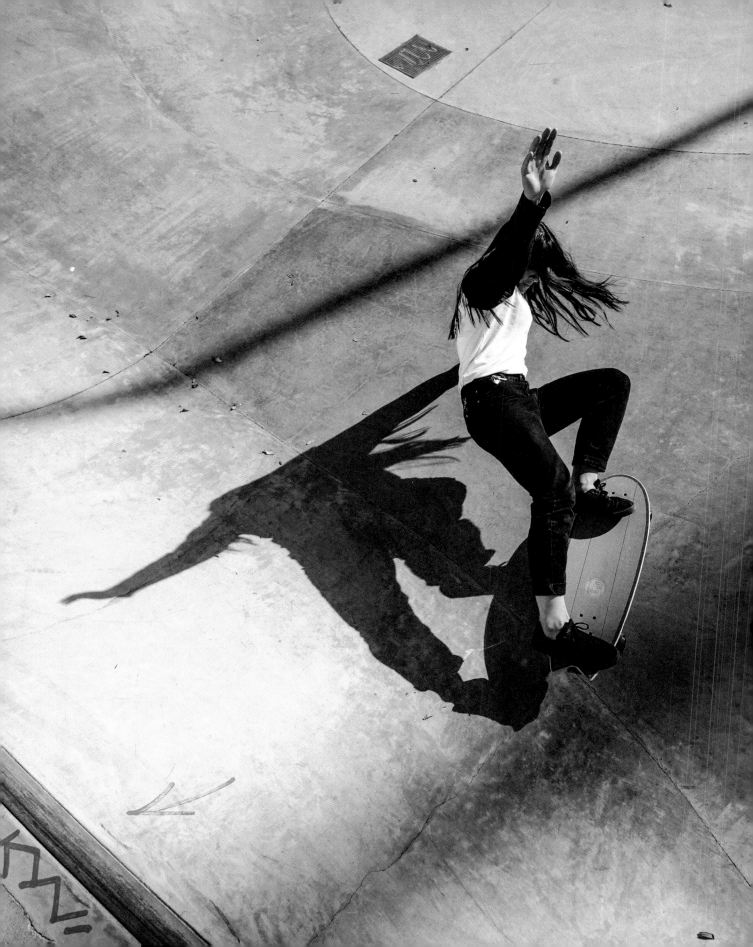

Marta Guillén
Photographer and traveler

@martagdiaz

My name is Marta Guillén and I'm thirty-two years old.
I grew up in the small town of Tarragona in northeastern
Spain, but from a young age I'd always wanted to live in Bar-
celona. I moved there to study film, and it was in Barcelona
that I met the woman who is now my wife. I got my taste for
skateboarding and surfing from her—I'd always been attracted
to skateboarding culture but I hadn't really gotten into it,
I guess because I didn't know anyone to skate with.

Skateboarding has offered me a different way of seeing life,
and of living it. It's taken me around the world and given me
the opportunity to meet wonderful people, people who have
taught me a lot and have passed on their values. Skate-
boarding and travel have helped me be more able to cope
with difficult days or times in my life, and to overcome my
insecurities and fears.

I love to travel whenever I can, seeking out remote and unique
places. There's nothing better than having the memory of that
moment, that place, and the unique smells, sounds, and
light that each landscape offers.

Eider Walls in Baró de Viver skate park, Barcelona, Spain 215

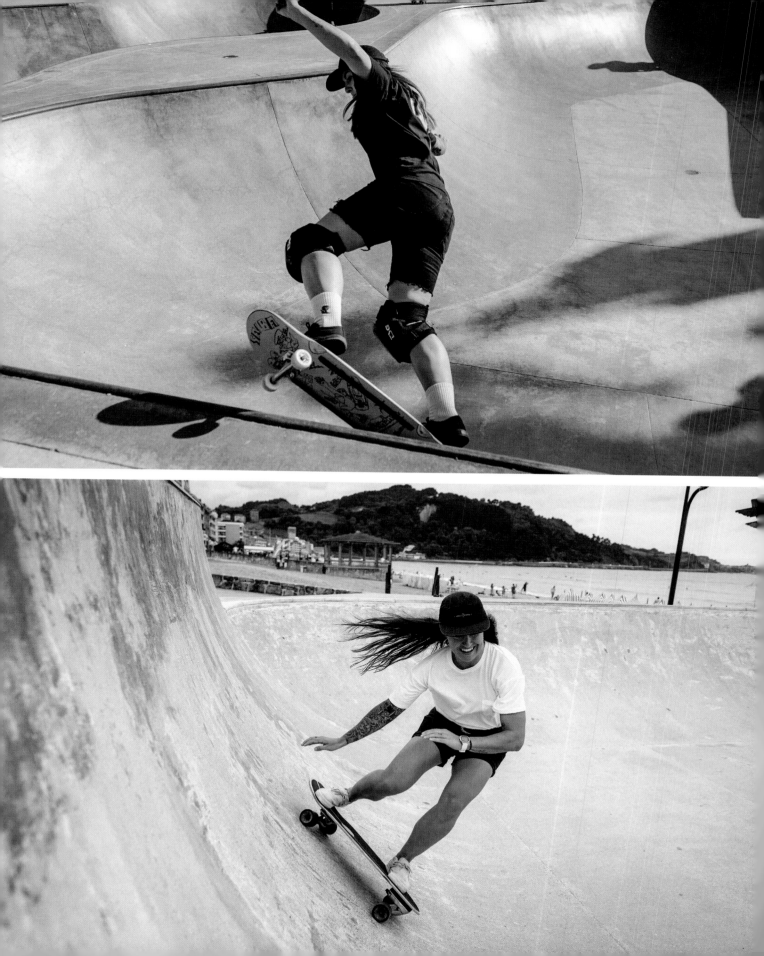

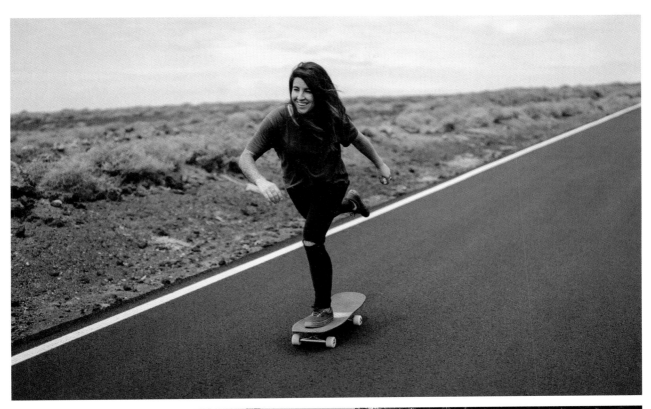

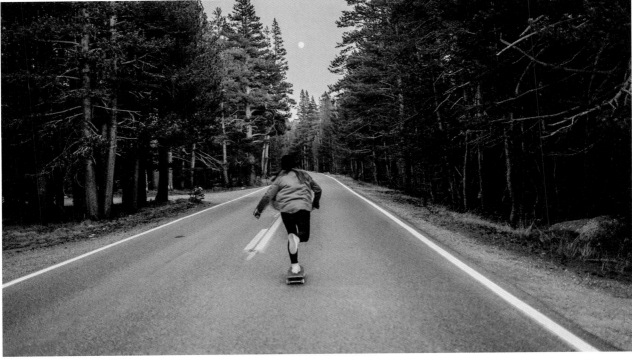

◁△ Eider Walls in Venice Beach, California, USA △△ Eider Walls in Gran Canaria, Spain

◁ Eider Walls at Zarautz skate park, País Vasco, Spain △ Eider Walls in Sequoia National Park, California, USA

217

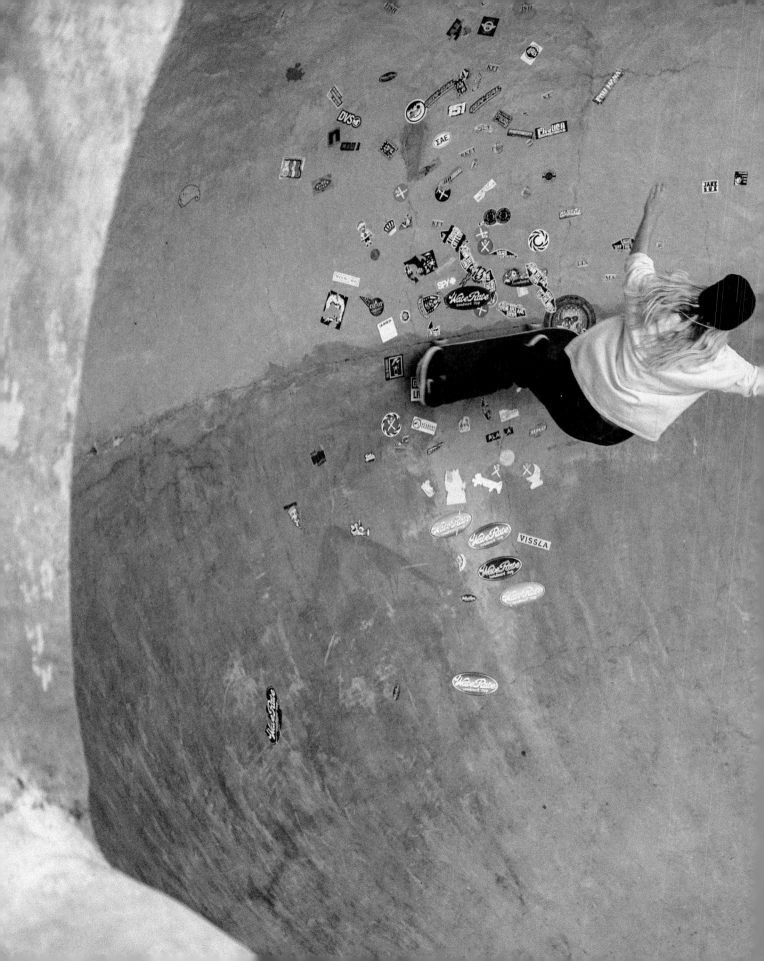

Don't just admire others for what they can do—celebrate yourself.

MARTA GUILLÉN

Cristina Mandarina at Volcom Brothers Skate Park, Mammoth Lakes, California, USA

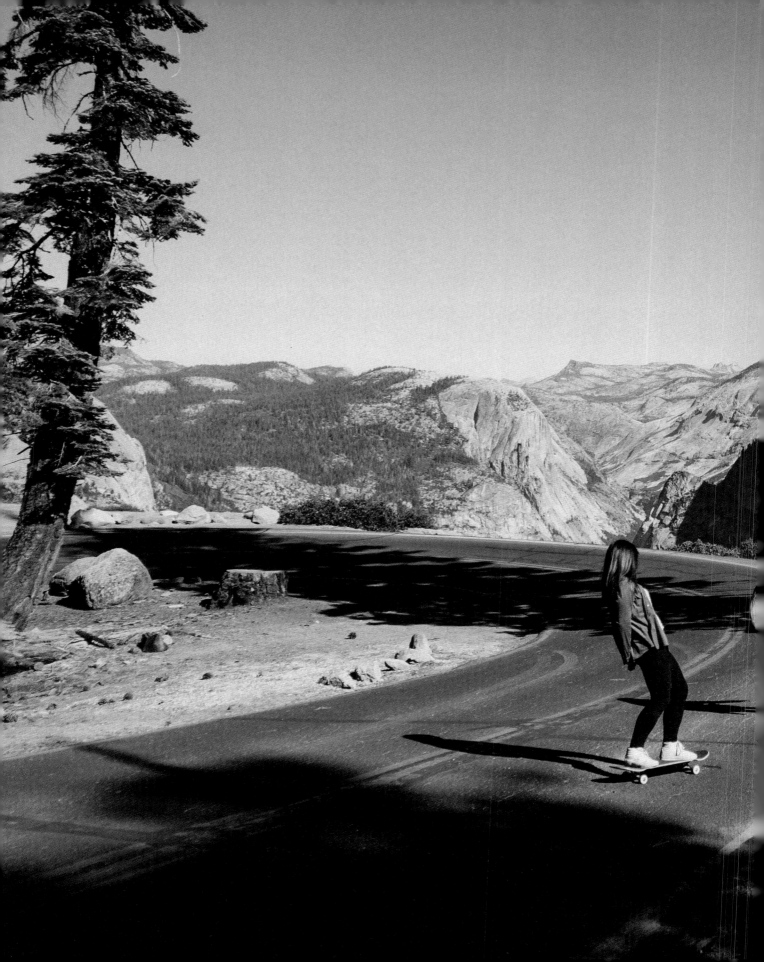

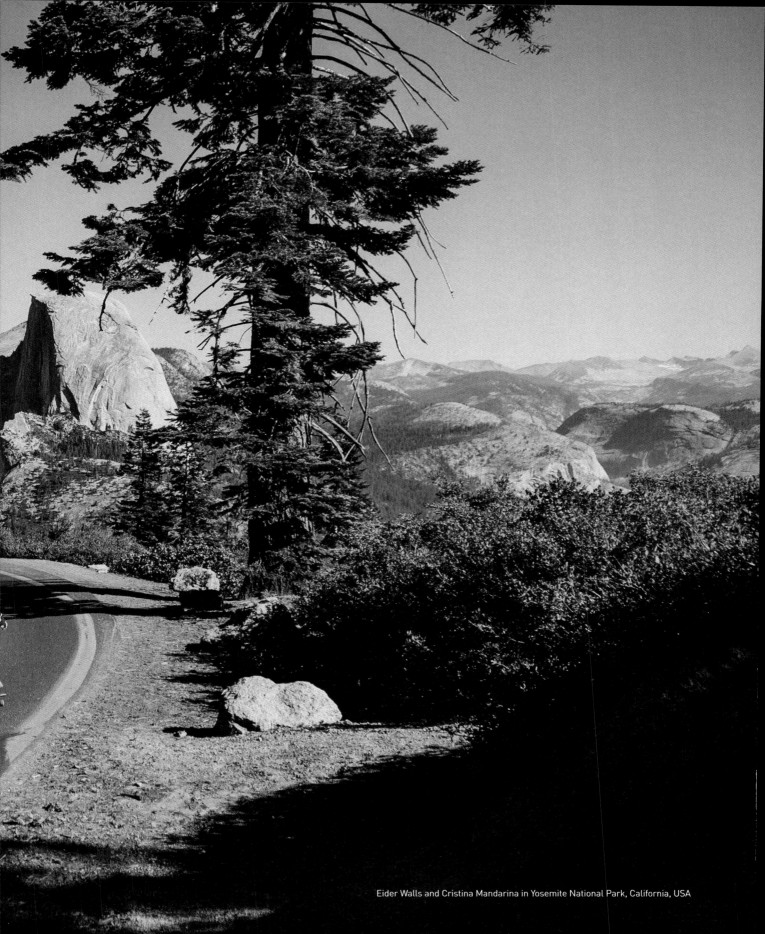

Eider Walls and Cristina Mandarina in Yosemite National Park, California, USA

Kamali

Ten-year-old skater

@kamaliskater
kamali-film.com

I'm Kamali, a mermaid who skates and surfs. I do everything I do for the fun and joy it brings me. I live in Mamallapuram, a beautiful town by the sea in Tamil Nadu, India. It's famous for its cultural monuments, especially stone-carved architecture, including the Shore Temple, the five rathas (shrines in the shape of chariots), Krishna's Butterball (a gigantic boulder), and India's oldest lighthouse.

We're lucky that we have a small skate park in our village, but we would love a new, bigger one. Right now, I'm the only girl who skates there, but we hope more girls will come and learn to skate. Many parents are afraid to let their daughters skate—I'm really lucky that my mother allows me to follow my dreams and do what I love.

My message for other girls is: Please don't be scared, just try it. Girls can skate, girls can be free, girls can be equal to boys.

Mamallapuram Beach, Tamil Nadu, India

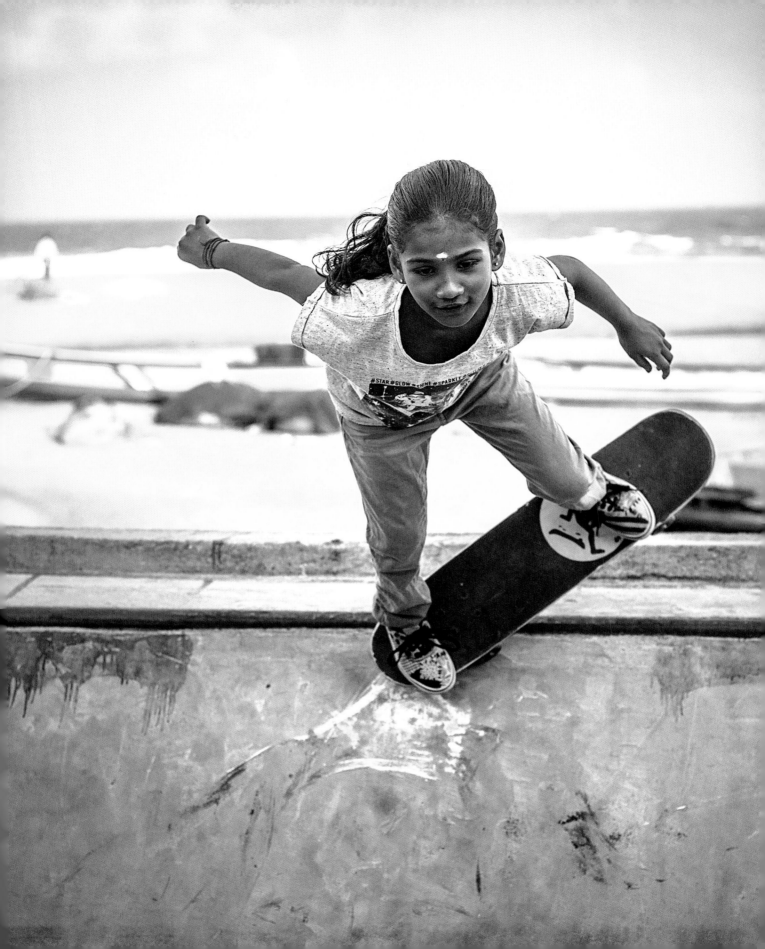

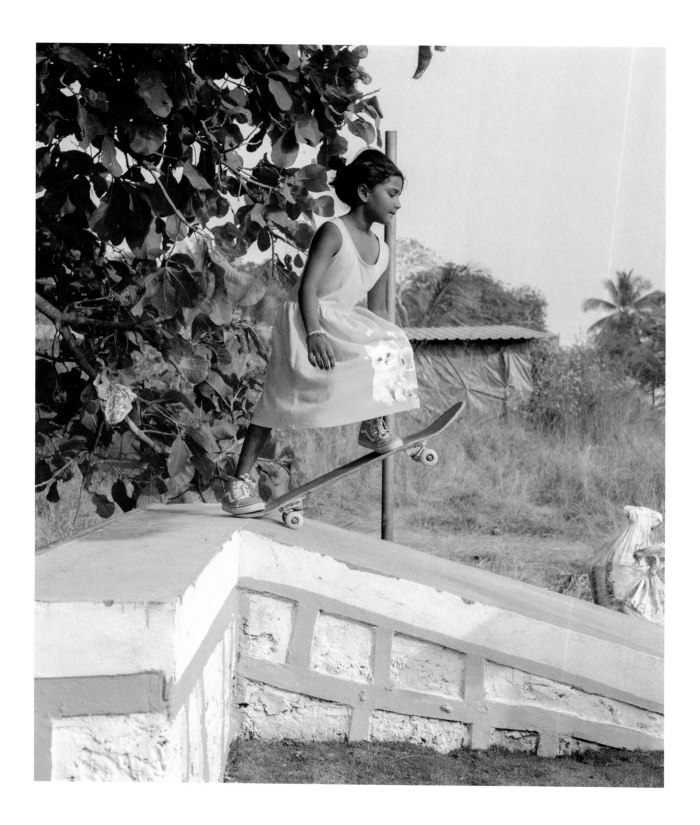

△ EscoBar, Assagao, Goa ▷ Mamallapuram Beach, Tamil Nadu | India

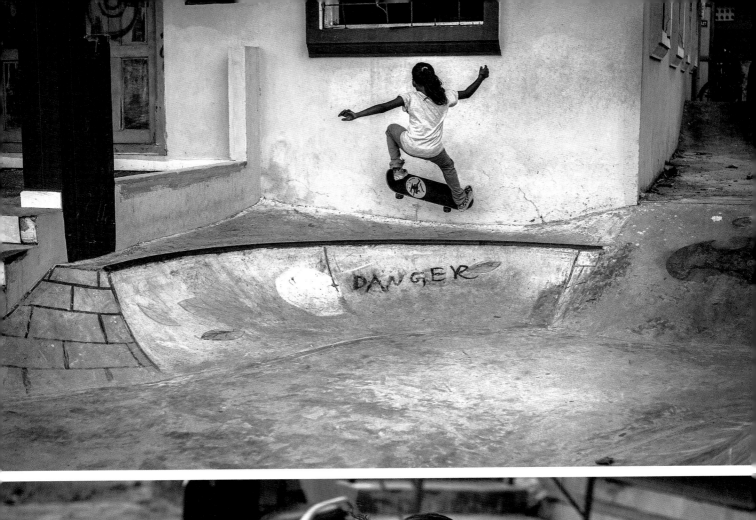
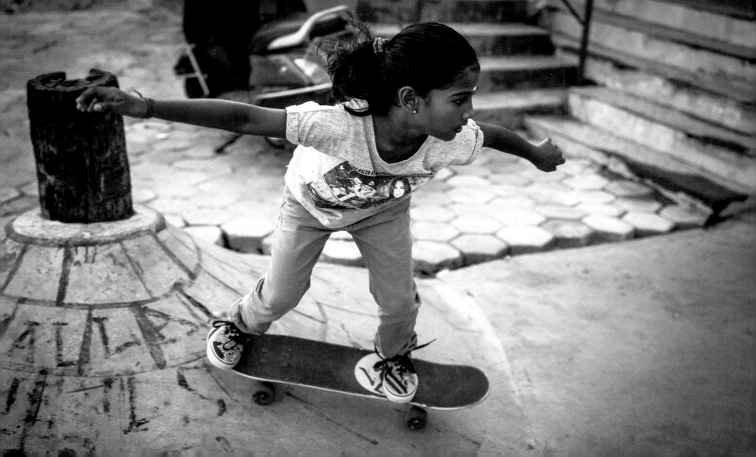

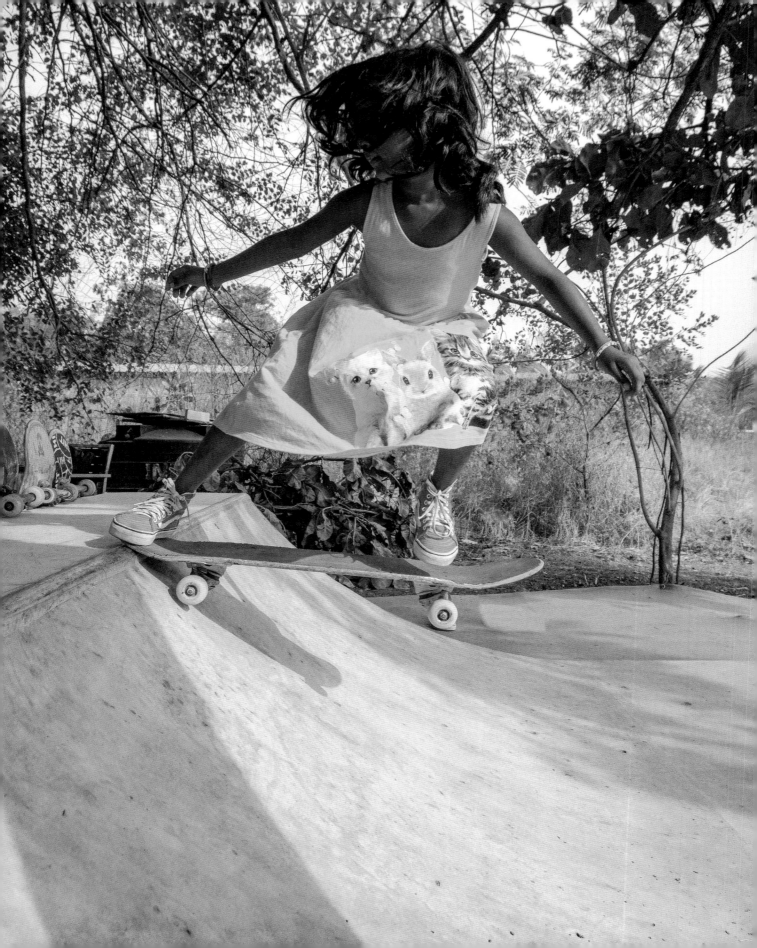

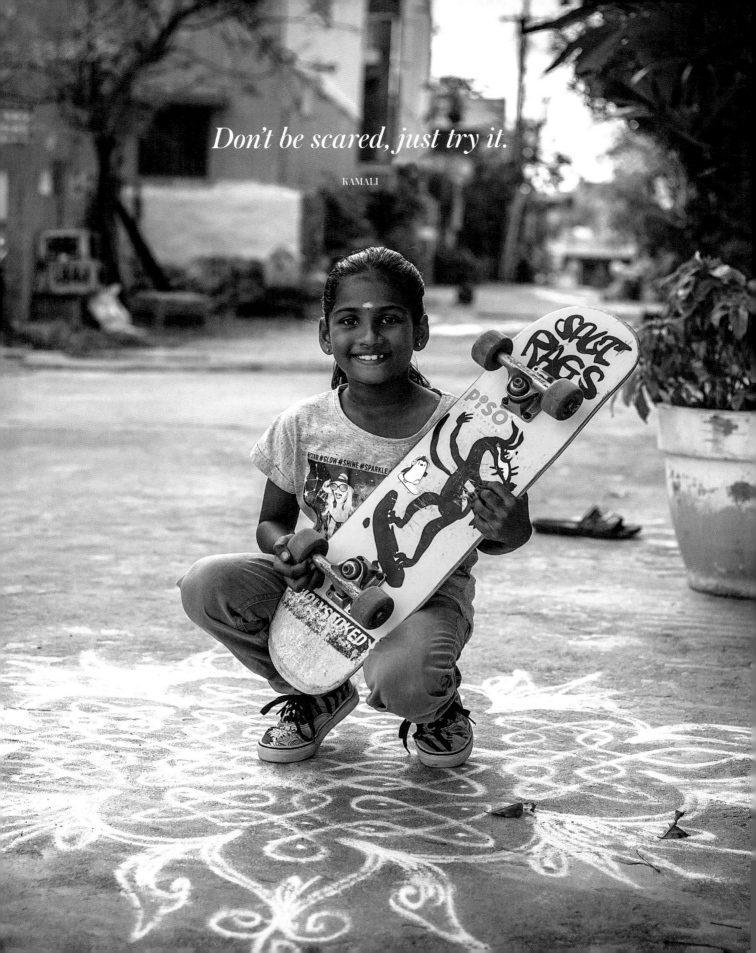

Don't be scared, just try it.

KAMALI

Petra Kostyál

Ski instructor, longboarder, and photographer

@petrakostyal

My name is Petra Kostyál, I'm twenty-one years old, and I'm from Hungary. I don't really know why I skateboard—it's hard to explain why you do what you do—but I think it's mainly for the feeling of it. When I'm skating, there's nothing else: It's just me, my board, and music, and I can totally forget about the world. After a good skate session it feels like everything is alright with the world, and I don't feel lost anymore.

Longboarding is just like life to me: You fail sometimes, and it can feel like it's impossible to land a trick or do the combo you want, and maybe it hurts—but you always get up and try again. If something doesn't happen, maybe it's because it's just not the right time.

I'm really grateful for everything that longboarding has given me and all the good people I've met along the way. It's taught me to be patient and to never give up; to enjoy what I'm doing; and to help others. I actually think longboarding saved my life, and no matter what this life brings, it will always stay with me.

Zalaegerszeg, Hungary

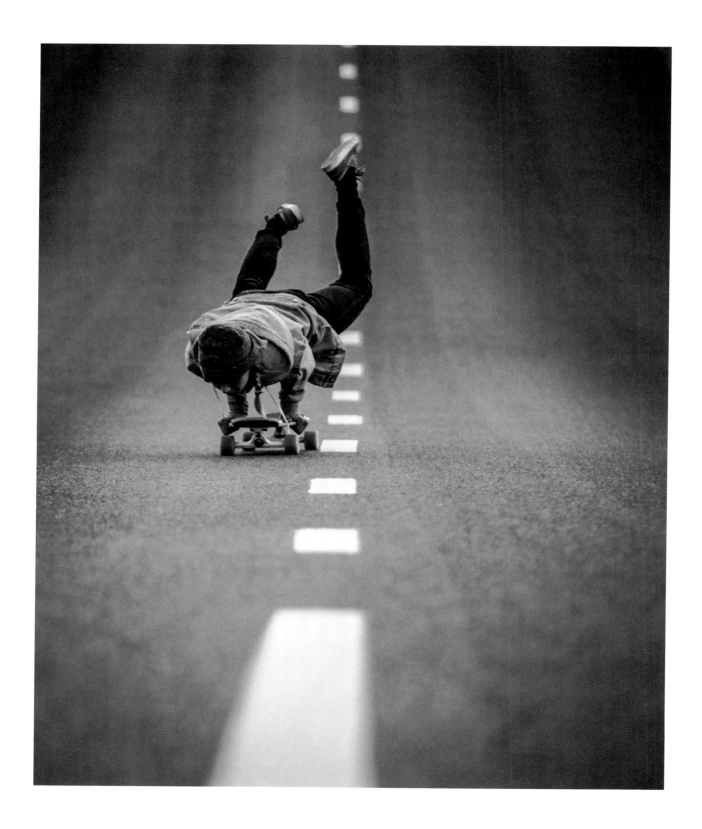

Zalaegerszeg, Hungary

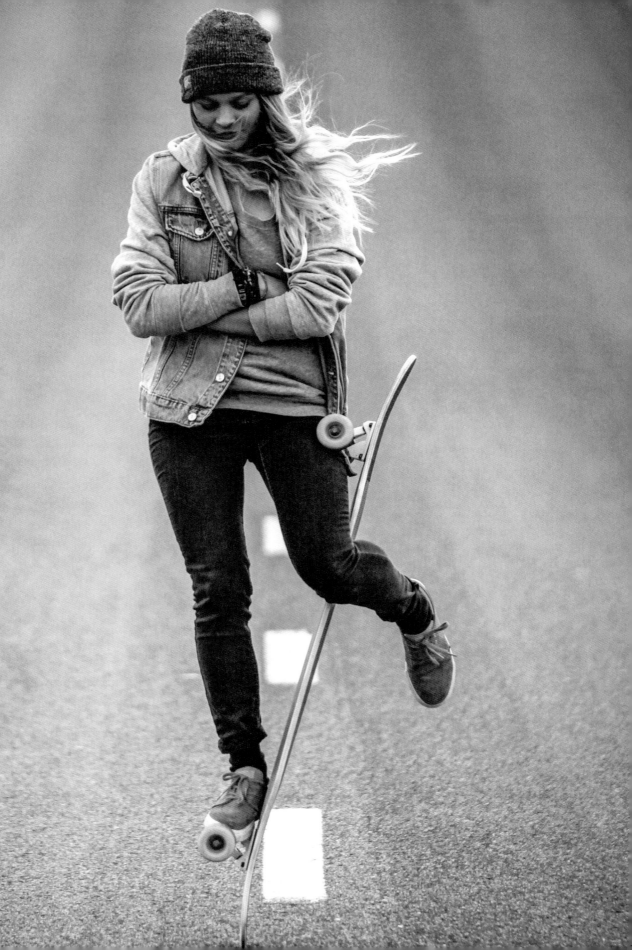

Valeria Kechichian

Advocate for change

@valeriakechichian
@longboardgirlscrew
@longboardwomen

I'm a forty-year-old human being living on Planet Earth. I was born in Argentina of Armenian descent, and I've been living in Europe for the past twenty years.

I never fitted into the roles society expected of me. From a young age, I couldn't understand nor fulfill many of those demands. I was confused by the notion that there was a right and only way to do things. I was also puzzled by why I was treated differently from the boys. You could say that it was this that ignited my passion and quest for equality at a very young age.

I started longboarding when I was twenty-eight, in a desperate effort to change my lifestyle after several years of heavy partying and some substance abuse. I went on to create a social project and community called Longboard Girls Crew (LGC) with my friend Jacky Madenfrost in Madrid in 2010. LGC supports, promotes, and empowers girls, womxn, and trans and nonbinary humans in male-dominated sports such as skateboarding and longboarding. Over the years the community grew stronger, and we now have crews and ambassadors in over sixty countries. It's the biggest in the industry, breaking stereotypes and social norms around the world.

It's crucial to have accurate representation of womxn in action sports. To move away from the stereotypical image of a young, skinny blonde girl cruising around, and towards a diverse and accurate representation of ethnicities, ages,

body types, and skills. Through LGC, I discovered there is much more to the story we're told, and I realized the importance of both quantity and quality of female exposure. I slowly started dismantling a system I no longer believed in, and I now work as an advocate for change.

Our gender should not determine the things we're exposed to, encouraged to do, or expected to do. There are many ways of living and finding happiness, and it's important we're encouraged to find our own way, free of gender labels and cultural commands.

Inspired by the huge impact longboarding and LGC has had on the lives of thousands of girls and womxn around the world, I've created the nonprofit Longboard Women United, which uses skateboarding and longboarding as tools for social change in extremely vulnerable areas. Our projects include working in orphanages in India, with survivors of human trafficking in Cambodia, in Islamic neighborhoods in Malaysia, and with refugees in Europe. I've found my life path in social contribution, and I'm excited to bring the joy, empowerment, and self-confidence that skateboarding and longboarding brought to my life to those who need it most.

I'm now into unlearning most of what I was told as a kid and learning new ways, convinced that change starts in us and that change is us.

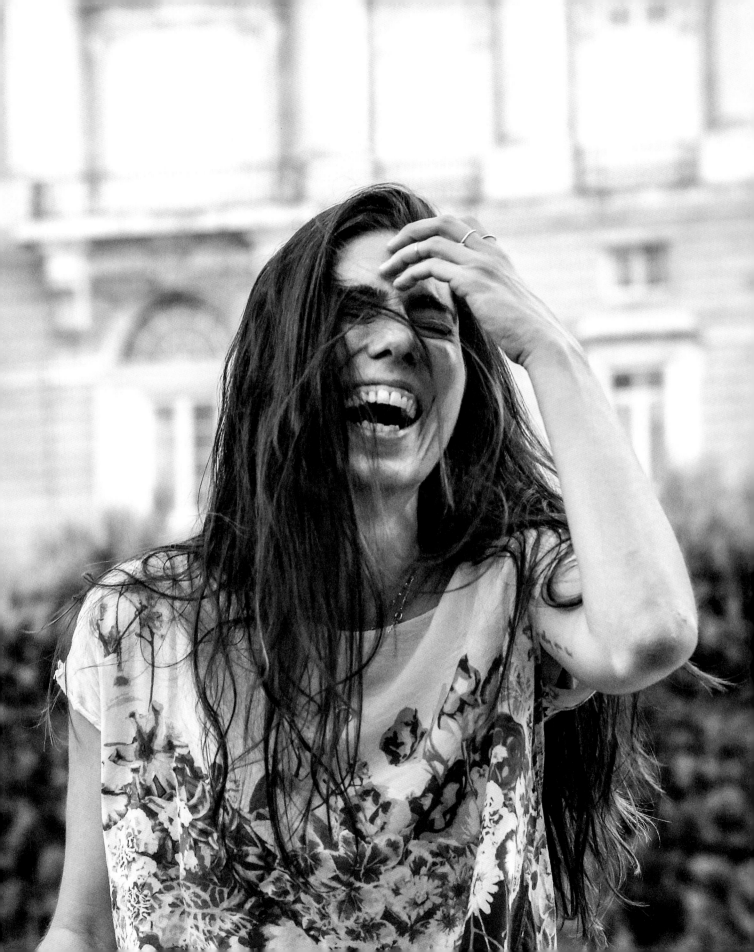

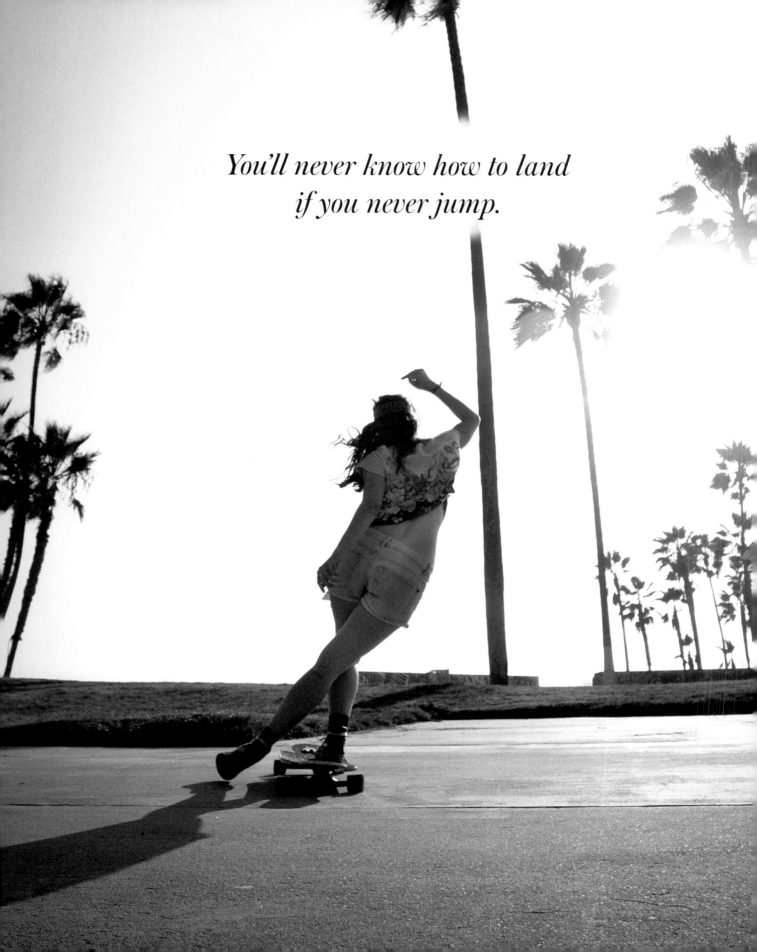

*You'll never know how to land
if you never jump.*

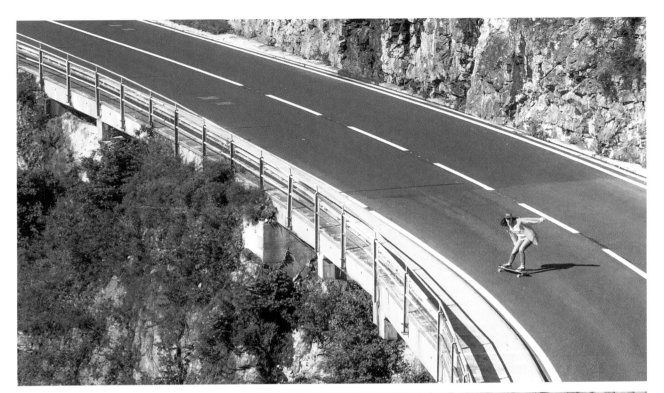

◁ Venice Beach, California, USA △△ Switzerland △ Madrid, Spain

Manon Lanza

Skater and surfer

@allonsrider

I started motocross at the age of six. It was from that moment on that my life revolved around action sports. Now, twenty years later, I've decided to radically change my way of living by moving to be by the ocean, shaking up my opportunities and erasing preconceived ideas of how to live that totally don't fit me.

Some years ago, I made a promise to myself. Men occupy a lot of space in media and television, and I decided it was time to highlight women for their performance and endeavors rather than for their bodies as marketing objects. That promise resulted in Allonsrider.fr, a website I created with my best friend in 2013, highlighting the stories and achievements of the women I admire. We put the focus on girls in board sports. The goal? To show the world that girls are not just asses on glossy paper. Girls can ride.

Today, I'm lucky to be surrounded by an amazing community of more than 135,000 people on Instagram. Every day, I try to motivate ride-lovers to push their boundaries, and more generally to encourage women to believe in their dreams. I want others to have the opportunity to feel the way I feel when I have my feet on a board.

Let's be honest, it's not that easy to learn skateboarding. And it's especially hard when no one else around you has ever picked up a skateboard. When you're afraid to start something new, or when everybody says it's a "boy thing," and you wear a bra. I don't claim to be a professional skateboarder, but I know what it's like to scramble to achieve your goals, to feel uncomfortable in a skate park, and to want to give up.

Skating doesn't have to be intimidating. But I know that many people constantly battle with a fear of failure and of being judged. That fear grows inside them, often blocking them from achieving their goals. Sometimes we need a little push and a little fight to discover our true potential. Finally, what does failing mean? Being bad at something, or not trying at all? It's only by trying that we succeed.

Huntington Beach, California, USA

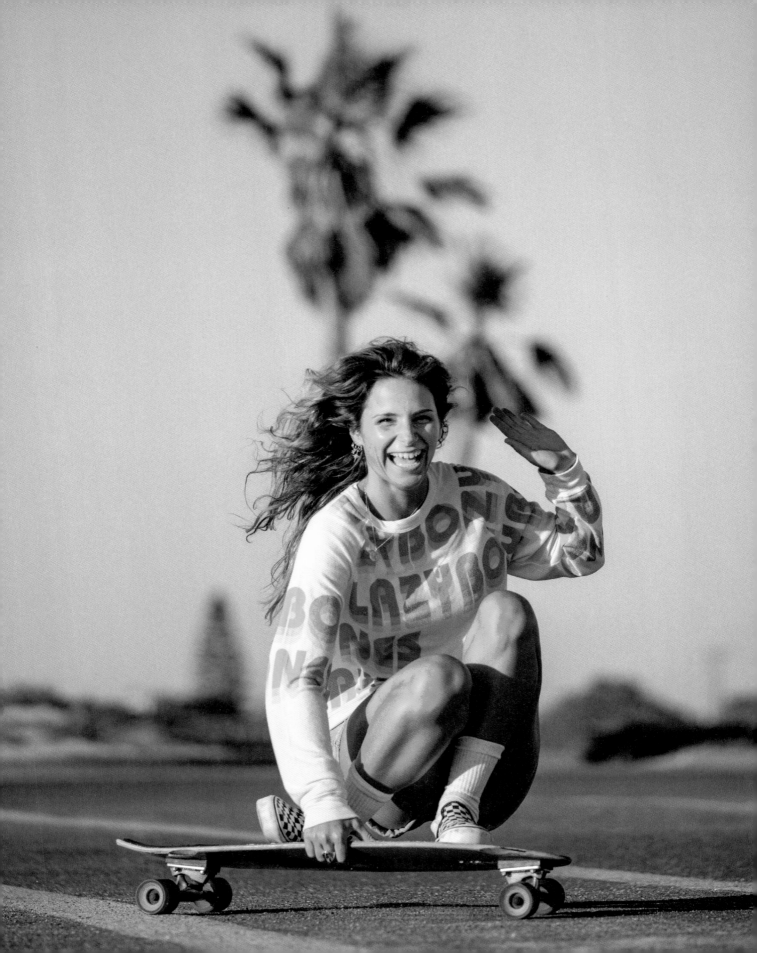

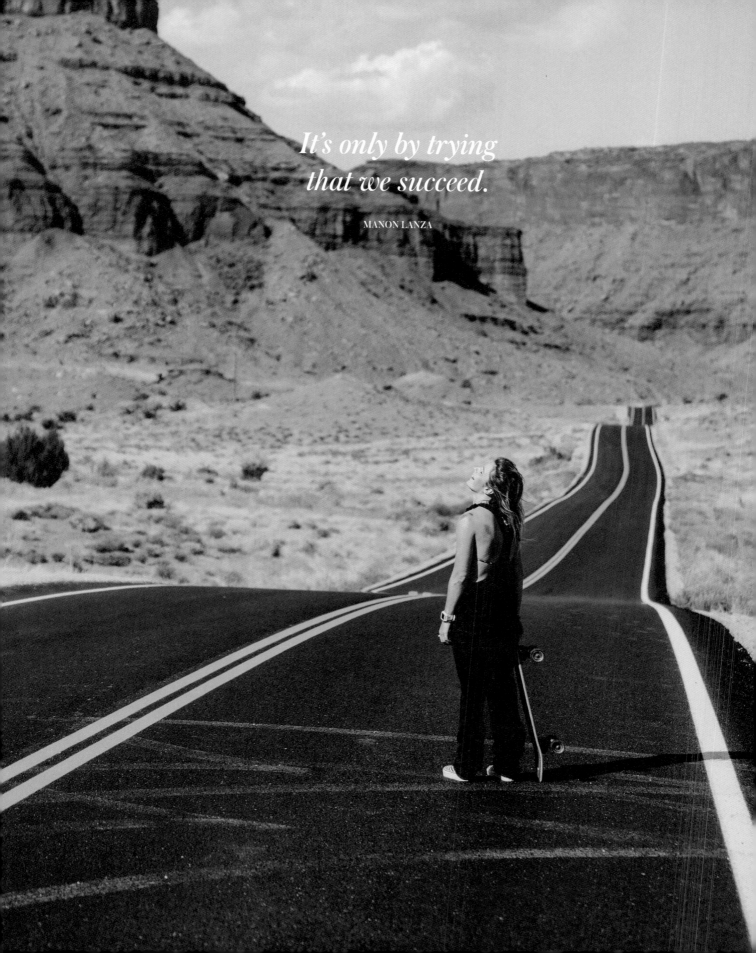

It's only by trying that we succeed.

MANON LANZA

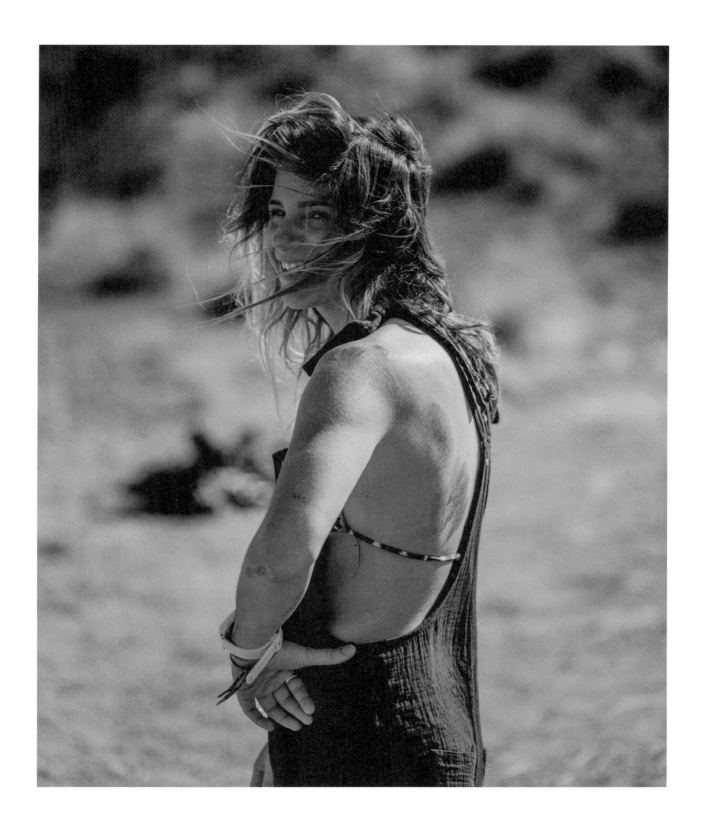

Moab desert, Utah, USA ▷▷ Moab desert, Utah, USA

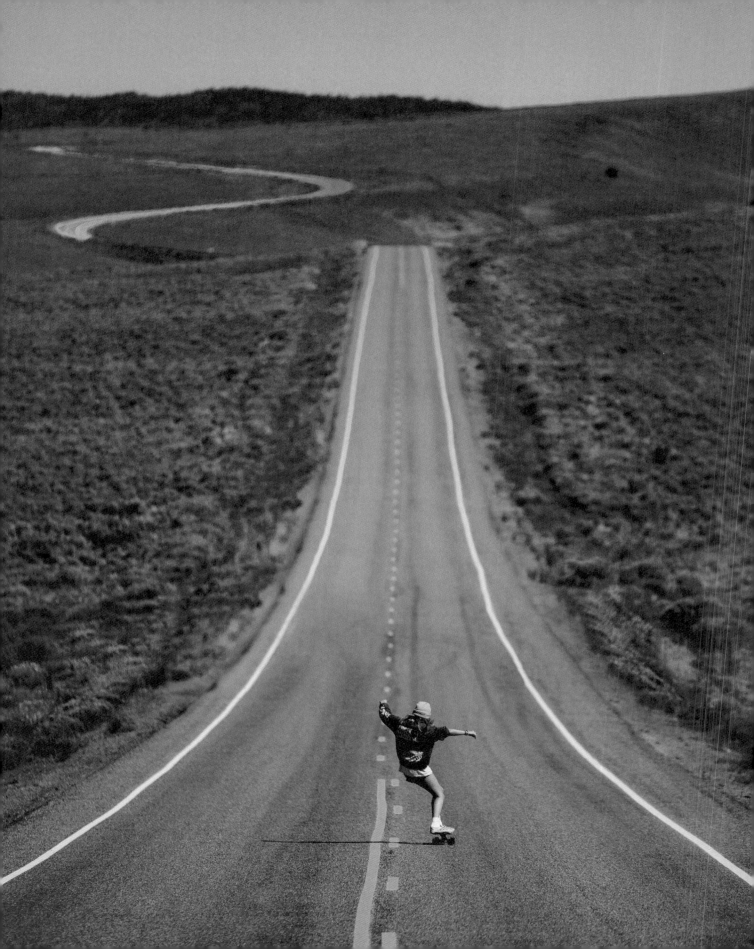

· MINI GUIDE ·

Skate crews, associations, and nonprofit organizations

BABESNSKATE
On a mission to expand the female skate community

SPAIN & ITALY

@babesnskate_bcn
@babesnboards
FB: babesnskate

Babesnskate, based in Barcelona, is the first skate event agency for women. We run camps, classes, events, and parties where the mission is to teach girls that it's possible to skate, and that the skate lifestyle and culture can be enjoyed by everyone. Our project believes in women's power, in pushing the limits, and in dismantling prejudice through the reappropriation of the concepts of women, body, and space.

EXPOSURE
Serving women globally

GLOBAL

exposureskate.org
@exposureskate
@skaterising

Exposure is a nonprofit that empowers women and girls through skateboarding. It started with one event, a benefit for survivors of domestic violence, which has now become the largest women's skateboarding event in the world. We have a youth program for girls aged four to eighteen, Skate Rising, where participants engage in service projects for at-risk communities and then take part in a skate clinic; and we also offer free skate clinics for women aged eighteen to eighty.

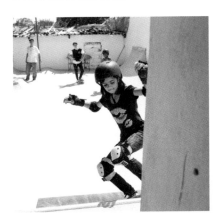

FREE MOVEMENT SKATEBOARDING
A dedicated women's program

GREECE

freemovementskateboarding.com
@freemovement__sb

Free Movement Skateboarding is a nonprofit organization based in Athens, Greece. We provide skateboarding workshops and an educational program to empower underprivileged youths and refugees and bring communities together. Our programs focus on improving the physical and mental wellbeing of the young people we work with while promoting gender parity and aiding integration. We also deliver a focused Women's Program on a weekly basis in partnership with Womxn Skate the World.

GIRLS SHRED
Get confident on board

THE NETHERLANDS

girlsshred.com
@girlsshred

I was always on the lookout for any girls who skateboard, surf, or snowboard, and I started organizing events and sessions in 2008. I run Girls Shred on my own and never expected it to grow this big; it excites me every day to see so many girls out there nowadays. The aim is to empower, inspire, and motivate others, to connect with like-minded skaters, and meet new shred buddies. —Imke Leerink

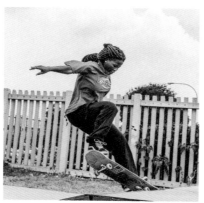

GIRLS SKATE SOUTH AFRICA
Encouraging more girls to skate

SOUTH AFRICA

girlsskatesouthafrica.org
@girlsskate_southafrica

We started Girls Skate South Africa, a nonprofit organization and movement, with the aim of breaking down the feeling of intimidation encountered by females within this male-dominated field. Our goal is to spread the love of skateboarding while also making the Girls Skate name synonymous with skateboarding among female and LGBTQ+ skateboarders nationally. Girls Skate provides skateboarding lessons and collects old boards in order to hand them out to those who need them.

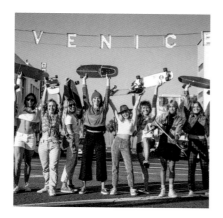

GRLSWIRL
We want women to feel that skate is accessible, approachable, and fun

CALIFORNIA, USA

grlswirl.com
@grlswirl

GRLSWIRL's nine women co-founders come from all walks of life. We believe that we can use our individual stories to help liberate women and aid them in conquering their fears and insecurities through the act of trying something new. We embody the message that you don't have to be a certain "type" of woman to get on a board and learn. We inspire one another to get better, whether it's at our sessions or through social media. We have created a safe space for our members to get out of their comfort zones, ask questions, fall a little, laugh a lot, and create lasting memories.

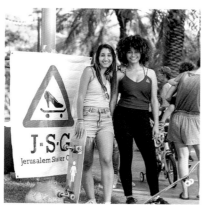

JERUSALEM SKATER GIRLS
Social activities for a diverse community

ISRAEL

jerusalemskatergirls.com
@j.s.g_jerusalemskatergirls

Jerusalem Skater Girls, a community for skateboarding women in Israel, was founded in 2010 by Paola Ruiloba and Maayan Levi. For us, skateboarding—a competitive sports field—is a way of life and our way of expressing, fulfilling, and evaluating ourselves according to our abilities as skaters. Our community consists of members of different backgrounds: Jewish, Christian, Muslim, and more. We use skateboarding to empower women and give them personal development tools through training, support, and competitions.

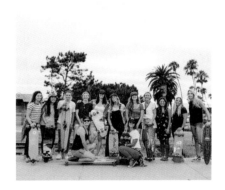

KATEBOARDS
Women's skate company

CALIFORNIA, USA

kateboards.com
@kateboards

KateBoards is a female-owned and operated company founded by Katie Adams in 2018 and based in Encinitas, California. We are dedicated to the inclusion and progression of female riders of all levels through community, collaboration, and quality products. We collaborate with female artists to create the graphics for our boards and provide the highest quality skateboards so women can enjoy skateboarding to the fullest. We hold meetups twice per month and offer private lessons.

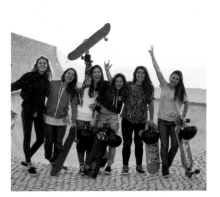

LONGBOARD GIRLS CREW
Changing an industry and social stereotypes

GLOBAL

longboardgirlscrew.com
@longboardgirlscrew

Longboard Girls Crew was created in Madrid, Spain, in 2010. We wanted to make this male-dominated sport as inclusive and accessible as possible, and to increase the representation of women longboarders, which at the time was scarce and highly sexualized. Through events, videos produced by and featuring womxn, and a new kind of exposure where diversity is key, we branched out. Today we have communities and ambassadors in sixty countries, helping build a stronger, healthier society for all humankind.

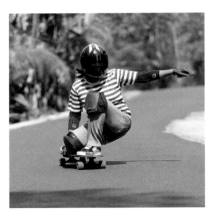

LONGBOARD GIRLS CREW INDONESIA
Creating community

INDONESIA

@lgcindonesia
FB: LGCIndonesia

The formation of Longboard Girls Crew Indonesia began when Gemala Hanafiah, an Indonesian female pro surfer, tried longboarding for the first time and realized that it could be an alternative activity for surfers living in urban areas. As longboard- ing became increasingly popular among Indonesian girls, they started to organize meetups and practice sessions. This led to a search for an international community. After coming across the Longboard Girls Crew, founded in Madrid in 2010, the Indo- nesia chapter of the crew was established.

LONGBOARD WOMEN UNITED
Skate for social change

GLOBAL

longboardwomen.org
@longboardwomen

Guided by the force, empowerment, and transformation brought to our lives through running Longboard Girls Crew, we created our nonprofit, Longboard Women United, to use skate and longboarding as tools for social change in vulnerable communities around the world. To date our projects include working in orphanages and rehab centers in India, in Islamic neighborhoods in Malaysia, with refugees in Europe, and in vulnerable areas across North and South America. You can collaborate with us by volunteering or donating via our website.

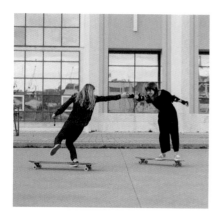

LONGBOARDING DAYS & NIGHTS
A safe and fun
environment

PORTUGAL

longboardingpt.com
@longboarding.pt

Longboarding Days & Nights is a
pioneering longboard dancing and
freestyle community in Portugal. Our aim
is to spread the love for longboarding and
inspire people to get out of their comfort
zone. We organize events, lessons, and
one-of-a-kind longboard camps where
anyone can learn how to skate in a safe
and fun environment.

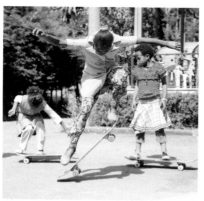

MEGABISKATE
First girls' skateboarding
team in Africa

ETHIOPIA

megabiskate.com
@megabiskategirls
@megabiskate

Megabiskate, founded in 2005 by Israel
Dejene, is a skate movement based
in Addis Ababa, Ethiopia. It is a bridge
for change, aiming to connect children
with opportunities for economic, social,
and educational development and
empowerment. Megabiskate provides
skate training and equipment, teaching kids
how to skateboard while also focusing on
teamwork and leadership skills. Dejene also
founded Megabi Skate Girls, the first girls'
skate team in Africa, focused on empowering
young girls through the art of skateboarding.

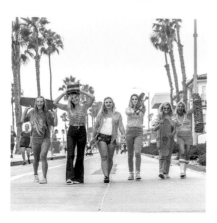

SHE SKATES HERE
Monthly meetups
for all abilities

USA

@sheskateshere

She Skates Here was created so that
women of all abilities and backgrounds
who are interested in or inspired by
skateboarding can connect and skate
together. San Diego is a skate mecca, with
world-class skate parks, backyard ramps,
and superb weather, making it a great
place to shred and meet like-minded
individuals. She Skates Here hosts
monthly meetups at skateparks around
the country for skaters of all abilities.
#comeskatewithus

SKATE GAL CLUB
Skateboarding lessons
and art workshops

GHANA

@surfghana
@skategalclub

Skate Gal Club is an initiative based in
Accra, Ghana, that works to empower
women through skateboarding. Access
to the club is free and the organization
offers skateboarding lessons as well as
art workshops and activities like yoga,
hula-hooping, Soul Sister Circle and
more. Today we have more than sixty
active members who take part regularly
in our monthly meetups. The project has
received a lot of support and positive
feedback and has definitely helped to put
Accra on the map!

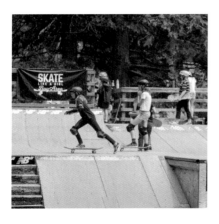

SKATE LIKE A GIRL
Social justice
through skateboarding

SEATTLE, PORTLAND,
SF BAY AREA, USA

skatelikeagirl.com
@skatelikeagirl

Skate Like a Girl is an organization serving thousands of skaters in Seattle, Portland, and the San Francisco Bay Area.* The mission is to create a more inclusive community by promoting confidence, leadership, and social justice through skateboarding.

*This organization is not affiliated with this publication.

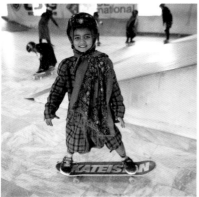

SKATEISTAN
Teaching children
that skateboarding
truly is for everybody

AFGHANISTAN, CAMBODIA
& SOUTH AFRICA

skateistan.org
@skateistan

Skateistan is an international NGO that empowers children through skateboarding and creative education. With skate schools in Afghanistan, Cambodia, and South Africa, we put girls' participation at the center of what we do and are proud that half of our students are girls. We run girls-only sessions, employ women as educators and role models, and teach children that skateboarding truly is for everybody.

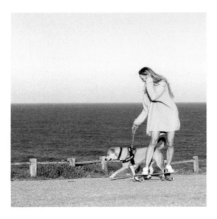

SMILESKATES
The joy of being a beginner

CYPRUS

smileskates.com
@smile_skates

Don't wait for that "perfect moment" to embark on your new beginning. Stop waiting, and, like water, gently run, drop, fly; see new places with a fresh eye. Celebrate the joy of being a beginner—we're all beginners in what we're actually trying to learn, achieve, reach, and break through. Life is an adventure, and the journey is the destination.

◁ Elizabeth Killi

WOMEN SKATE
THE WORLD
Inclusivity, empowerment,
equality

GREECE &
THE NETHERLANDS

womenskatetheworld.com
@womenskatetheworld

Women Skate the World is an organization dedicated to inspiring, empowering, and engaging womxn through skateboarding. Co-founders Amber and Nanja met while volunteering with a skate organization in Palestine, and discovered a shared passion for skateboarding and empowerment. They decided to do more, and Women Skate the World was born. Based in Athens and Amsterdam, the program combines education, creativity, and skateboarding with the aim of working towards a more inclusive and equal society.

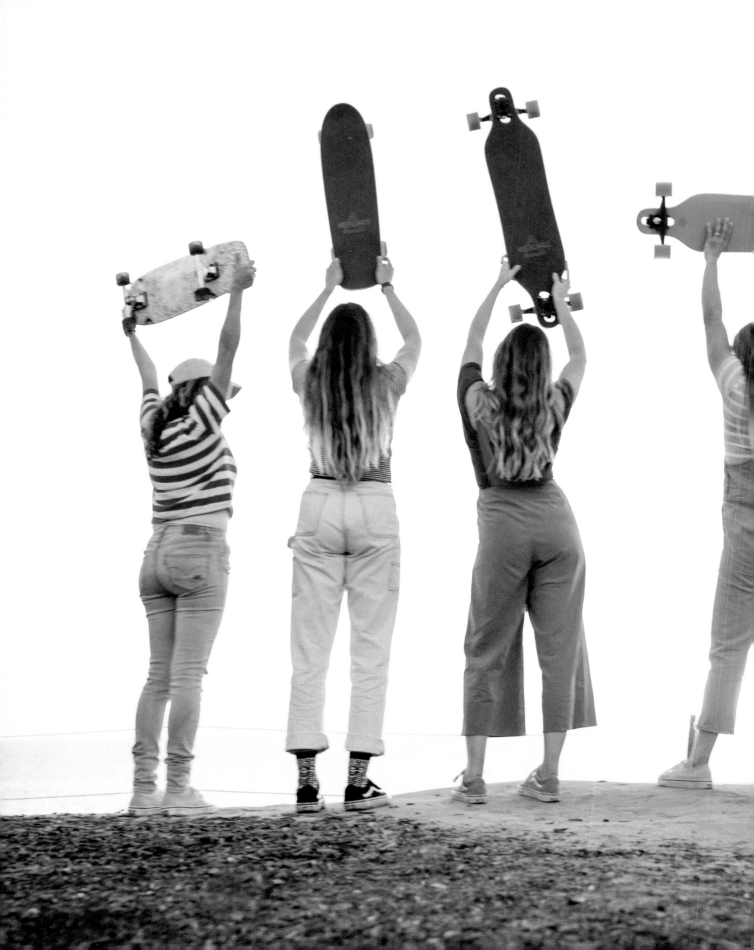

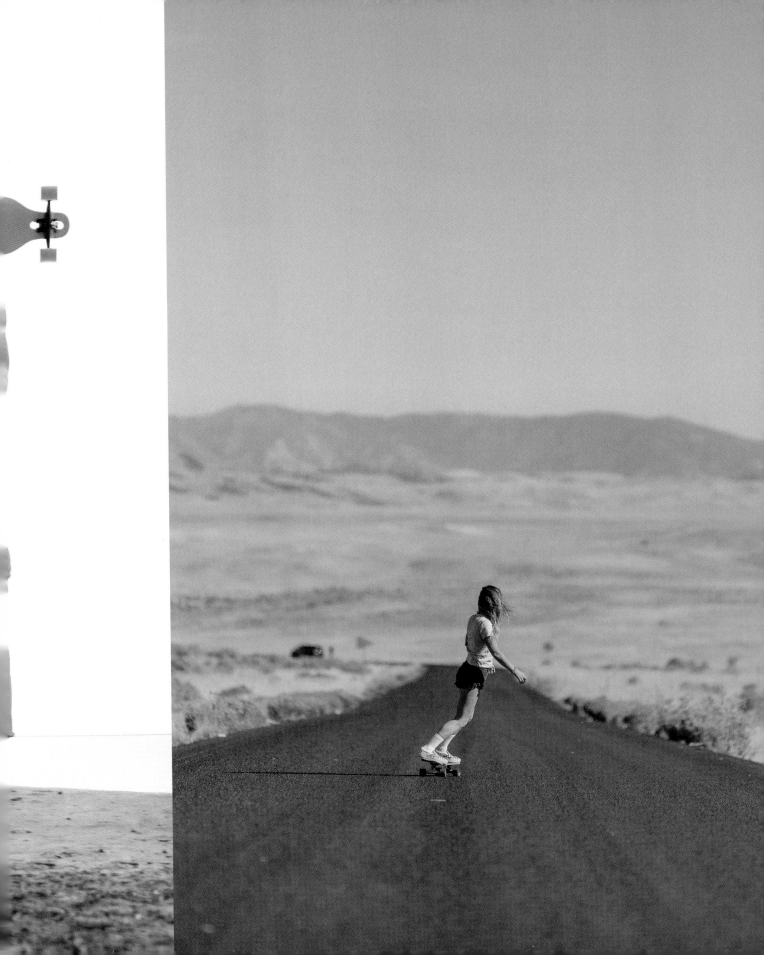

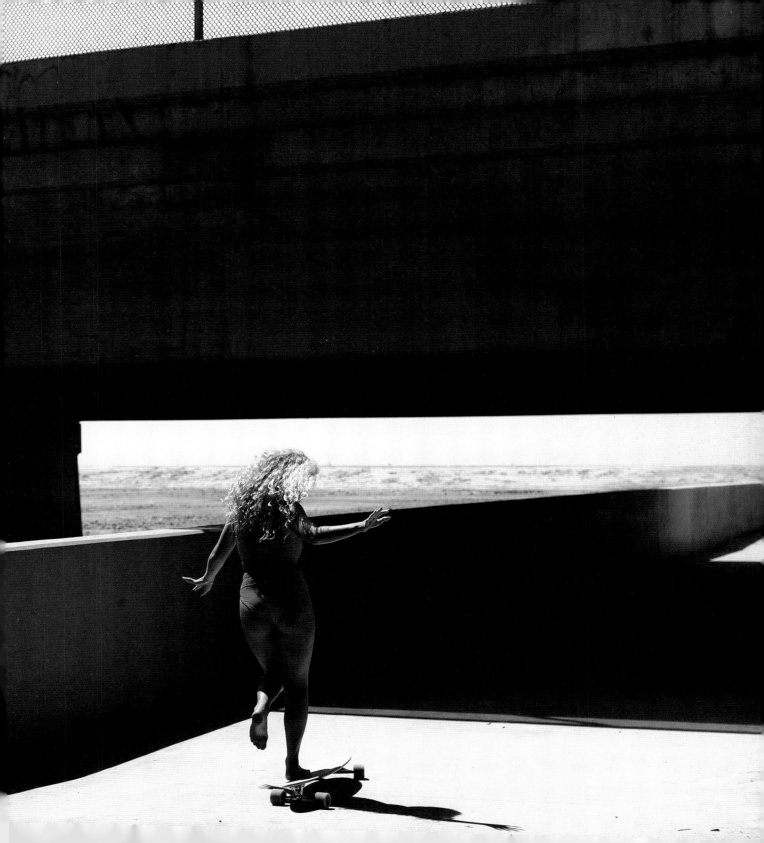

PHOTO CREDITS

A

ALEX CAVE
Alexcaveprintingco.com
@imalexcave
Page: 243 (Free Mov. Skateboarding)

ALEXANDER MALYSHEV
@alex_____m
Pages: 30, 31b, 36

ALEXANDRE CRIQUIOCHE
Alexcrk.com
@alex__crk
Pages: 81, 82, 83, 85

ANATOLY LAMTEV
Pages: 193, 198, 199

ANDY BUCHANAN
@andy_buchanan_photos
Page: 247 (Skateistan)

ANNE-CHARLOTTE MOREAU
Annecharlottemoreau.fr
@annecharlotte.moreau
Page: 247 (Women Skate the World)

ANTHONY TACHE
@anthography_
Page: 237t

ARIAN CHAMASMANY
TheGelLab.com
@ari_shark
Page: 236

ARTYOM PONYAVIN
@generic.mahmud
Page: 31t

ASHLEY RANDALL
Ashleyrandallphotography.com
@ashleyrandallphoto
Pages: 87, 90

ALYSSA FIORAVANTI
Alyssafior.com
@alyssafior
Page: 6

B

BREN LOPEZ FUENTES
@brenstormin
Pages: 11, 16

BRIE LAKIN
Brielakin.com
@brielakin
Page: 245 (Kateboards)

C

CAYLEE HANKINS
cayleehankinsphoto.uk
@alittlepickmeup
shoots with @fast_women
www.thefastwomen.com
Pages: 46, 48, 49, 50

CLARENCE K.
Clarencekphotography.net
@clarenceklingebeil
Pages: 39

CLAUDIA LEDERER
Claudialederer.com
@claudia__lederer
Pages: 4, 156, 158, 159, 160, 161, 162, 164, 165

CLOTHILDE BURON
@clow_photos
Page: 208t

COOLNVINTAGE
Coolnvintage.com
Page: 15

D

DANIEL TAYENAKA
Saltedbeardphoto.com
@saltedbeard
Pages: 113, 148

DG KIM
@longboard_yuni
Pages: 18, 20, 21, 22, 23, 24, 25, 26

DIEGO SARMENTO
Diegosarmento.com
@diegosar
Pages: 94, 96, 99

DMITRY AIZENTIR
@soaizy
Pages: 194, 195

DÓRA KOSTYÁL
@dorakostyal
Page: 231

DUCK VADER
@duckvaderphoto
Pages: 74, 76, 77t

E

ELISE CRIGAR
Elisecrigar.net
@elise_crigar
Pages: 114, 116, 118, 119, 120, 122, 123, 140, 144, 146, 252

ELIZAVETA ZORYCH
@zorychlissa
@zorych_photo
Pages: 29, 32, 37

F

FABIAN REY HOERMANN
Grannoir.com
@grannoir
Page: 72

FANNY CHU
fannychu.com
@fannychuphotography
Page: 56t

FERNANDO JUNIOR
@fmajuniorphoto
Pages: 92, 95, 98

G

GABRIEL NAKAMURA
@gabrielnaka
Page: 244 (GRLSWIRL)

I

IAN AND ERICK
Iananderick.com
@iananderick
Page: 2

IAN LOGAN
Ianloganphoto.com
ianloganphoto.blogspot.com
@ianloganphoto
Pages: 182, 184, 185, 186, 187, 188, 189, 190

ITAMAR EYAL
Itamareyal.com
@itamareyal
Page: 106

J

JAIME OWENS
Skateboarding.com
@jaimeowens
Pages: 7

JAKE NACKOS
yo.jakeandash.com
@instasize.official
@ashleynackos
@jakenackos
Pages: 240, 241, 242, 249

JENNIFER ROBERTS
jenniferroberts.ca
@jenniferroberts
Page: 1

JO SAVAGE
Josavagephoto.com
@jo_savagephotography
Pages: 101, 124, 126, 127, 128, 130, 131, 132, 137t, 145, 149, 239, 248

JOANNE BARRATT
islandstyleimages.com
@joannebarratt_photo
Page: 246 (She Skates Here)

JOÃO PEDRO CORDEIRO
@joaocordass
Page: 12

b - bottom

t - top

© Prestel Verlag, Munich • London • New York, 2020
A member of Verlagsgruppe Random House GmbH
Neumarkter Strasse 28 • 81673 Munich

Cover: Wafa Heboul, photo by Claudia Lederer
Back cover: Photos by Ian Logan (top left), Lanna Apisukh (top right), Dg kim (middle right), Marta Guillén (bottom left), Fernando Junior (bottom right)

Library of Congress Control Number is available; a CIP catalogue record for this book is available from the British Library.

The US-based nonprofit organization Skate Like a Girl is not affiliated with this publication. To find out more about their work please visit www.skatelikeagirl.com

Editorial direction: Julie Kiefer
Concept and coordination: Carolina Amell
Photo research: Carolina Amell
Design and layout: Carolina Amell
Copyediting: Aimee Selby
Production management: Friederike Schirge
Separations: Ludwig Media, Zell am See
Printing and binding: DZS Grafik, d.o.o., Ljubljana
Paper: Profibulk

Verlagsgruppe Random House FSC® N001967

Printed in Slovenia
ISBN 978-3-7913-8707-9
www.prestel.com